ARCHITECTURAL
ILLUSTRATION

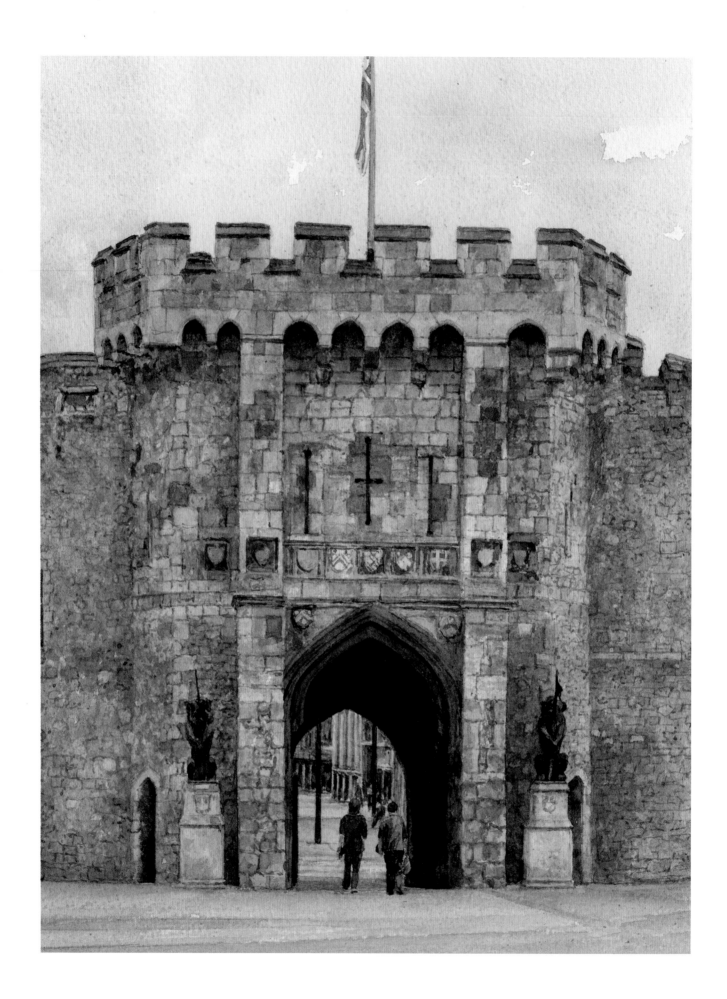

ARCHITECTURAL
ILLUSTRATION

PETER JARVIS

THE CROWOOD PRESS

First published in 2018 by
The Crowood Press Ltd
Ramsbury, Marlborough
Wiltshire SN8 2HR

www.crowood.com

British Library Cataloguing-in-Publication Data
A catalogue record for this book is available from the British Library.

ISBN 978 1 78500 403 2

Front cover: The RSA building in John Adam Street is the home of The Royal Society for the
Encouragement of Arts, Manufactures and Commerce. It was designed by the Adam brothers
and completed in 1774 as part of their innovative Adelphi scheme. Several photographs were
used as primary reference to piece together this view of the façade, which could not be seen
in reality due to the narrow street. Watercolour over pencil on 90lb Canson Montval Aquarelle
NOT stretched watercolour paper at 500 × 360mm.

Back cover: Part of the old medieval walls of Southampton looking towards St Michael's Church
beyond. Watercolour over pencil on 140lb Saunders Waterford NOT stretched watercolour
paper at 340 × 270mm.

Frontispiece: Southampton's Bargate was built around 1180 and is constructed of stone and
flint. It was the gateway to the walled city of Southampton and formed part of its fortifications.
The dark washes applied to the underside of the archway establish the tonal range of the
building and contrast against the view beyond. The figures help to give scale. Watercolour over
pencil on 90lb Canson Montval Aquarelle NOT stretched watercolour paper at 350 × 430mm.

Graphic design and layout by Peggy & Co. Design Inc.
Printed and bound in Indai by Replika Press Pvt Ltd

Contents

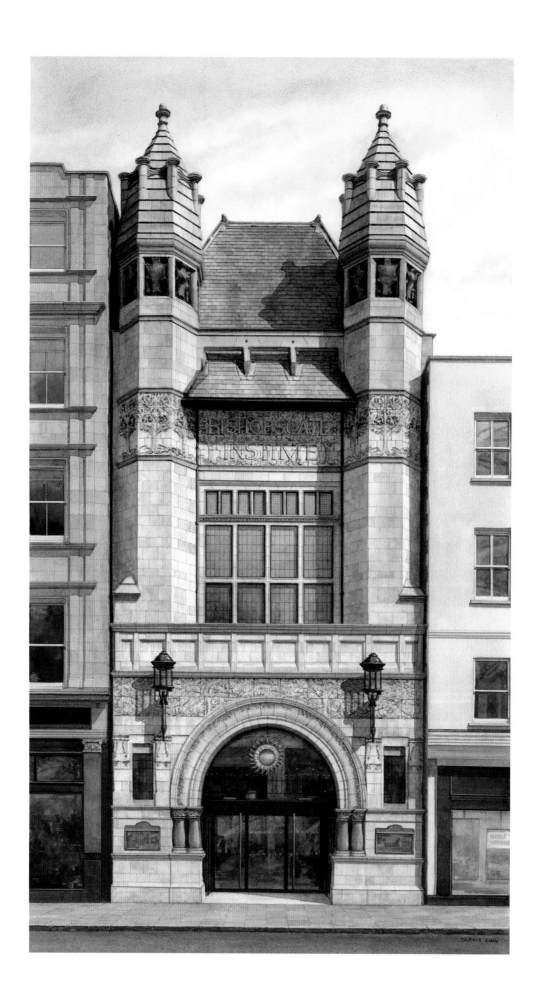

Introduction

A dictionary definition of the word illustration is: 'a picture, design, diagram, etc. used to decorate or explain something'. This book is about the illustration of buildings and the built environment and how buildings are seen in context. It's not an instruction book on the use of digital methods, or any other medium, but it does cover some basics on a range of applications. It examines the subject primarily from the author's standpoint as a traditional architectural illustrator, but also looks at the illustrator's role in broad terms and how architectural design is presented in the public domain. It contains worked examples and step-by-steps, mainly hand-drawn by the author, in order to explain to the novice the fundamentals of the subject. Selected case studies and artists' profiles are also included for interest to the more advanced practitioner.

These days many illustrators work by combining traditional skills with computer skills, but it's the role of drawing that remains the most important component in providing the foundation to a successful outcome. Drawing is about looking and observation, but it's also about enquiry and investigation. Through observation one learns about the nature of a subject; how it works or what materials it is made from. The act of drawing on location, done over an hour or so in a particular place, will enhance other forms of studio-based applications. With regular practice, drawing and sketching skills help to improve an illustrator's ability to create convincing and credible illustrations. Technical problems are often easier to solve through drawing and can be communicated without the hindrance of the written word. Many architects start out with freehand concept drawing as a means to exploring initial ideas. Such drawings can be referred to as the outcome of 'self-commune': engaging in a dialogue with oneself. There are many role-models to look to in this respect: the great architect Ted Cullinan is a master of the sketch and has produced many 'draw and talk' videos, and Sir Norman Foster is an enthusiastic advocate of this type of drawing. The late Hugh Casson famously sketched during his travels and published several books of his work done whilst visiting major British cities. More often than not, the role of the architectural illustrator will move back and forth from visualization to representation; from prediction to documentation, all of which can be described as illustration.

Approaches to drawing can be far-ranging and diverse in purpose and outcome. As a radical visionary, the late Zaha Hadid produced many drawings and paintings in which she explored the limits of architectural form. Much of this work was never realized in built-form but represented the potential of structural possibilities. She used perspective to

Bishopsgate Institute was designed by Charles Harrison Townsend and opened in 1895 as a centre for culture and learning. This illustration shows the façade of the building as seen from the opposite side of Bishopsgate, but the naturally occurring vertical convergence has been corrected in Photoshop. Designed in the fashionable styles of the Arts and Crafts movement and the Art Nouveau style, this building has all the elegance of this period with filigree stonework and decorative twin roof turrets. Watercolour over pencil on 90lb Canson Montval Aquarelle NOT stretched watercolour paper at 580 × 320mm. (Courtesy of Luke Johnson.)

communicate the dynamics of architecture and in doing so created dramatic results if, at times, somewhat inaccessible to the general public. Álvaro Siza, the great Portuguese architect, spoke about the different purposes of drawings: to generate ideas; to develop them; to communicate; or for simple pleasure. Many architects still talk about the pleasure of drawing and sketching as a way of exploring shape and form in design and this is still considered to be important alongside digital methods.

In architectural illustration it is crucial to have a knowledge of building materials and methods of construction. This can be very broad depending on the type and design of a building. Vernacular buildings can date from medieval times and rely on indigenous materials in their construction whereas modern city blocks are made from concrete, steel and glass. Familiarity with building terminology can help to avoid any misunderstandings between the illustrator and client; there is a glossary of terms at the back of this book. Many illustrators specialize in particular building types, often relating their style and method to its appropriate representation: a medieval hall house rendered as a computer generated image (CGI) might not lend itself to the medium as well as the use of traditional pen and ink or watercolour. The important skill here is in maintaining the consistency of style and technique within the illustration.

Photographic skills are also important and acquiring these has been simplified with the advent of digital technology. Many projects require the illustrator to superimpose proposed buildings into photographs of existing urban and natural landscapes. This process is often enhanced by using on-line maps and street views that have now become standard tools in the illustrator's toolbox.

The term architectural illustration is a relatively modern one and has its roots in the topographical tradition of watercolour painting occurring at the start of the eighteenth century. Prior to this time early topographical drawings were often the work of surveyors and mapmakers who were familiar with the conventions of architectural drawing and perspective. During the late seventeenth century wealthy landowners would commission aerial views of their country homes from talented draughtsmen and artists. The topographical style was introduced to England in the drawings of Bohemian artist Wenceslaus Hollar (1607–1677) and taken up by two Dutch draughtsmen, Jan Kip and Leonard Knyff, who produced many topographical views of British country houses and gardens in the form of engravings.

At this time the topographical watercolour was first and foremost a record of an actual place, its aesthetic value of secondary importance. By the mid-eighteenth century topographers were employed to record the traveller's journey in the Grand Tour through France and Italy, which resulted in a proliferation of pen and ink wash drawings. Such drawings were reproduced and published in travel journals, art magazines and as prints.

The first artist to reveal the true aesthetic of the genre was Paul Sandby (1730–1809) who is often referred to as 'the father of English watercolour'. Sandby and his brother, Thomas, greatly influenced both painting and architecture at this time. Paul Sandby was a founder member of the Royal Academy, established in 1768, and Thomas Sandby was its first Professor of Architecture. Paul Sandby was one of the pioneers in the use of watercolour for topographical scenes incorporating figure compositions in the foregrounds. Sandby's work was very exacting and 'draughtsman-like' in execution, which typified the common approach to the medium at this time. Often described as 'coloured-drawings', they were finely drawn on watercolour paper in pencil with transparent washes overlaid. Although Sandby never visited Italy, his work was the first to reflect the new Romantic spirit developing in Europe and the interest in classical architecture. The Italian architect and visionary Giovanni Battista Piranesi (1720–1778) was instrumental in this movement and many English architects including Robert Adam (1728–1792) and Sir William Chambers (1723–1796) went to Rome to meet him. The romantic and picturesque philosophy was here to stay. Through the medium of watercolour it was to capture the hearts and minds of the English people. Its essence was characterized by writers and theorists, most notably Uvedale Price (1774–1829) and Richard Payne Knight (1750–1824) who took its original relationship with the paintings of Claude and Poussin and developed a contemporary aesthetic idea. This notion of the 'picturesque' in art and architecture was a major factor in the way buildings and the landscape were portrayed at that time and has survived to this day.

Architectural drawing borrowed many of the qualities inherent in the picturesque aesthetic of the late eighteenth century. As a method of representation it was governed by the same influences that shaped the buildings themselves and architects strove to create atmospheric visualizations of their intended reality. In this ambition many compositional devices were used, such as a greater attention to landscape foreground and background, existing trees and buildings, entourage elements such as action poses in figures and horses, dogs and carriages as well as emphasis on colour, light and atmospheric conditions. The landscape architect

Humphry Repton (1752–1818) used all these elements and more, in his now famous Red Books which he presented to his clients. These consisted of 'before and after' perspective drawings showing proposed new designs on a hinged flap attached to the drawing.

The new emphasis became focused on the enhancement of nature and its relationship with the built environment. Also, there was recognition of nationalistic differentiation between style and individuality. Natural landscape and atmosphere, peculiar to a particular place, became important in its representation and the demand from the travelling public was to encourage collectors of paintings and drawings from around the world.

A major effect of this new approach in architectural drawing was a rise in overall standards and the emergence of many artists who were largely untrained in the finer points of architecture. The most notable was J.M.W. Turner (1775–1851) who, together with Thomas Girtin (1775–1802), was responsible for raising the profile of topographical painting to a fine art. Other noteworthy artists were Michael Angelo Rooker (1743–1801), John Varley (1778–1842) and later, John Ruskin (1819–1900) who was hugely influential in the promotion of the 'Picturesque' in watercolour painting which impacted on the topographical artist. Ruskin was a skilled draughtsman in his own right and his writings influenced how artists composed and presented both the natural and built environment in topographical painting.

Watercolour painting became an important skill to professional architects and surveyors in the representation of proposed architecture. Because of its ease of application, the medium of watercolour was widely adopted by draughtsmen in engineering and shipbuilding during the nineteenth century and many fine examples can be studied in both these areas. At this time a number of 'how to' books and guides were published giving advice on mixing colours in order to represent certain materials. The box given here shows examples of this and is typical of how materials were represented on measured orthographic drawings.

Colour coding in architectural drawing was in use by the mid-eighteenth century but not standardized. Different offices used a variation of colours to denote building materials, especially noticeable on sectioned elevations. The use of watercolour applications in both painting and draughtsmanship at this time perpetuated its popularity in England. It was a timely coincidence of the picturesque sensibility in art and architecture with the popularity of the medium, which was to have a significant effect on how architecture was to be represented in the future.

MATERIALS COLOUR PALETTE

Cast iron	Payne's Grey or Neutral Tint
Steel	Purple: mixture of Prussian Blue and Crimson Lake
Brass	Gamboge with a little Sienna or Red added
Copper	A mixture of Crimson Lake and Gamboge
Lead	Light Indian Ink with a little Indigo added
Brickwork	Crimson Lake and Burnt Sienna
Firebrick	Yellow and Vandyke Brown
Grey stones	Light Sepia, Burnt Sienna and Carmine
Soft woods	Pale tint of Sienna with a little Red added
Hard woods	As above but darker tint with greater proportion of Red

Unlike the topographical drawing, the perspective represented proposed architectural design and became a common means of showing buildings in a realistic setting. In fact the best perspectives were so convincing they were difficult to distinguish from topographical views. Of course this pleased the architects' clients immensely and those with elite skill levels were in high demand.

Perspective drawings reached a height of achievement in the nineteenth century through the work of Joseph Michael Gandy (1771–1843) who worked exclusively on Sir John Soane's architectural designs for eleven years. Most famously, the sublime quality of his aerial perspective showing Soane's design for the Bank of England (1830) as a ruin, received critical acclaim. The architectural competition was, and still is, a common means in achieving design outcomes for public buildings. As a result of this there is a surplus of un-built design proposals stored in our national archives, where the perspective drawing survives as the only evidence of an architect's vision.

The golden age of architectural drawing continued through the 1800s into the twentieth century with work from architectural artists and perspective draughtsmen such as Charles Robert Cockerell (1788–1863), Alfred Waterhouse RA (1830–1905), William Walcot (1874–1943) and Cyril Farey (1888–1954). The work of these and other skilled artists was in high demand and regularly exhibited in the Architecture Room of the Summer Exhibition at the Royal Academy. In fact, Farey was so popular that his work dominated the RA and the phrase 'Fareyland' was coined in this connection.

The picturesque sensibility in architectural drawing maintained a certain popularity throughout the nineteenth

century and even alongside the Modern Movement of the 1930s and into the 1960s. It was fuelled by a variety of influences, not least the invention of photolithography in about 1868 when the first plate was published in *The Building News*. This brought about a great increase in the number of pen and ink drawings, a genre dominated by the work of Richard Norman Shaw (1831–1912), William Eden Nesfield (1835–1888) and Arthur Beresford Pite (1858–1934). Also with improvements in painting techniques generally, many drawings were reproduced using aquatint etching methods and these were regularly published in magazines such as *Ackermann's Repository* and later in *The Builder*.

The new Gothic Revival style and the Arts and Crafts movement were also responsible for the continuation of picturesque qualities in drawing, although Ruskin and William Morris were concerned about the over-use of perspective drawing in their belief that good architecture was a matter of good building and not the method of its representation. The case for and against the use of perspective in the representation of proposed architecture raged on throughout the nineteenth and twentieth centuries. Architectural drawing methods began to embrace a variety of styles and techniques in order to produce eye-catching presentations that would stand out from the rest. One particular technique was referred to as 'dazzle', which was initially developed in pen and ink and later applied using other media. This is where atmospheric sky and landscape effects were used to add drama to a picture. Competency in architectural drawing and rendering has always ranged from the adequate to the inspired and artistic. Techniques in both traditional draughtsmanship and artistic representation were, and still are, a means to the creation of style. The technique of 'dazzle' in the hands of a competent draughtsman, demonstrated great command and skill, whereas by the less accomplished, it was over-used. This resulted in the method of representation becoming more important than the architecture itself.

Dazzle and similar techniques were used to develop a variety of drawing styles which, it could be argued, were a furtherance of the picturesque aesthetic. One of the most distinct drawing styles at this time can be seen in the work of Charles Rennie Mackintosh (1868–1928). Mackintosh's technique, much imitated, was the result of many influences, the Arts and Crafts movement and Art Nouveau being the most prominent.

The perspective drawing flourished from the early nineteenth century until the turn of the twentieth century. At this time controversy began to surround its preparation and use and the Royal Institute of British Architects decided that they should not be used in competitions and by the 1920s perspectives had all but disappeared from these events. Throughout these years of dispute, however, there continued to be a demand for perspectives especially for use in publications and exhibitions, the former being the most successful way of advertising an architect's work. At about this time many newly qualified architects who displayed skills in drawing and rendering, began to specialize in this activity, marking the emergence of the full-time freelance illustrator.

With the increasing move towards specialization within the professions, the perspective artist became an established sub-profession of the architectural and building industry. Architects recognized this and were able to select a style of drawing and rendering to suit a particular project. As we move through the decades preceding the Second World War, opportunities arose for the architectural draughtsman who had the ability to visualize a design proposal in a pictorial manner. In the recession-hit 1930s, a recently trained architect who could draw and had the skill to visualize from plans could increase his chances of full-time employment.

At a time when the great public patrons of modern art included Shell, London Transport and the Post Office, the equivalent in modern architecture were of a much lower profile. The poster artists such as Edward McKnight Kauffer (1890–1954), Paul Nash (1889–1946) and Tom Eckersley (1914–1997) may have represented the new architecture in their work, but the public was still comparatively conservative in its response. Collaborations with painters was crucial in representing modern architecture in the same light and several associations between artist and architect were developed at this time. *The Architectural Review* was responsible for bringing together artists and writers of the day during the 1930s and '40s. Articles by Nikolaus Pevsner, Robert Byron and John Betjeman were featured regularly in the magazine that saw Gordon Cullen (1914–1994) as assistant editor between 1946 and 1956. Cullen made a significant contribution to the content of *The Architectural Review*, both written and illustrated, which was partly responsible for the increase in his popular style of illustration and his inroads into book illustration and graphic work.

In the main, however, few architectural illustrators crossed the divide into publishing and book illustration. Some, like Hugh Casson (1910–1999), developed a painterly style of representation comparable with painters of the day and achieved recognition alongside the commercial artist

for his loose watercolours. Most, however, relied upon sound draughtsmanship and stayed within the architectural and building industry for their work.

The early 1970s brought about the term 'architectural illustration' to describe this activity and the Society of Architectural and Industrial Illustrators was founded in 1975 as the first professional body to represent practitioners of the genre. This was later changed to the Society of Architectural Illustration (SAI) in order to reflect the subject matter as a result of its change to charity status in the mid-1990s. The establishment of the SAI was shortly followed by the American Society of Architectural Perspectivists (ASAP), now called the American Society of Architectural Illustrators (ASAI). As a result, many other societies across the world have since been formed.

The SAI represents a broad range of methods and media used by its members with specialisms including traditional and digital media, 2D and 3D illustration and animation, photography and model-making. Fields of work include reconstruction and heritage, publishing, advertising and the architectural design and building sectors.

Many artists and illustrators represent the built environment in their work, often using buildings as context or background as well as main subject matter. However, it's the architectural illustrator who specializes in this genre, working in a variety of areas from creating house portraits to digital visualizations of proposed city schemes. In architectural design, illustrators are used at different stages of the process: before, during and after a building's construction. At the initial design stage it is often the in-house architectural technician or visualizer who is employed to create presentation visuals working closely with the architects and designers with a freelancer brought in at a later stage.

Architectural illustration can be seen as a celebration of all things architectural and has a role in its representation from concept to built form. An architect's initial idea sketches often deal with exploration and enquiry at the early stage of the design process and in the formulation of design intent; a sketch can contain the basis of communicating an idea to others and eventually lead to the realization of an architect's vision. Once a building is completed it becomes the symbol and representation of this process and can be judged on its success or otherwise.

Even with the advent of the computer generated image (CGI) during the early 1990s, the client and public's expectations of architectural illustration has changed very little. Its purpose is still to inform and expand the understanding of both proposed and existing architecture, albeit by ever

THE ARCHITECTURAL ILLUSTRATOR'S SKILL SET

Knowledge in:
- building materials and architectural history
- colour theory and rendering
- geometry and perspective
- website and on-line applications

Skills in:
- traditional drawing and location sketching
- traditional and digital colour techniques and applications
- photography
- composition and design and layout

more sophisticated means. Traditional rendering methods exist alongside digital means depending on the type and nature of a project. It is clear that there is a continuing requirement for conventional illustration training and a need for the illustrator to have a basic knowledge of 'picture-making', which is deemed just as relevant today as it was in the early twentieth century.

The activity of architectural illustration brings together a range of skills and knowledge within art and design, as summarized in the box. From sketching to SketchUp, and from pastel to pixels, the architectural illustrator engages in many areas of specialization and medium dependent upon the type, stage and process involved. Most illustrators develop a style that is commensurate with the type of commissioned work undertaken. Competence in freehand sketching, as well as more accurate drawing, is also fundamental to the illustrator's skill set.

Architectural illustrators often have a qualification in architecture or interior design and specialize in making visuals. However, as a result of a research project undertaken by the author (Royal College of Art, 1996), it was discovered that illustrators have a breadth of backgrounds and training, including general illustration, fine art, graphic and exhibition (3D) design amongst others (one illustrator interviewed was an apprentice to the great sculptor Frank Dobson but turned to illustration afterwards).

Emerging from this rich heritage, today's architectural illustrator fulfils an important role in communicating architectural design. Now in the twenty-first century, the time-honoured perspective view continues to play a central role in representing architectural design to an increasingly sophisticated audience. Alongside more general forms of illustration, architectural illustration plays an important role in representing aspects of the urban landscape.

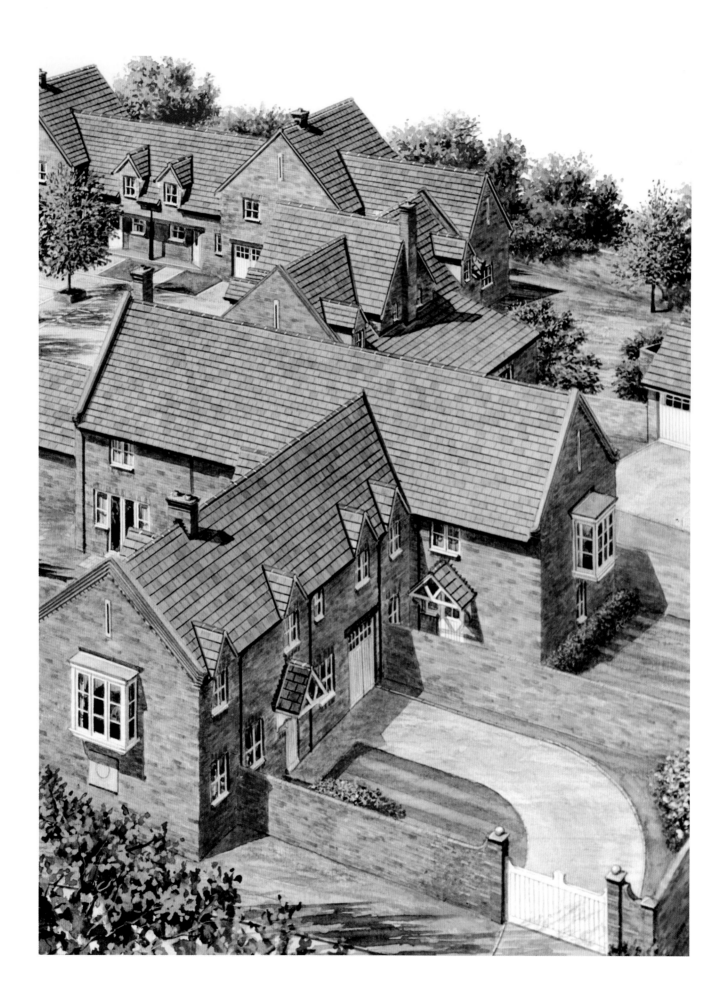

CHAPTER 1

Context and Applications

Having unrivalled powers of truth-telling it can also magnificently lie. It IS the honest architect's most candid and Inconvenient friend: it is the dishonest architect's most artful and convenient con-federate.

H.S. Goodhart-Rendel on the perspective drawing

Architectural illustrations are not just used in the architecture and building sector but also across a range of applications in the design, advertising and publishing industries. Commissions emanate from different sources and for a variety of reasons from historical reconstructions, through to the representation of existing buildings and the prediction of future built form, the appropriateness of each being central to its purpose. This chapter looks at the breadth of requirements and uses of illustration.

The commission

A commission can take a variety of forms and arise from a diverse range of sources, from an individual requesting a house portrait, to an international firm of architects who require a series of artist's impressions. A new client may have found your website directly or through representation via an agent or membership of a professional body. Experienced or long-standing illustrators gain a large percentage of work though recommendation achieved through successful completion of prior commissions. Most illustrators will sign their work or have credits printed alongside

the image which give name and contact details or website address. This is important and is the best way to acquire new commissions.

Most commissions arrive via an email message and the first step for the illustrator is to provide a quotation. In order to give a quotation the illustrator will need certain pieces of information which would normally include a set of architect's drawings (sometimes referred to as a set of plans) if the project is a new build development, or photographs if the building is existing. Sometimes, information is less than forthcoming and it may be necessary to use Google Maps, or the equivalent, in order to identify the site, and Street View to see the building from street level. If the building or development is within reasonable travelling distance then there is nothing better than to make a site visit. Having an intimate knowledge of a project can save you much time and often means you can anticipate problems that may arise. It is often the case in the process of commissioning illustration, that the illustrator will spot an inconsistency on a drawing or identify a feature on-site that has been overlooked. It is usual to incorporate the expenses of a site visit into your quotation.

Detail of an aerial perspective view of a proposed housing scheme. The illustration gives a realistic representation of each building with indications of material type and colour as well as overall landscaping.

The client

Who, then, are those who commission architectural illustration? A client's needs can range from an illustration in a magazine or journal to a complete advertising campaign; from a TV programme to a planning application. In the architectural and building sector, architectural illustration is generally accepted as a term that refers to a specialist service not normally available 'in-house'. This service is often provided by a self-employed freelancer working as an independent or by a studio offering a range of styles. A client may be looking for a particular style or technique to fit in with a specific project or, in the case of a magazine editorial, a certain house style. Let us, then, look at potential clients and their needs.

The planning process

In England there are six stages in the planning application process for permission to build on land and illustrations can play an important role in achieving planning consent. For larger housing or mixed-use developments permission is considered through a committee, whereas for smaller and non-controversial schemes a planning officer will decide on the outcome. Either way, a visual of some kind, usually a perspective drawing, is often the best way to show what the scheme will look like once built. Sometimes it will be the planning committee, on receiving an application, who will request that a visual be prepared in order to clarify a particular building design or overall scheme. This is clearly an additional expense but can save time and money later on in the process. Planning officers and the make-up of committees vary in knowledge and experience and particularly in the ability to understand 2D plans and elevations. This is where the role of a perspective illustration comes in – by making the architects' design intent accessible to all.

At other times an illustration may be needed to accompany an appeal when an application has been turned down and the developers need to give more visual information surrounding a particular project. The illustrator and designer often form a partnership in this process, the aim being to present a scheme in as convincing a way as possible in order to achieve planning approval. In this context the illustration is a means to an end. There's a famous story about the design of a well-known cricket clubhouse which was presented using a perspective illustration drawn by the great architect and illustrator Cyril Farey. Farey portrayed the scheme with a game of cricket in progress and the committee spent all their time arguing about the way the cricket teams were placed on the field of play. This took the whole of the meeting and after a long argument at the end they approved the scheme without opposition – just like that!

Illustrations and visuals prepared to accompany a planning application can present many challenges, often determined by sensitive aspects relating to a site or scheme. Sometimes it may be as straightforward as blending new build materials and colour with local buildings in the immediate vicinity; at other times it could be the maintenance of existing trees protected under a preservation order or consideration for a historic landmark. This can be time consuming and expensive for the developer or client who would normally be instructing an architect or, in particularly difficult circumstances, a planning consultant in order to achieve a satisfactory result.

An illustrator may be brought in when the design is at an early concept stage requiring a 'sketch' approach and then later on when the design has been approved at outline planning. A concept sketch may be concerned with a building's 'massing' in order to give the client an idea of the overall scheme, or just an indication of how a new building will look alongside adjacent buildings or landscape features. (When dealing with listed buildings this is always of prime concern.) A more finished illustration would normally be commissioned when the design is finalized and for promotion and selling purposes. Achieving planning consent is rarely a straightforward business and for good reasons: after all, most of us live and work in and around urban environments as well as in rural towns and villages so we would expect the process to involve consultation, particularly with local groups and other interested parties such as the Environment Agency. For example, the presence of protected species or wildlife habitats would necessitate some form of provision and this may need to be represented in illustrations of a scheme. The most common example of this is the presence of bats or newts, which can delay planning approval for more than a year giving time for observation as to whether a habitat is still in use.

Generally speaking, perspective illustrations are the most useful form of visualization and can be understood by the majority of people. However, they are also the most subjective and this means that it is the illustrator's responsibility to portray a building and its setting honestly. This can be done purely through drawing or by superimposing photographs onto a background. Through image-manipulation software such as Photoshop this can be an effective method of communication and a way of explaining aspects concerning scale and proportion, particularly when blending new buildings with existing.

Advertising and marketing

Art directors regularly commission illustration and can work from positions within large companies or advertising agencies. Advertising campaigns are often well funded and commissions can be very lucrative for the illustrator. The downside is that work can be all-consuming and extend over a considerable time, taking precedent over smaller commissions. Large building companies and developers will employ advertising agencies to promote and market new properties soon to come on to the housing market, and this forms a significant source of work for the architectural illustrator.

As with planning applications, mentioned earlier, whatever the issues involved in this type of project, illustrative material needs to represent a proposed scheme with honesty. This is particularly important within the architectural design and building industry. During the construction boom of the late 1980s there was a proliferation in the demand for the 'artist's impressions' and artistic licence abounded. There were limited restrictions over the way new buildings were represented which led to a plethora of over-elaborate and misleading information. In 1991 legislation was brought in to control the description of property through advertising and sales literature which resulted in the Property Misdescriptions Act. Prior to this time protection was provided under the Trade Descriptions Act 1968 and the Misrepresentations Act 1976. A major change under the new Act was that control was extended to cover those other than estate agents, which included solicitors, house-builders and developers. Much of the new Act was based on the Estate Agents Act 1979 and covers all forms of publication including text, pictures, plans, advertising of all kinds and anything said in conversation. It is now an offence to publish misleading or false statements and it is important to include a disclaimer to cover any liability. As a result there was a general feeling of nervousness about the enthusiasm that some illustrators and their clients had shown in artistic representation of buildings, and the industry has since been more concerned with monitoring the appearance of illustrations. Nevertheless, controversy still remains over the visualization of proposed architectural design even with digital methods which are often indistinguishable from an actual photograph.

The way a building design is presented in the public domain has always been a sensitive issue. An artist's impression, in the right hands, can be a form of visualization that allows the general public to make sense of a proposed development but in the wrong hands it can be misleading. A good example of this was the controversy surrounding the redevelopment of Paternoster Square next to St Paul's Cathedral in London, which took 10 years and 3 schemes to result in its final approval. The perspectives produced for one proposal were highly criticized as dishonest after publication in the media. One illustration showed a view looking across the square from an impossible viewpoint positioned inside an existing building.

With large schemes the best way to show how a design looks is to commission a traditional card model. These days the model would be created using a digital file and outputting to a laser cutter, with the assembly done by hand. The advantage of the model is that it can be viewed from an infinite number of positions, if somewhat reliant on a certain amount of imagination in doing so. In reality, particularly with large schemes, successful communication relies on several forms of illustration and use of media combining traditional and digital 3D, still and animated representations.

Like any other product, buildings are designed to a budget and for a purpose. In housing this will range from a one-off architect-designed dwelling to a large residential development. Architects and developers often specialize in building uses, covering commercial, leisure, healthcare, education, heritage and conservation. After planning consent, and before work starts on-site, it's important to promote and advertise a new scheme. Sometimes this is purely for selling purposes in the private housing sector but it may also be to attract investment or to promote a business opportunity. In housing, advertising is aimed at a specific demographic, for example first-time buyers or the retired, and this will influence the composition and features included within an illustration. Entourage elements are worth spending time and practice on to complete the overall convincing nature of a composition. If the inclusion of cars is necessary as part of a busy urban scene, then it's important that they are up to date – the same goes when including people, ensuring they are dressed in contemporary clothing without looking like they have just left the catwalk! Entourage elements can help to suggest activity relating to a particular building use or place. Many illustrators build up a collection of relevant images to include in a composition, such as people, cars, trees, animals, garden and street furniture, all of which add to the credibility of an illustration.

Advertising work means that the illustrations could be used in a variety of ways from television to magazines and the press, so it's important that the work is scanned as a

high resolution file at around 600dpi, which will normally fulfil most applications. The largest reproduction would be used on hoardings or large-scale advertising street signboards; anything less than 600dpi will produce a pixelated image at this size.

Publishing

The book publisher will be looking to match an illustrator's style and ability with a particular book title. If the subject is sixteenth-century vernacular buildings then a hand-drawn style may be the answer. Should the title be concerned with the design of contemporary office blocks then a digital rendered technique may be the most appropriate. Book illustration work is often commissioned with good notice of the publication date allowing the illustrator time to research, plan and prepare artwork. The author and illustrator of a children's book are often one and the same, or at the very least have a close working partnership. The most likely titles requiring architectural subject matter here would come under non-fiction subjects. Commissioned illustration could be for cover or dust jacket only, or for contents as well depending on subject matter and budget. There is a plethora of titles relating to architectural design, many of which are profusely illustrated. Such books often contain explanatory drawings including cutaway views, elevations and plans, aerial and street view perspectives and interiors showing room layouts and furnishings. These illustrations are often annotated and captioned to provide information about the design and historical styles and developments over the centuries. This means that the illustrator would need to follow the editor's instructions carefully as well as to engage in research into design aspects and theories.

In book illustration the size and layout of the artwork is often dictated, depending on whether there is a series' house style or if the book is a one-off and the designer is brought in as a freelance, similar to the illustrator's contract. In this case the illustrator is normally supplied with a page layout or at the very least a page grid showing the text and image roughly positioned as a guide to an illustration's shape and format. A designer may require illustrations to be produced as artwork to a specific size, particularly if there is to be a large number of images in the book. This could be twice or three times up on the finished printed size so that the artworks are all consistent throughout the book. Sometimes the style of artworks is set by the editor if there are several illustrators involved, again for the sake of consistency as in the case of an encyclopaedia or travel guide. The position where an illustration sits on a page

layout is important for the illustrator to know for several reasons. Will the illustration bleed off the top or side of the page? Will it be positioned across the gutter? How much space will be allowed for any annotations and captions? All of these questions will dictate the overall shape and design of an illustration and how it sits on the page.

Generally speaking, publishing commissions are less well-paid than advertising work but can extend over longer periods of time. This means that it can be easier to work around a book project alongside other commissions. Also, book editors are normally specialists within their subject areas and experienced in commissioning freelance illustration. They will often have spent time unearthing reference material that the illustrator can use, thus cutting down the time spent on research.

Editorial

Working for magazines and journals can be fast paced with short deadlines, depending on how often a title is published. Newspapers are even faster and deadlines for commissioned illustration can often require turn-rounds within 24 hours. The illustration style needed here would have to be economical in terms of output. Monthly magazines are a rich source of commissioned artwork for many illustrators with art editors able to plan several weeks ahead. This gives the illustrator time to spend on research and preparation prior to working on final artwork. The relationship that an illustrator builds with an editor is of utmost importance and is often one that lasts for many years. As with book publishing you are in the hands of the editor who will have publication deadlines that cannot be extended, so the illustrator must be prepared for the all-nighter from time to time. The author once spent most of Christmas and Boxing Day completing a commission for *Good Housekeeping* magazine with a deadline before the New Year! However, with judicious workload planning this can usually be kept down to a minimum.

Organizing your workload

Workload organization is crucial to an illustrator's skill set and accepting too much work at one time can only end in tears. Having a balance of different types of work can be an advantage and offer opportunities for a regular workload at times when there are peaks and troughs. With experience, structuring work so that there is continuity between different stages of projects running concurrently can be possible without getting overly stressed. Most projects can be broken down into the following stages: initial briefing; site visit

and/or research; draft composition for client approval; and the finished artwork. Working on more than one job at any one time needs careful organization and planning, depending on deadlines and the complexity and size of project. Large projects may necessitate a considerable amount of reference material including architects' plans, photographs and drawings. This means that picking up and changing from one job to another can be quite an upheaval. This is less of an issue when working digitally where all the reference material is stored on the computer, but even here the mental transition in redirecting one's concentration across several projects should not be underestimated. When possible, aim to start and complete one project at a time.

CASE STUDY 1

Planning application: Swan Cottage, Alresford, Hampshire

Context

A listed building with recent extension on a large plot including a stream and lake within a wooded area of mature trees and shrubs was acquired with planning permission to improve, refurbish and extend the existing accommodation. The architect's brief was to provide a design proposal which was sensitive to the age of the property as well as the location. The property is located on a mature plot which has been somewhat neglected in recent years. The gardens were mainly laid to grass and incorporated large mature trees, hedging and boundary shrubs with extensive bamboo planting, all of which was to be cleared and improved although changes to the overall landscaping was to be kept to a minimum.

Illustration brief

The brief was to prepare two watercolours showing the cottage and grounds with the new build extension blended within the existing walling and planting. The cottage had a roof covering of clay tiles and it was agreed to replace this with a reed thatch which was confirmed as the original roofing material using photographic evidence. The timber-framed extension was added quite recently and designed by the renowned classical architect Robert Adam and was to be replaced by extending the original flint-faced wall and 'disguising' a new timber single-story building. Finally there was to be a timber bridge spanning the narrow stream to the lake at the side of the cottage. The whole emphasis was to be on the vernacular qualities of the building and blending new with old. The architect agreed with his client that, in order to show these changes to the

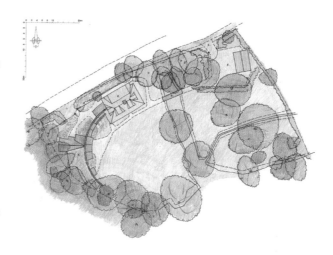

Architect's site plan drawn at a scale of 1:200 showing the existing plot with proposed changes and additional extensions to the cottage. (Images 1–7 courtesy of Chris Carter RIBA.)

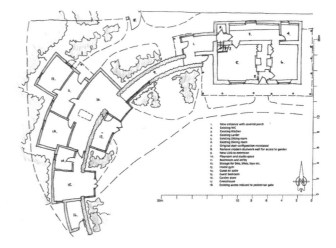

Ground floor plan drawn to a scale of 1:100 showing proposed extension to the existing cottage.

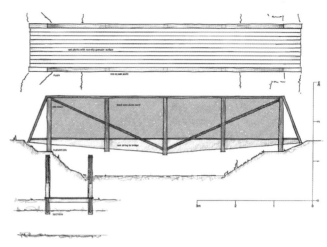

Orthographic drawings of a proposed new link bridge at a scale of 1:100.

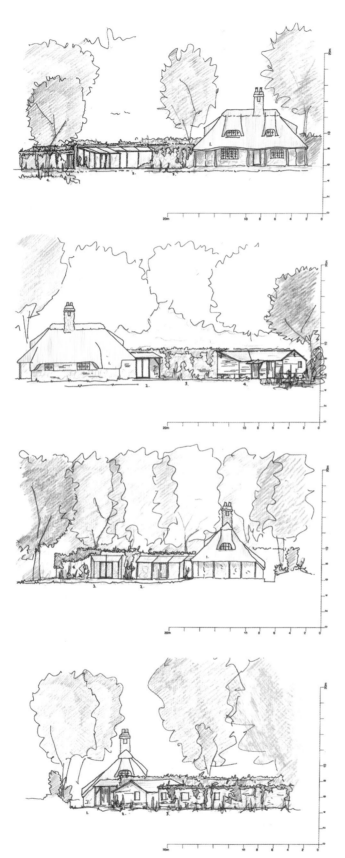

Orthographics of each elevation drawn at 1:100 showing proposed changes and extension to the existing cottage.

planning officer, there would be a need for two perspective views, one from the lake showing the rear gardens and cottage, and the second of the front aspect from the road.

Process

At the time of preparing the artworks the architect's design drawings were at an early concept stage, drawn by hand and not for public scrutiny. This meant that it was necessary to interpret these in the spirit of the architect's verbal briefing when we met on site. As mentioned earlier the emphasis was to be on the rustic qualities of the dwelling and gardens (in other words, plenty of ivy and wild flower meadows) but without taking artistic liberties. So the first task was to assess the 50 or so photographs taken on the site visit and make a decision on the best viewpoints. Starting on the rear view it was straightforward to match the position where the selected photograph was taken and mark this point on the site layout drawing. This way the photograph could be used as a basis and the drawing of the extension to the cottage, new thatched roof and the new bridge superimposed. When taking site photographs it's advisable to set the focal length to around 50mm which roughly equates to the eye's normal cone of vision without peripheral distortion. This way when setting up a perspective drawing from the site plan to a similar angle of view, it will blend with the photograph. The same process was adopted for the street view of the front using photographs taken from the road. On this one, due to a rise in the camber of the road, it was possible to establish an eye-level that was slightly raised which was taken into account when setting up the drawing of the extension to the cottage.

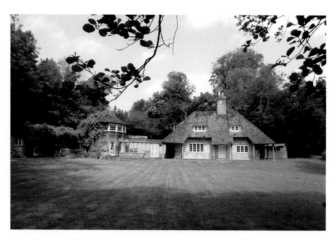

Site photograph of existing south aspect from the rear of the garden.

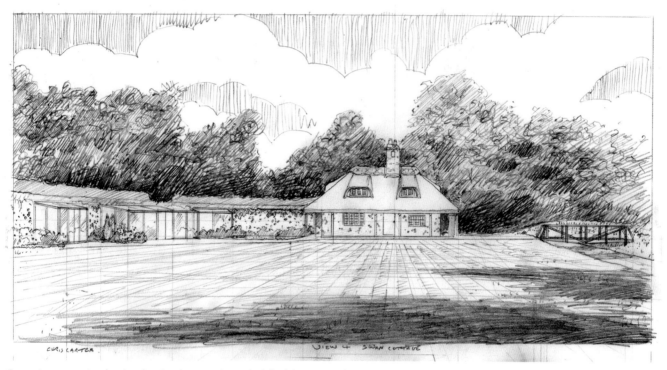

One-point perspective drawing showing the extension to the left of the cottage, the new thatched roof on the cottage and link bridge to the right-hand side.

Once scanned, both pencil drafts were emailed to the client and received approval to progress to finished colour. Comments received regarding the rear garden view included creating the impression of a wild flower meadow, and for the street view to 'ghost' the new extension through the boundary hedging. At the time of writing the architect and his client are still awaiting planning approval.

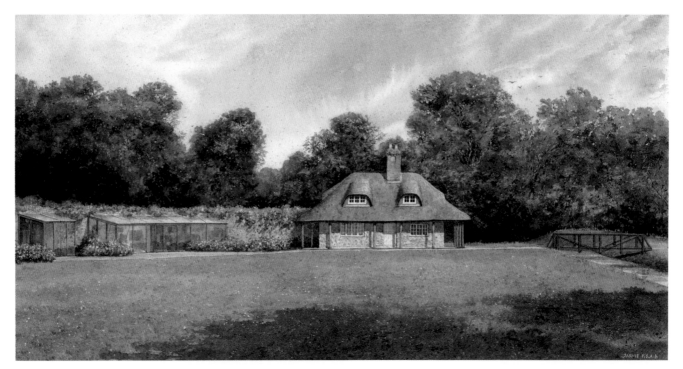

Finished colour view from the garden based on the photograph but incorporating a wider field of view in order to take in the bridge and glass fronted extension. Watercolour over pencil on 140lb Arches 226 × 436mm.

Site photograph of existing entrance from the road showing the existing round building which was to be replaced.

Pencil draft showing a perspective view of the proposed replacement extension and revised entrance. Part of the extension is shown 'ghosted' through the hedge to show its position and level as seen from the lane.

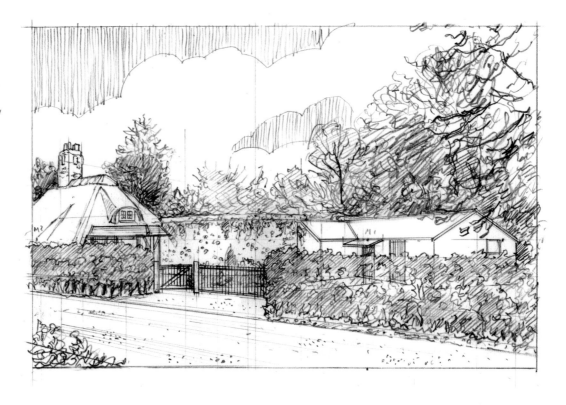

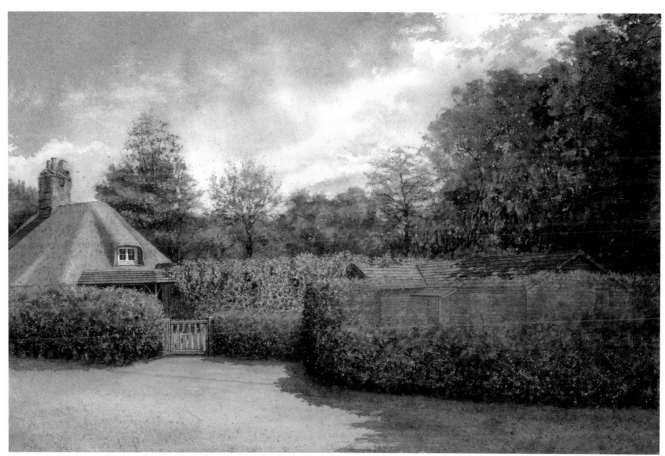

Finished colour view from the lane showing the remodelled entrance drive and hedging. Watercolour over pencil on 140lb Arches 241 × 362mm.

CASE STUDY 2

Advertising brochure: listed Georgian town house, Chichester

Context

A Grade II listed Georgian townhouse in Chichester scheduled for reallocation from an apartment and offices to its original residential use, requiring extensive refurbishment. An emphasis was to be placed on the provision of a day room offering views of the gardens which had been well maintained and stocked with mature trees and planting. The house can be accessed from the large garden and garages to the rear of the property and the developers were keen to express the potential that the property could afford through on-line and brochure advertising.

Illustration brief

The commission from the advertising agency was to produce four illustrations for use on-line and as printed material in magazines and the press. The initial use was for an estate agent's brochure containing site and floor plans, location maps and directions and local area information. At the initial meeting with the client it was decided to produce a view of the front façade, a rear view showing the gardens, and two interiors, one of the bathroom and dressing room and one from inside the proposed dayroom extension looking out into the gardens.

Site photographs of town house showing street view, rear view from the garden and interior view of first floor room showing original oak paneling. Notice how narrow the road is, which would have made it impossible to use for illustration purposes. (Photographs courtesy of Chris Orr.)

Process

Wire-frame 3D models were provided as basic set-ups for each illustration and on-site photographs used as reference for existing materials and colours etc. The street elevation was difficult to portray from photographs due to the narrowness of the street and the 3D model was particularly helpful in this respect. Of red brick construction with the ground and first floor courses laid in a Flemish bond with burnt headers, and the top floor with an alternate contrasting bond, the house stands proud from its neighbours. Almost entirely in its original form, a fine porch with columns protecting an ornate fanlight above the entrance door added to the imposing elevation of the house. This illustration was to feature on the front of the brochure with the rear view and gardens showing the proposed garden room extension, on the back. This view allowed a lot more freedom in the overall illustration design and representation of both proposed and existing features.

Moving inside and into the largest of the two first floor front rooms, the main feature you are confronted with is the oak panelling and full height windows with shutters: classic Georgian elegance. This room was to be the subject of the third illustration, which was to portray the master en-suite bathroom and dressing room with generous proportions at 6.5 × 5 metres. The illustration was to show the potential that the space had to offer rather than how it would eventually be designed and the designers provided suggestions and advice on this. The final illustration was to be the view from inside the dayroom looking out into the gardens and, once again, guidance was received from the designers concerning the type and design of furniture, fittings and flooring. The whole emphasis on this one was to portray how the windows would bring light into the room as well as provide a viewpoint onto the gardens. Once approved at pencil draft stage by the client each illustration was completed in watercolour.

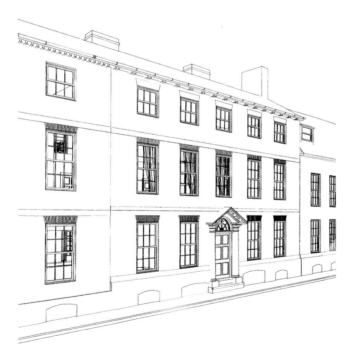

Wire frame 3D models of street and garden views created using ARCHICAD. (Images courtesy of Chris Orr.)

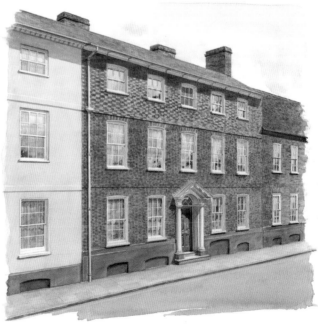

Finished watercolour illustrations showing street and garden view. Notice the additional garden room extension to the rear view and the attention to the detailing of the decorative brickwork to the front street elevation.

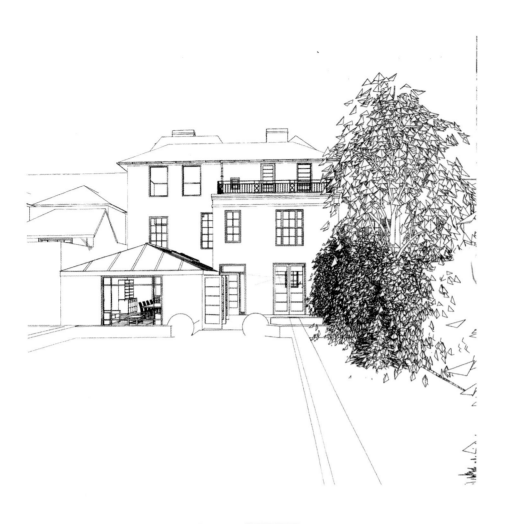

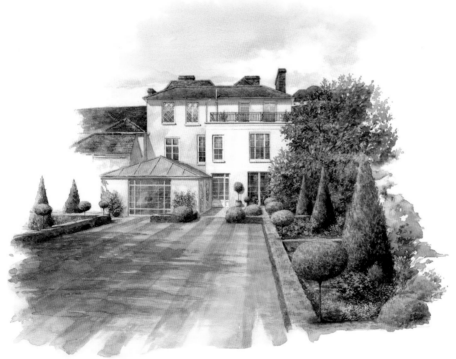

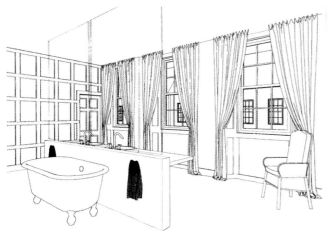

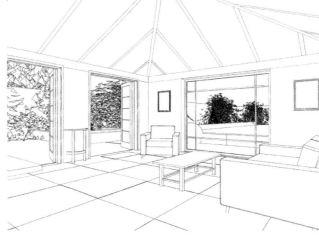

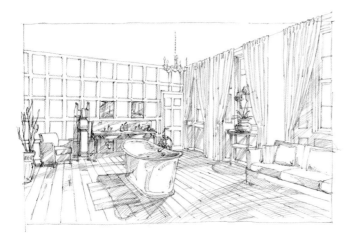

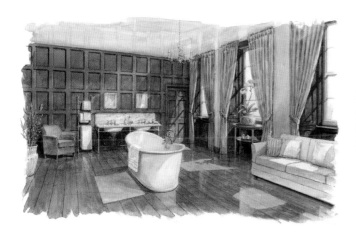

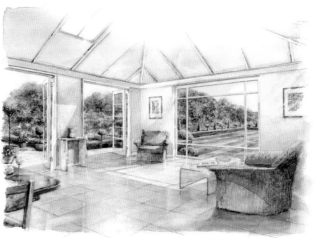

Wire frame 3D model of proposed bathroom design to the front first floor room. Notice this was changed in the pencil draft, which was sent to the client for approval. (Image courtesy of Chris Orr.)

Wire frame 3D model and pencil draft of proposed dayroom extension with furniture and fittings. (Images courtesy of Chris Orr.)

Finished watercolour illustrations showing bathroom and dayroom. Notice the changes made to the furniture and fittings, carried out to the client's wishes.

Book illustrations: 'For the poor children of London': A brief life and history of Sir John Cass and Sir John Cass's Foundation

Context

A publication to mark the tercentenary of the founding of Sir John Cass's Foundation Primary School in 1710. The Foundation was established from the creation of a small charitable school in the City of London at Aldgate and now makes major educational grants to disadvantaged young Londoners on an annual basis.

Illustration brief

Working with the book designer Andrew Barron, the commission was to provide watercolour illustrations of the major buildings associated with the Foundation together with items relating to the story of Sir John Cass. All were to be used in the book to decorate and inform. The initial client meeting involved site visits to the three main buildings: Sir John Cass's Foundation in Jewry Street; the Foundation Primary School, Dukes Place; and St Botolph-without-Aldgate Church, all within close proximity. Access to each had been organized with short guided tours of the significance and history of each and their place within the Sir John Cass story. The secondary use of the illustrations would be to have them framed and hung within the reception area at Jewry Street. All the illustrations would be produced using photographs as primary reference material.

Process

The Foundation building

The headquarters of the Foundation in Jewry Street, a fine red brick building, was opened in 1902 and provides the charity's administration and offices. Due to the narrow street and the long façade of the building it was difficult to photograph well, hence the requirement for a watercolour illustration. It was clear on the initial visit that a position looking north would provide the most suitable viewpoint. After a few rough sketches and many photographs taken on site, a pencil draft was prepared and subsequently approved. The designer decided to use the illustration as large as possible so it was placed over a double-page spread in the book and captioned with a title.

Having established the final print size it is common practice to prepare the artwork at about one and a half to two times larger, which results in a good quality reproduction. The designer requested that the illustration should have a pleasing edge to the artwork rather than being cropped or having a page-bleed so this was an important consideration in the composition. On the site visit day the weather was dull and so to brighten up the street view the façade was treated to the effect of strong sunlight and the introduction of cast shadows. Finally, to give scale and an urban feel, entourage elements consisting of a car and two figures were included in the foreground.

The Church

St Botolph's Aldgate is a Church of England parish church situated on an island at the junction of Houndsditch and Aldgate High Street in the City of London. It is an eighteenth-century brick building with stone quoins and window casings and is designated a Grade I listed building. At the time of visiting there were road works surrounding the building, making it difficult to discern the entire site and therefore many photographs were taken from a variety of viewpoints. These were then pieced together to create the final image.

The School

The Sir John Cass's Foundation Primary School is a red brick and stone building dating back to 1908 and is Grade II listed. The main challenge in illustrating this building was its overall length. It seemed appropriate to show the entire elevation from a standing viewpoint opposite the church. This view would show the symmetry of the building's design as well as giving an indication of its depth through a third dimension rather than just an orthographic projection. This meant taking several photographs and joining these together to complete the façade. The addition of cast shadows to the architectural detailing, together with the natural planting to this aspect, all helped to complete a picturesque representation of the building in context.

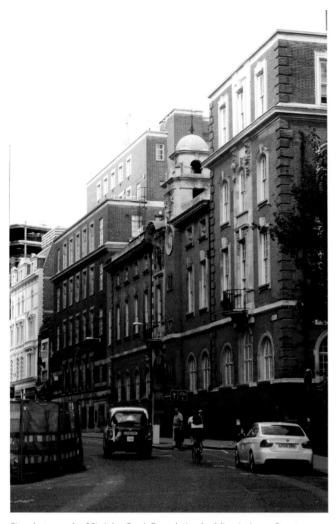

Site photograph of Sir John Cass's Foundation building in Jewry Street, London. The front elevation of this building is west facing but gets very little sun due to the tall buildings opposite.

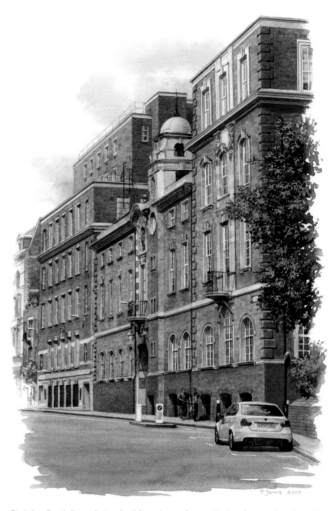

Sir John Cass's Foundation building, Jewry Street. Notice the overhead position of the sun, which casts shadows on both faces of the building, helping to describe the ornate design features. Illustration in watercolour over pencil on 90lb Canson Montval Aquarelle 340 × 240mm. (Image courtesy of Sir John Cass's Foundation.)

Related buildings

Additional illustrations were completed to show other buildings and features including a statue of Sir John Cass in Jewry Street, the City University's Business School, renamed the Cass Business School, and Sir John Cass's Foundation and Red Coat School in Stepney. These were all completed in black and white using a fine liner pen and watercolour washes. As with all the illustrations for this book, it was important that each image had a well-designed edge as each would be positioned on the page cut to white and not cropped or placed to bleed off the page.

Site photograph of St Botolph-without-Aldgate Church. The position of this building on its site on a busy London road was simplified for illustration purposes. At the time of writing the vicinity is being remodelled, providing a new public space and park for ease of pedestrian access.

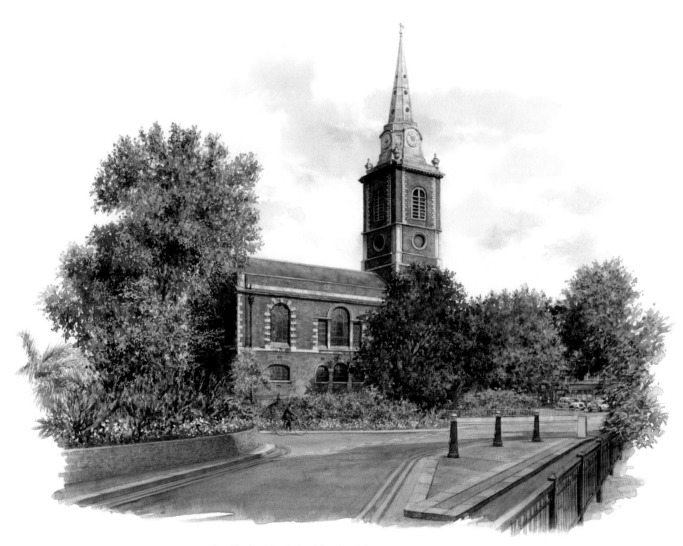

St Botolph-without-Aldgate Church. Notice that the office building behind the church has been omitted together with the road works barrier in front, done for aesthetic reasons. Illustration in watercolour over pencil on 90lb Canson Montval Aquarelle 303 × 409mm. (Image courtesy of Sir John Cass's Foundation.)

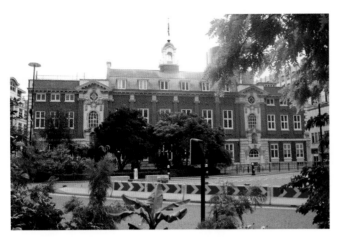

Site photograph of Sir John Cass's Foundation Primary School. This building is sited opposite the church and was difficult to photograph, being partly obscured by trees and planting. The building will benefit from the current remodelling being undertaken.

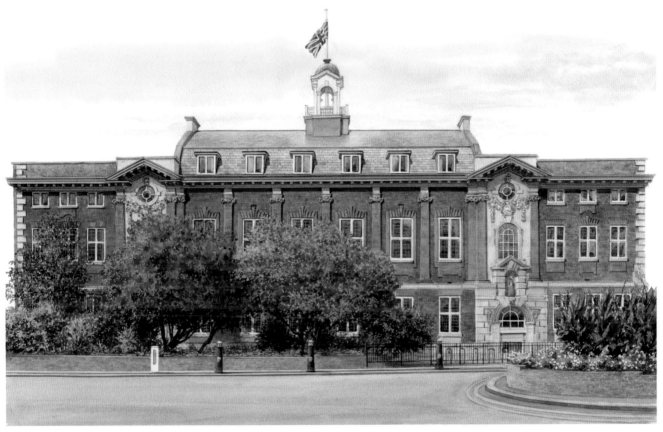

Sir John Cass's Foundation Primary School. The illustration was created by 'stitching' together several photographs and correcting distortion in the images to make a one-point perspective view. The foreground was cleaned up for aesthetic purposes. Illustration in watercolour over pencil on 90lb Canson Montval Aquarelle 235 × 382mm. (Image courtesy of Sir John Cass's Foundation.)

Sir John Cass's Foundation and Red Coat School. Illustration in watercolour over ink line on 90lb Canson Montval Aquarelle 251 × 296mm. (Image courtesy of Sir John Cass's Foundation.)

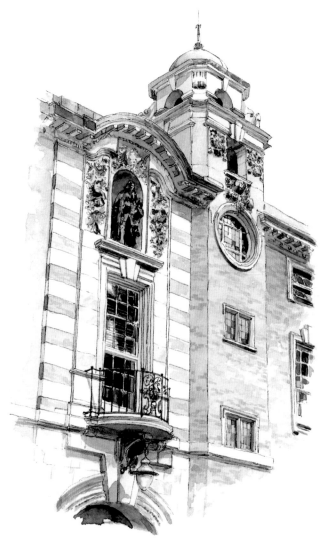

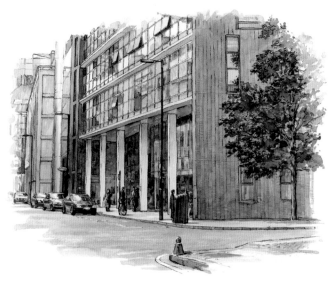

Sir John Cass's Business School. Illustration in watercolour over ink line on 90lb Canson Montval Aquarelle 224 × 274mm. (Image courtesy of Sir John Cass's Foundation.)

Statue of Sir John Cass on the Jewry Street building. Illustration in watercolour over ink line on 90lb Canson Montval Aquarelle 269 × 180mm. (Image courtesy of Sir John Cass's Foundation.)

In-house estate agent's magazine: Southampton feature

Context

The *Country and Individual Homes* magazine for buyers and vendors in Hampshire is a quarterly magazine published on behalf of a local estate agent. It has regular features of local interest for those living in, or wishing to move into, the area. The editors were looking for illustrations to accompany an article on Southampton's Old Town, focusing on its medieval architectural inheritance and in particular the Bargate.

Illustration brief

To submit a minimum of seven colour illustrations for publication in the magazine. The designers were unsure as to the quantity they would be able to use in the feature article and requested that the illustration formats be both landscape and portrait and to a size that would be suitable for enlarging and cropping. In the event, four out of the seven illustrations submitted were used in the magazine feature, which extended to three pages.

Process

The Bargate, Tudor House and Westgate Hall were all originally prepared as artworks for a proposed Old Town guide (a project still on the back-burner...) and the latter two are, at the time of writing, sold as postcards. The view of King John's Palace was a private commission and the original watercolour artwork remains in a private collection. Each illustration was prepared from photographs and supporting sketches. Apart from King John's Palace, the buildings were photographed on an overcast day without sunshine. Cast shadows can be a great asset to the architectural illustrator as their use can help to describe depth and texture within an illustration. However, they can also obscure detail and for these historic buildings it was important to represent their structure and materials used. By omitting shadows it allows the viewer to better focus on a building's construction details which, particularly with the timber-framing, can be easily understood. In the case of King John's Palace, which is almost a flat elevation, the strong cast shadows were helpful as depth codes in describing distance within the picture-plane.

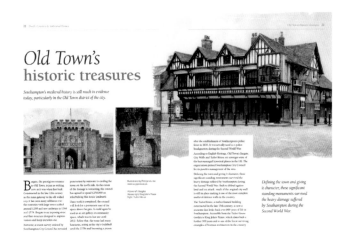

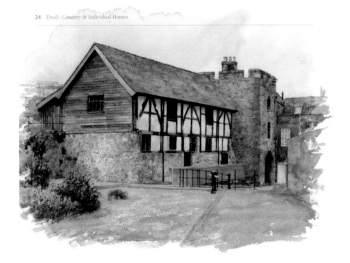

This magazine article uses coloured drawings instead of photographs in order to illustrate the old town buildings in Southampton. The advantage of using artwork over photography, in this context, is that the former can emphasize and clarify aspects of a subject as well as expressing a more personal interpretation. (Image courtesy of Chris Orr.)

Don Coe

Don Coe was evacuated during the war and left school at the age of fourteen to work at the Portland naval dockyard. After the war he started work at J.W. Artists in the Strand, London and stayed with that company in all its different guises for over twenty-two years. He had no formal training and during that time learned 'on the job' lettering, typography, photography, model making and all of the other disciplines necessary for the successful studio. As a young interior designer he worked on the coal mine feature at the Festival of Britain in 1951 and, following National Service, supervised the installation of the Sudanese Pavilion at the 1964 World's Fair in New York. Much later on, and after he became self-employed, he was appointed 'Boat Show Architect' and designed the central feature and all of the main exhibition stands at the annual London Boat Show, at Earls Court for a couple of years. He was accepted as Fellow into the Society of Architectural and Industrial Illustrators – now the SAI – in the late 1970s and for twenty or so years was its chairman. He is currently President of the SAI.

I've frequently been told I am 'cavalier' in my attitude toward the production of art, design and drawing, for I'm of the opinion that none of that can be taught. You can do it or you cannot. If you like it you'll get better at it. I count myself lucky that I was born at a time when it was one's portfolio that landed the job and not where you went to school.

My current job as an architectural illustrator began after the Boat Show job came to an end in the 1980s and I needed to make a living. I started to sketch the local environment of South London and offered the results to local picture framing shops offering to do house portraits for a tenner a time. The orders came flooding in because they were able to sell the bespoke service at reasonable cost, complete with frame.

After a couple of years I found that I was doing more and more sketches for planning applications so I began to direct energy towards architects, designers and builders. The deal was that I would visit their office to do the required sketches there and then, in return for immediate payment. The fee was kept affordable and once more the work came flooding in. I took to travelling further afield to my clients

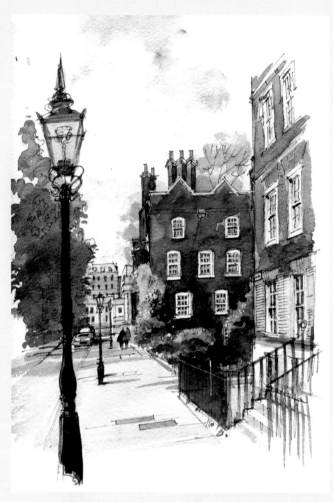

Occasional urban sketch. I very rarely sketch 'out of hours'. I have enough of that whilst at my daytime job. If ever I do feel like doing a freebie I'll usually do so from a photograph in the comfort of the drawing board. Here's one I did earlier. (A print of it was subsequently sold!)

by buying a 900cc Honda 'Fireblade' motorcycle. Then computers came along! I've kept up with the technology sufficiently to allow me to do the work at home using scanner and email.

Currently I have a client list of just over 130 and offer a standard service comprising the following process: I will produce up to three roughs for approval of viewpoint, content and detail. On approval I'll complete and send three line and wash sketches by email – all on the same day. A typical line and wash sketch of this sort will take about 30–40 minutes to complete. All three are done before colour is applied.

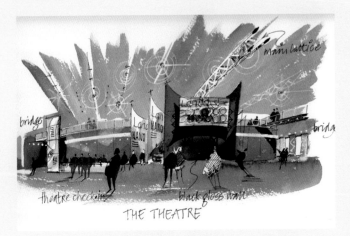

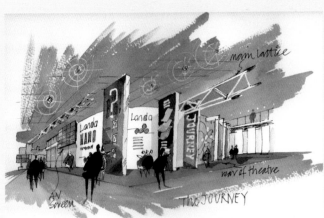

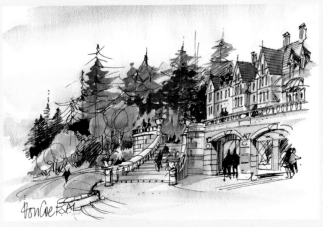

Golfing hotel design. A building was proposed for an area of Scottish landscape. It had yet to be designed. To quote the client's brief: 'An hotel catering for golfers, with views over the course. It could have a shop attached. I'll leave the design to you.' That was the brief; here's the sketch.

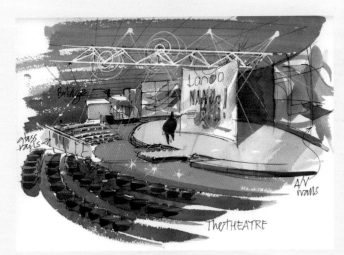

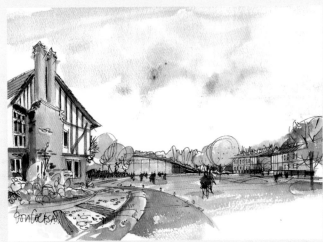

Another typical briefing: 'We have an existing school with extensive grounds in which we would like to build a sports facility which will not intrude too much. Maybe have a green roof? Here's a photograph of the school and the grounds beyond.'

Exhibition stands. In consultation with the designer, these sketches gained approval of the manufacturer of printing machinery for a stand at an international printing exhibition. (Image courtesy of Kenneth Goodall.)

From time to time the SAI will present seminars to universities and other educational organizations, demonstrating the role of the present day architectural illustrator, so I get to wield a pen and brush for some more fun sketches! At these seminars I'll usually describe the wide variety of jobs that come the way of the architectural illustrator. Shown here is a selection of the sketches recently presented.

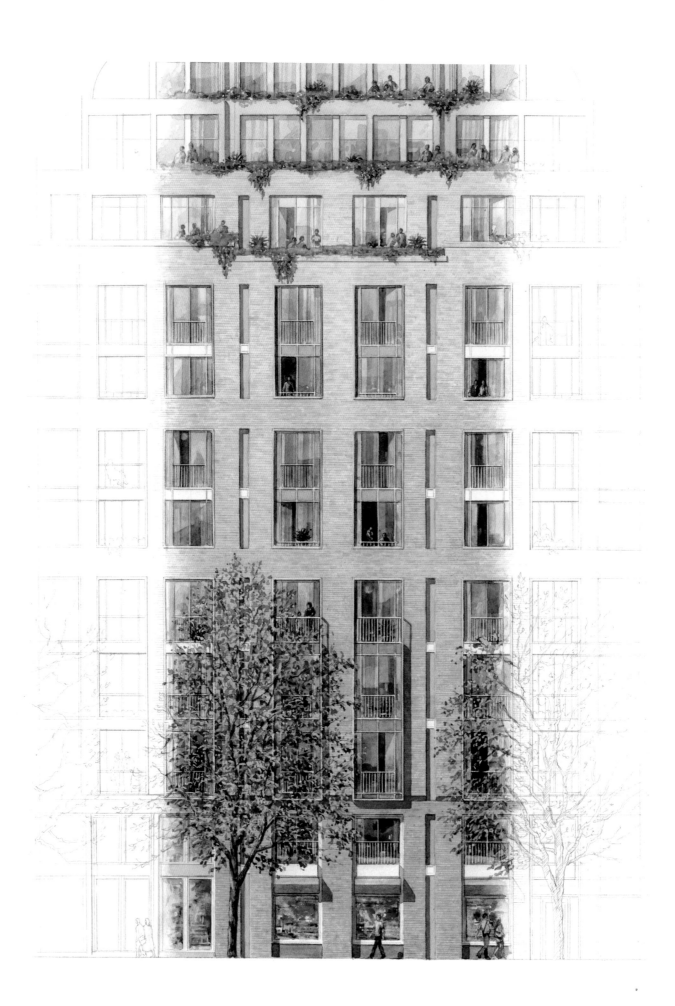

Drawing Methods and Process

*If you intend to make a living at drawing, by all means learn it
[the rules of perspective] now, and do not have them bothering
you and your work for the rest of your life.*

Andrew Loomis

ARCHITECTS' PLANS

Whether working on a new-build development, a vernacular barn conversion or an existing building, it is very likely that there will be architects' plans involved. Even with historical buildings or reconstructions, plans are normally drawn from on-site measurements and photographs (counting brick courses is a common method) in order to understand their design and construction. Measured drawings of the more noteworthy historical buildings are often available as copies from the many public archives that hold architects' plans (*see* Useful Contacts), as well as from specialist books such as Banister Fletcher's *A History of Architecture*. It was once thought that early churches and cathedrals were constructed without the preparation of drawings since there was little evidence of their existence. It is thought possible that floor plans were made on site and subsequently disregarded after the building was constructed or, more likely, that they perished over time. However, it's been shown that even in ancient times the Greeks and Romans used highly standardized plans together with models and, therefore, masons needed minimal instructions. It appears that the scale drawings we are

A detail of a typical elevation of an apartment building designed for a proposed city development completed at the concept stage of the design process. Watercolour over pencil on 90lb Canson Montval Aquarelle NOT stretched watercolour paper at 490 × 340mm.

familiar with today were not developed for building design and construction until the thirteenth century.

The term 'Architects' Plans' is used to cover the type of drawings that an architect will make in order to communicate a building's shape and form. These can start as concept sketches, especially if the project is a high-profile public building, but also for individually designed houses as well. This is where the architect has to balance his own ideas against that of the client, all the time exploring architectural possibilities. Such drawings may be a combination of 2D and 3D and are often just a means to an end rather than for public or client scrutiny, fascinating as they are. 2D drawings or orthographics are accurate projections and contain much of the information needed for the illustrator to interpret into an accessible form. Elevations, plans and sections conform to geometric rules that make this type of drawing measurable and in the final state, ultimately, a statement of contract that is legally binding. The first set of orthographics to be produced will be general arrangement or working drawings, usually at a scale of 1:100 and often containing a disclaimer against inaccuracies in measurements. Once approved by various parties involved, the next stage would involve more accurate orthographic drawings at a larger scale, often 1:50 which then lead to detail drawings of aspects of construction at scales up to 1:1 for use on-site.

An illustration may conform to any one of the accepted conventions used in architectural design and not just as reference for drawing in perspective, and it is worth spending time looking at some of these.

ARCHITECTURAL DRAWING CONVENTIONS

Orthographic projection

Orthographic projections include plans, elevations and sections, and in order to give a complete picture of 3D form these need to be seen together. An imagined image can then be formed by those familiar with the convention used. As the dominant method of formal representation, orthographic drawings combine pictorial elements with accuracy and as such are accepted as legal documents in

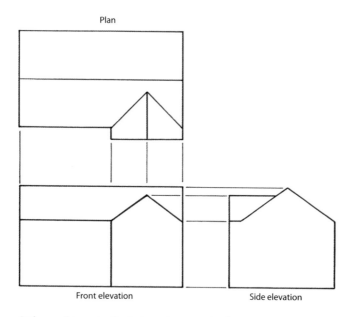

Plan

Front elevation Side elevation

Orthographic projection is the main convention for representing the plan, elevation and section of a building and is a single-plane drawing. This means that measurements can be taken from this type of drawing, although not in a single view. Each projection is drawn to a stated scale and is in true proportion.

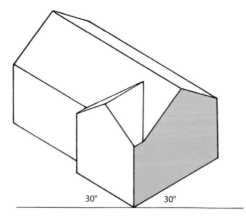

30° 30°

Axonometric drawing uses the scale and, in the case of **isometric**, the measurability of orthographic drawing but in a single view using three dimensions. The axonometric view offers an infinite number of angles but without converging parallels; it is only isometric that gives a true scale in each direction.

the evidence of proposed built form. There are two types of projections: first angle and third angle. To understand both methods you need to imagine the object in question floating inside a transparent box. In first angle, each elevation is viewed from the front and then projected onto the side of the box behind. With third angle the elevation is viewed in the same way but projected onto the side in front of it. In both cases the 'boxes' can be unfolded flat to reveal the elevations in position on each of the six faces.

Axonometric drawing

Axonometric means 'to measure along axes' and includes isometric, diametric, trimetric and oblique projections and each type uses parallel projection. With isometric, each of the three axes of the object is drawn 120° apart (or 30° left and 30° right to the horizontal) with one axis vertical. All measurements are true lengths or scaled equally. In diametric projection the two horizontal axes are equal angles with related foreshortening and the vertical axis is considered separately. With trimetric projection each axis is at a different angle, each with relative foreshortening. Oblique projections have one angle between two axes at 90° and the other two at 135° each, again, with relative foreshortening. Other than isometric, each projection can be adapted and used to suit a particular viewpoint and given foreshortening relative to each axis.

Perspective drawing

Linear perspective drawing is the only geometrical method of representation that attempts a mimesis of how we see in order to make sense of our environment. It relies on conical rather than parallel projection and, as such, does not give measurable characteristics of any reliability. There are several ways of setting up a perspective and many illustrators have adapted and personalized these; the theory, however, remains constant and has been in evidence for over 500 years. The main difference that sets linear perspective apart from other methods of pictorial representation is that it references to a single viewpoint. In many respects it can be compared to the viewfinder of an SLR camera where only one eye is used to look through a wide angle to zoom lens which can be adjusted to suit the subject matter. In fact research shows that looking through a 50mm lens equates approximately to a lateral 45° angle of view when setting up a perspective drawing.

The skills of the architectural illustrator can be brought to enhance all these conventions; for instance, with an elevation drawing, by the addition of aesthetic techniques

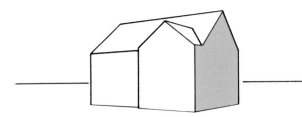

Perspective drawing is the only method that gives a realistic representation where vanishing parallels converge to one, two or three perspective points, depending on the type of view.

Child's drawing of a house (drawing by Jenson Dowland, aged 5). Children tend to draw what they see in two dimensions until later, when natural enquiry takes over with a more sophisticated approach to representation.

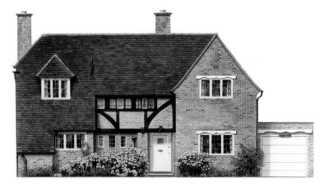

This **elevation** of an Arts and Crafts style house has been faithfully recorded in minute detail with subtle use of soft cast shadows, which act as depth cues giving the illusion of a third dimension.

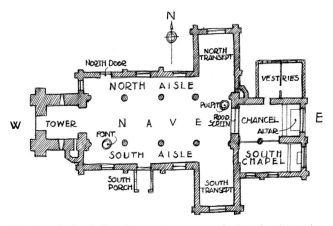

Plan view of a church. Plan views require a more sophisticated understanding of pictorial codes and symbols than elevation drawings.

using colour applications, tone and cast shadows to create artwork that is more accessible to a wider audience. Sometimes it's just as effective to use a street elevation of, say, a row of terraced houses or an office building as an orthographic rather than a perspective view, especially if the building can be viewed from a distance.

However, it is the perspective view that brings to life a proposed building design and is the mainstay of the illustrator's skill set. The highly respected architectural artist Ben Johnson, a master of perspective, once said, 'When you walk through a building you take in elevations', which may mean that our minds are continuously converting what we see into a geometrical construct in order to make sense of it. This can be partially borne out in the drawings of children. When asked to draw a house, a five-year-old will draw a large rectangle and smaller ones for windows, roof and a chimney, but there is seldom indication of a third dimension or vanishing parallels.

Elevation drawings are familiar to all of us in this way and are the primary method of drawing used to stimulate recognition of objects in others. Plan drawings require a greater understanding and knowledge as we cannot experience plans of buildings in the same way as elevations. As with all conventions, a basic appreciation of the concept

is essential in making sense of the information therein. Here's a good example of this. During a recent drawing class with interior design students, several in the class were confused by a floor plan given out as the basis for a furniture plan. The floor plan was drawn at 1:50 scale and the class was asked to create a suitable furniture layout using paper to represent items of furniture and fittings at the same scale. 'I'm just having so much trouble imaging this in reality', said one person, and so it was decided to set out the dimensions on the floor of the teaching room with masking tape to mark out the area and to use existing tables and chairs. Once done the students were much more able to appreciate the sense of space through the haptic nature of this experience.

SITE AND CONCEPT SKETCHING

During the summer months there's nothing better than spending an hour or so in the great outdoors, with sketchbook and maybe a box of watercolours in hand. (On a cold or wet day this may not seem quite so attractive!) Nevertheless, a degree of competency in freehand sketching can be very beneficial to the architectural illustrator, particularly at the start of a project. This is when you are familiarizing yourself with the task ahead, and there's nothing more impressive when you first meet your client on-site, than a few quick composition sketches to establish a working relationship. People who don't draw are impressed by those who can and in the world of illustration it's almost a given. Alongside your camera it's an important tool but to be successful requires regular practice. An A5 hardbound sketchbook with good quality heavyweight cartridge paper, and a fine liner or 2B pencil, are all you need to demonstrate your superior drawing skills whatever the weather.

An illustrator's work will move from prediction to representation, in other words, from the illustration of proposed architecture to representing existing buildings, often blended together in a topographical landscape. Sketching on location can enhance the illustrator's skill set in the ambition to achieve a realistic outcome. To be able to walk around a site and make drawings as well as take photographs, allows the illustrator to recreate that which is existing and will contribute to the realism of a picture. Regular sketching directly from subject matter will help build an archive of mental images that can be drawn upon when working from reference material in the studio.

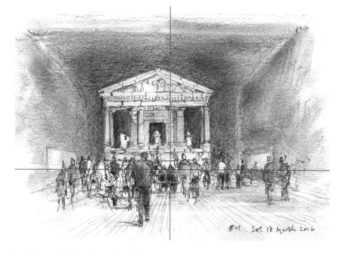

In this pencil sketch, made while sitting on a bench in a gallery in the V&A Museum, the eye level is lower than for those who are standing.

Equipment and materials

As mentioned, the most useful size of sketchbook is A5 portrait which is easily portable and can fit into your pocket or bag. It's also useful if you wish to draw across the gutter to make a larger sketch on a double-page spread. The best cover is hardbound as it provides a solid surface on which to draw, whatever position you adopt. If you intend to spend a long time drawing it's best to take a light folding stool, but for quick sketches a standing position is best and will give you the most natural perspective. Choose a sketchbook that is either sewn or spiral bound containing good quality cartridge: this will be suitable for light watercolour washes if the mood takes you. A 2B pencil is about the right grade; it won't wear down too quickly and gives nice darks without having to press too hard (and don't forget a sharpener and eraser). If you like to use a permanent line then there's nothing better than an ink pen with a nib and the one that's a joy to use is the Rotring Art Pen. These come as refillable or with ink cartridges, but be careful: the cartridges contain water-soluble ink, which if used with watercolour will run. Otherwise, there are numerous fine liners on the market which come in a range of line sizes and are usually waterproof. As you would expect, there is a large range of watercolour sets and boxes from which to choose, but for ease of use and economy the Winsor and Newton Cotman pocket box has a good range of half pans and is light to carry around – perfect for just adding colour washes over your sketches. Add to this a couple of good quality round sable brushes (size 3 or 4) and a larger wash brush, and all that's left is a water container; the best type for portability is the lantern collapsible style which can be folded flat. Some people prefer to add colour by using water brush pens which can be preloaded with different colour wash mixes before setting out – the only drawback here is the limited size and type of brushes available.

Sketching *en plein air*

More often than not, you will be asked to prepare an illustration as if viewed from a standing position. This type of view gives a realistic impression of how a particular building or development will be seen as if walking through an urban or rural environment. Sketching outside can be rather daunting to the novice, especially in a public area, but as long as you don't catch the eye of too many passers-by you will normally be left alone. Sitting or standing, you need to approach sketching outside with a plan of action; this will give you the confidence to attempt even the most complex view.

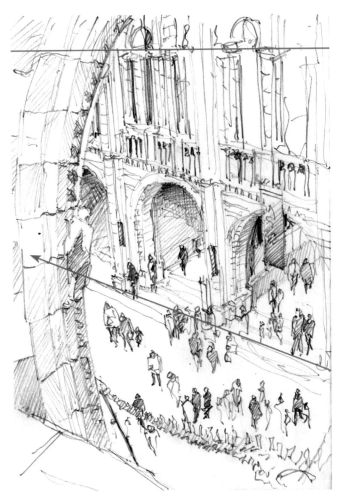

A sketch looking from above the main entrance hall in the Natural History Museum in London. The top horizontal line in red is the eye level with an arrow showing the direction of the left-hand vanishing point.

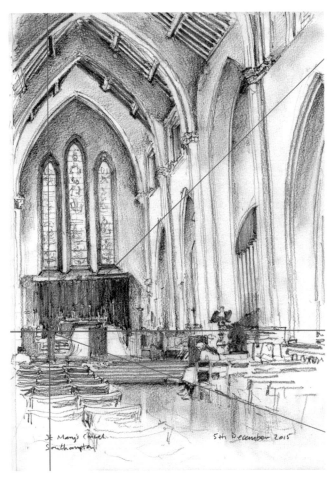

Pencil sketch inside St Mary's Church, Southampton, looking down the nave towards the east end from a standing position, showing the single vanishing point beneath the left-hand window. It's very useful to identify a vanishing point early on in a sketch, as it makes it much easier to draw depth and distance.

Eye level and vanishing points

The horizontal line that represents your eye level is the most important factor when sketching on location. The height of this line will vary depending on the position you will be drawing from. As a general rule, if you are standing on ground higher than your subject matter then it should be placed halfway up your paper or higher; if you are sitting down or in a position lower than your subject matter, the line should be in the lower half of your paper. This will act as a guide to composing the drawing on your paper – there's nothing worse than spending a while on a sketch to find that half of your subject won't fit on the page! Once you have decided where this will be positioned, according to the extent of the view in front of you, then draw a horizontal line across its entire width. Look again at the view that you are planning to sketch and then at your paper and decide if

you will have one or two vanishing points within the paper's edge (it's unlikely you will have more than one point unless you are a significant distance away or the objects in your view are positioned at different angles to one another – more on this later). If the vanishing point is within the page, place a dot somewhere on the eye level and everything else will flow from this. If there is no vanishing point within the paper's edges then you need to identify an approximate position off the page. Now decide on how much of the view you want to include on your paper and set the scale by drawing the farthest object and working from the distance to foreground. It may take a couple of attempts to get it right but it's worth spending the time when you start, as it will all come together at the end. Having a good working method and structure will really help to improve your confidence as you work through a drawing.

Viewpoint

If you are positioned close to your subject matter then you may notice some distortion at the periphery of your vision. As with the positioning of your subject matter, the way in which you select and represent perspective on your paper takes practice. For example, in this context it may be better to use a vanishing point to show convergence in the vertical lines of a building rather than keeping these parallel. In fact, when making a loose sketch, you may incorporate more information by distorting the view somewhat rather than slavishly copying what you see in front of you. A general approach would be to use perspective theory as a means to structuring how you sketch 'out in the field'. This way the sketch will be at least ordered and something that can be the result of enquiry and investigation and used alongside photographs to make an accurate perspective drawing.

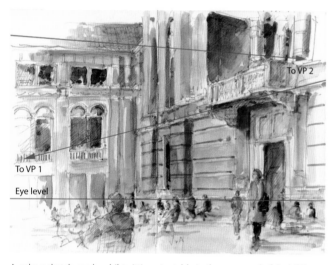

A colour sketch made whilst sitting at a table in the courtyard of the V&A Museum. An indication of two vanishing points is shown in red together with the eye level.

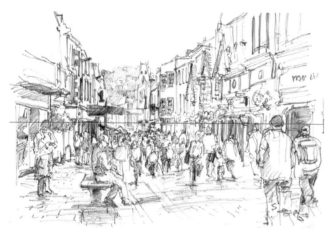

A pencil sketch looking down the hill in Winchester made at standing height. These kind of quick sketches can help when placing figures into commercial illustration commissions.

The other extreme position in relation to your subject matter would be at a great distance away, which might involve hardly any perspective in your sketch. However, in an urban landscape there are always adjacent buildings to which you can contextualize your subject matter and even in a rural context there will be perspective in landscape features such as trees, paths and even clouds! This will all help to create a convincing sketch or study that can be referred to later on. Invariably there will be restrictions when selecting a viewpoint on a particular site but these can be anticipated in some cases by looking at Google Street View prior to setting off on your site visit (*see* Chapter 5).

Sketching an interior space can be quite a challenge and this is where a good working knowledge of perspective really comes into play. With interiors you can often take liberties with peripheral distortion; the reason for this is that interior space is all around you, unlike external views that, more often than not, end with landscaping and sky taking over. Don't forget that perspective theory is a geometrical construct that doesn't allow for movement and is based upon a single viewpoint through one eye. When sketching on location, a solid understanding of perspective will enable you to structure what you see and help you to make sense of what's around you.

Selecting a view that conforms to a one-point perspective set-up is a good start and will often produce a convincing result. This is where, for instance, you are looking along a corridor or large space and all the vanishing parallels converge to a single point on the farthest wall on your eye level. Sometimes it's better to place the vanishing point slightly to one side and less symmetrical, to make a more interesting view. Making a sketch using two vanishing points is often a preferred view and can be more informative overall. This is where you position yourself looking into the corner of an interior space and the vanishing parallels converge both to the right and to the left sides of your eye level.

Entourage elements

Whether sketching interiors or exteriors it's most important to keep a sense of scale and proportion. Buildings themselves can do this by virtue of the ergonomics involved in their design, but sometimes it's useful to incorporate entourage elements such as people and cars, especially in an urban environment. The inclusion of figures can really bring a sketch to life and these need only be indications using a stylized line technique. In a public space, the best way of doing this is to start drawing your view and, once you have some heights in – doors and furniture, etc.

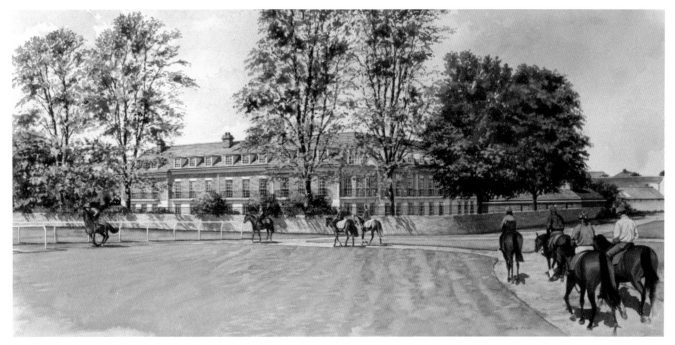

A view from the gallops in Newmarket, Suffolk, showing a proposed development behind an existing wall and mature trees. The inclusion of horses and riders was fitting for this illustration, which contextualizes the position of a new apartment block.

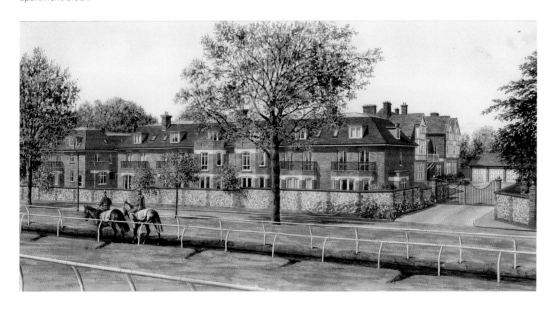

Another proposed development in Newmarket, Suffolk, this time showing horse and riders returning to the stud.

— include figures as and when people come and go from your field of vision. This is much easier if you are at normal standing height as most people's heads will be on or near to your eye level. As always, this will improve the more time you spend practising. The inclusion of entourage elements in more finished illustration will depend on the type of project and on your client's wishes. In digital work, 3D models or 2D photographs of cars and people can really add to the atmosphere of a scene but need careful placement and blending into a background. For traditional media the illustrator needs to use good reference to work from and practising on location with a sketchbook is a good way to do this, or by taking photographs for future use. Also, look to include different aspects that will suit the subject matter. An example of this was a commission to show a new development of apartments in the market town of Newmarket, Suffolk. The town is well known for its horse racing stables and racetracks and is home to more than 3,500 racehorses. With the land in question adjacent to the gallops and nearby stables, there was an obvious need to

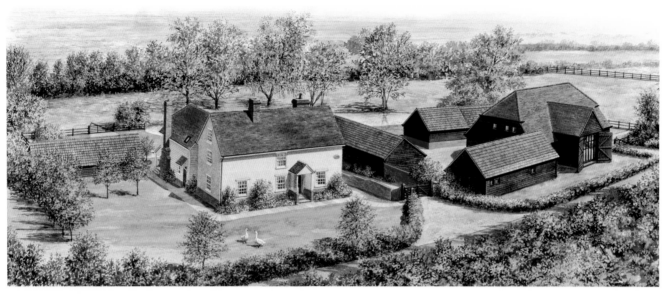

Aerial view of a proposed barn conversion showing a variety of entourage elements, including landscaping, existing trees and a pond.

Detail of the aerial view, with two geese in attendance!

Another occasion involved a site visit to photograph a group of medieval timber-framed barns soon to be the subject of a conversion to residential use. All was quiet on arrival at the site and after parking, a short walk along a gravel drive led to the farm buildings. The tranquillity, however, soon came to an end when two large geese appeared from behind one of the barns; at great speed, half running with wings flapping and making the most terrible sound, they proceeded to chase off the trespasser towards the sanctuary of his car. Needless to say the geese featured in the finished artworks!

One important benefit from the experience of sketching on site is the time spent looking at your subject in context. The very act of drawing will enable you to recall more detail when back in your studio and you will be able to make more sense from your site photographs. Once back in your workplace you can then start to piece together all your reference material and relate this to the illustration in hand.

PERSPECTIVE THEORY AND PRACTICE

show horses and riders in the illustrations. The reference for this was achieved through an early morning site visit to gather a few sketches and take photographs of the horses as they were being exercised. Horse and rider would trot to the start of the gallops, take their turn in a queue for a few minutes, gallop uphill at great speed and return down the opposite side of the track at a leisurely pace and head back to the stables.

Having looked at and used perspective in the practical context of location sketching, an understanding of its theoretical foundation will now be easier to appreciate. The old adage 'theory informs practice' is especially pertinent in the context of visual communication and in particular the act of representational drawing. Even when using 3D software in the creation of a computer model, a knowledge of perspective and geometry will make decision-making

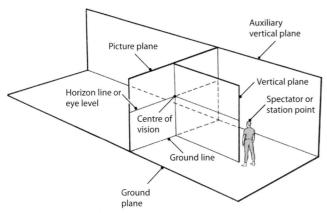

Illustration of perspective drawing theory, showing the set-up of planes, lines and points.

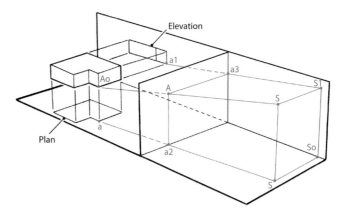

Perspective drawing by projection (1). This shows the theoretical set-up in the projection of one point, Ao, on the object, in relation to the Spectator (S).

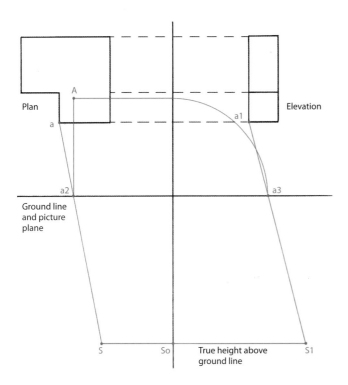

Perspective drawing by projection (2). This diagram shows the set-up after the Auxiliary Vertical Plane has been folded flat, as if hinged to the Ground Plane; and the Picture Plane has been folded forward containing point A.

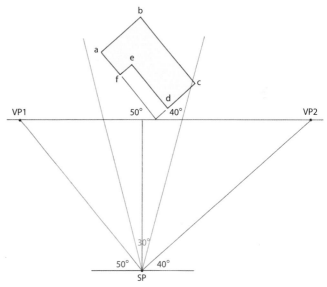

Perspective drawing by measuring points (1). The plan view shows the object at an angle of 50° to the left and 40° to the right of the Picture Plane, with the angle of view (Cone of Vision in red) from the spectator (Station Point) of 30° approximately enclosing the object. The Vanishing Points VP1 and VP2 are located by drawing parallel lines to both sides of the object from the SP.

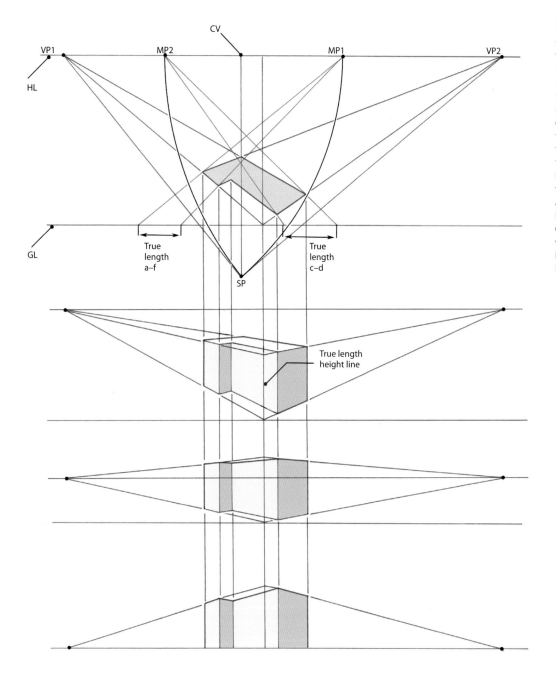

CV

VP1 MP2 MP1 VP2

HL

GL

True length a–f True length c–d

SP

True length height line

a far easier process. In most programmes there is a range of tools for creating a drawing and in some these are easy to use. However, ignorance of geometrical drawing theory can only work against achieving an optimum viewpoint and this is where a solid understanding of basic perspective really counts. In most cases, an architectural illustration starts with a set of orthographic drawings and, specifically, a site layout and floor plans. The traditional method is to use various forms of projection to achieve a final perspective drawing and this is no different when using digital means. However, this is where the similarity ends, as with

traditional drawing the illustrator must anticipate what the end result will be relating to viewing angle and height, whereas in digital drawing, apart from a general overview, this can all wait until the end. Once a digital floorplan has been imported and placed into position within a 3D programme, it's a matter of extruding heights and completing elevations in whatever view suits you best – there are no hard and fast rules. Once all the dimensions have been input, only then will the illustrator begin to deal with angle of view and viewpoint – in traditional drawing this would all have to be considered at the outset.

The perspective grid

We have already looked at using the main elements of perspective in sketching on location, so now let's look at the geometry behind it all. Creating a perspective grid or chart by hand is a good way to learn the geometry and is a practical aid for drawing a perspective view. Having a thorough understanding of perspective and geometry is essential even when working with 3D computer software and leads to ways of creating shortcuts and anticipating visual effects and avoiding distortions. Perspective charts have been available commercially for many years but for most illustrators they are very limiting in viewpoint. There are two main ways of setting up a perspective by hand: (1) by projection and (2) through the use of measuring points. Setting up using the former method, by projecting from a plan and elevations, requires a fairly large desk or drawing board with T squares and/or parallel motion in placing these in position. With the latter method (2), a drawing can be smaller and more manageable but requires a good understanding of the theory; simply choose the method that suits you best.

A perspective grid can be very useful for both interior and exterior drawings and can be used for accurate measured drawings as well as a guide for freehand work. The best way to work is by placing the grid underneath a sheet of layout or tracing paper and drawing over the top. With freehand drawing this allows freedom to concentrate on the subject matter without losing scale and proportion and, once mastered, can be a great asset in developing representational ideas for client presentations.

Of course, a 3D grid can easily be constructed using computer software and, in the hands of an experienced illustrator, this would normally be the desired method. However, the average user can do this without any awareness of the underlying theory and this is often the undoing of the novice. It's all too easy to present a computer drawing that looks distorted, and without knowledge of the underlying causes the problem can be a struggle to solve. There is an abundance of evidence of this, where poorly drawn CGIs have been used in the press and on-line, resulting in poor communication and a negative response from their target audience.

Constructing a one-point interior perspective grid

Here we see a rectangular floor plan divided into a grid of 8 by 16 squares where two lines are added to represent (1) the Picture Plane and (2) the Line of Sight. The Station Point is located by enclosing the entire floor plan within a 60° angle called a Cone of Vision. Next, a horizontal line is dropped down so that it is clear of the plan view which is to be the Eye Level. A point is located on the extended Line of Sight where it intersects the Eye Level which is called the Centre of Vision. From the two points where the 60° Cone of Vision intersects the Picture Plane two lines are dropped down to intersect the Eye Level. The floor plan is also dropped down to the Eye Level and a rectangle is drawn to represent the end elevation of a wall and this is divided into a grid of 8 by 6 squares. Using the point called the Centre of Vision the four Vanishing Parallels are projected from the corners of the end wall to meet the vertical lines dropped down from the Picture Plane. The remaining Vanishing Parallels are projected from the end wall grid to meet the outside rectangle which now represents the Picture Plane in elevation; this is now the perspective view of a room based on the gridded floor plan. Diagonals are now drawn to divide the floor plan in half and locate the centre point of the floor. The same procedure is carried out with the walls, and then floor and walls are subdivided in the same way to represent the 16 squares by 8 on the original floor plan. Distance Points (or measuring points) are located by projecting an angle of 45° either side of the Line of Sight to intersect the Eye Level. These are the vanishing points for the diagonals of the squares on the floor plan and if located earlier serve as an aid to the grid's construction.

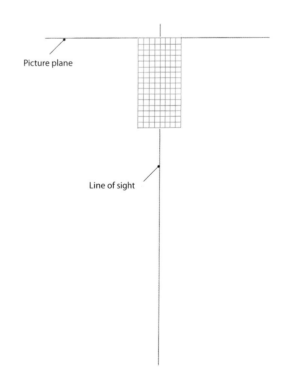

One-point interior perspective grid drawings.

One-point interior perspective grid drawings.

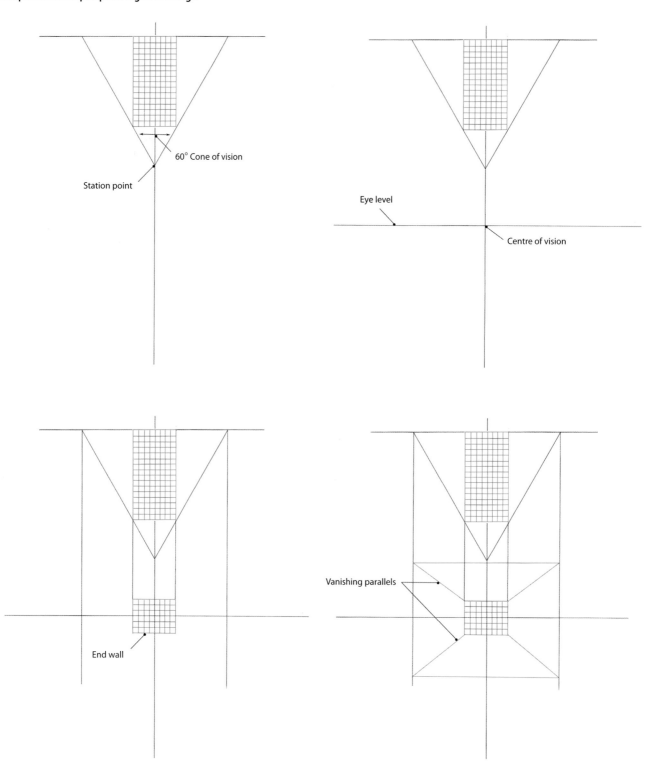

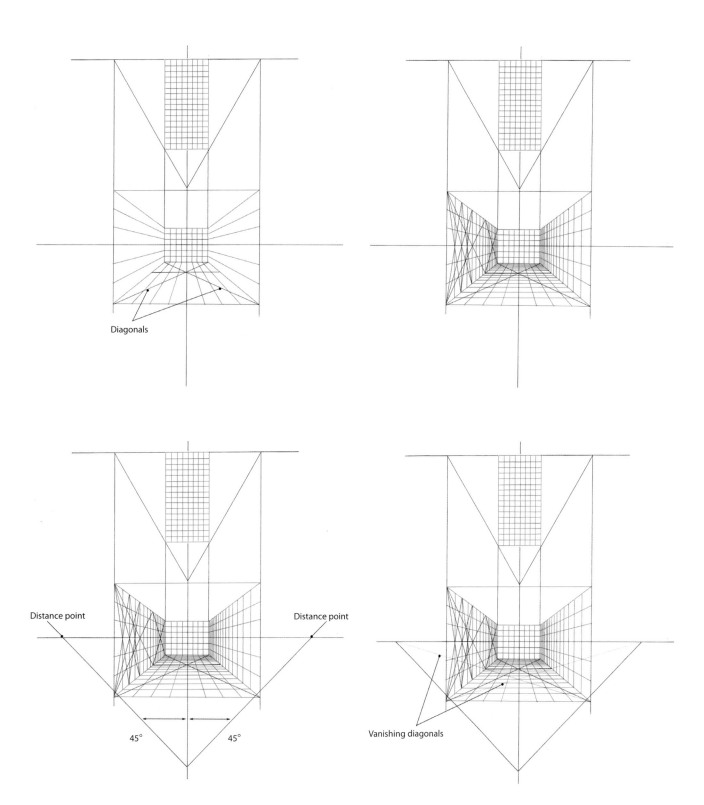

Diagonals

Distance point

Distance point

45°

45°

Vanishing diagonals

Constructing a two-point interior perspective grid

Two lines are drawn to the right-hand side representing (1) the Picture Plane and (2) the Line of Sight, similar to that in a one-point set-up, and a rectangular floor plan divided into a grid of 8 by 16 squares is drawn and positioned at a convenient angle to and touching the Picture Plane. The Station Point is located by enclosing the entire floor plan within a 60° angle called a Cone of Vision. Next, a horizontal line is dropped down so that it is clear of the plan view; this is to be the Eye Level. A point is located on the extended Line of Sight where it intersects the Eye Level which is called the Centre of Vision. From the two points where the 60° Cone of Vision intersects the Picture Plane two lines are dropped down to intersect the Eye Level and two more lines are dropped down, one from where the left top corner of the rectangle touches the Picture Plane and the second from where the right top corner is projected to the Picture Plane from the Station Point. The distance from the Station Point to the Picture Plane is now measured and this measurement is dropped down from the Centre of Vision on the Eye Level

to locate a second Station Point. From this point project two lines to intersect the Eye Level to locate two Vanishing Points, one left and one right. The left line is parallel to the long side of the floor plan and the line on the right is parallel to the short side. The height of the rear wall is measured on the line dropped down from where the left top corner of the rectangle touches the Picture Plane to the same scale as the floor plan, three squares above and below the Eye Level. From these points two lines are projected which converge to the Vanishing Point (left) to meet the line dropped down from the point projected from the right top corner to the Picture Plane. The rear wall is now drawn in. The two end walls are measured and lines projected in a similar way but converge to the Vanishing Point on the right and the ceiling and floor is projected in the same way. The room height is now divided into six on the far corner and projected around the walls. The same procedure is then adopted as with a one-point perspective by using diagonals to subdivide the walls into 16 by 8 squares. Lastly, the floor is divided into 16 by 8 squares.

Two-point interior perspective grid drawings.

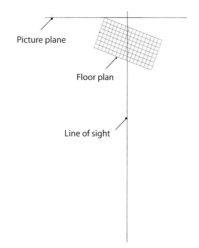

Picture plane

Floor plan

Line of sight

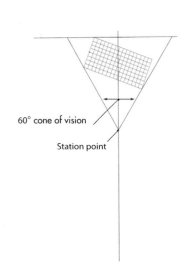

60° cone of vision

Station point

Two-point interior perspective grid drawings.

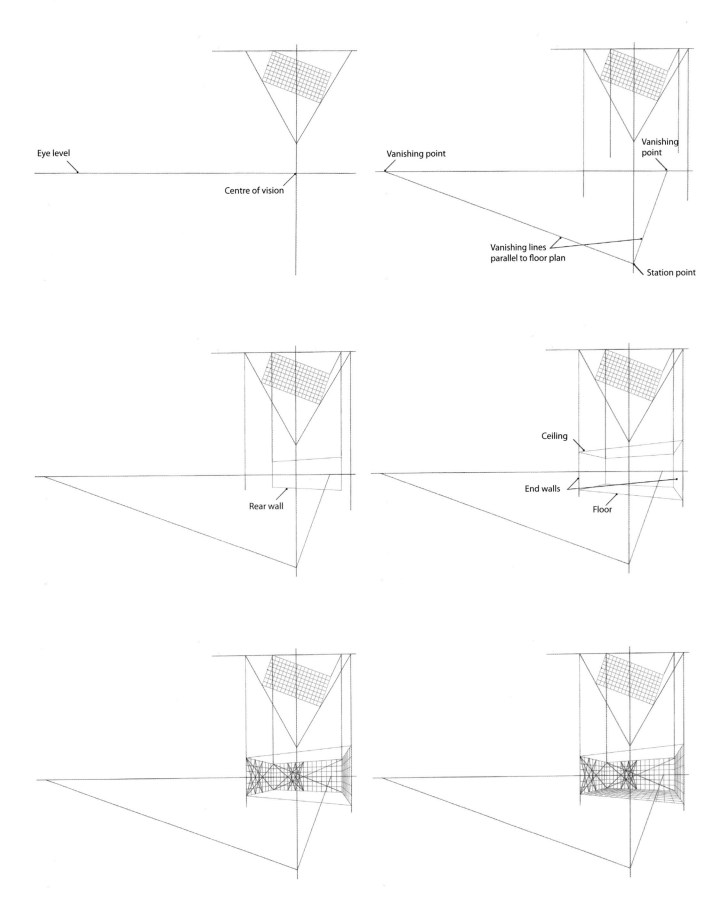

Constructing a two-point exterior perspective grid

Two lines are drawn representing (1) the Picture Plane and (2) the Line of Sight, similar to that in an interior two-point perspective. Next, a rectangular floor plan divided into a grid of 8 by 16 squares is drawn and positioned at a convenient angle to and touching the Picture Plane. The Station Point is located by enclosing the entire floor plan within a 30° angle called a Cone of Vision. Next, a horizontal line is dropped down so that it is clear of the plan view which is to be the Eye Level. A point is located on the extended Line of Sight where it intersects the Eye Level which is called the Centre of Vision. Now the distance from the Station Point to the Picture Plane is measured and this measurement is dropped down from the Centre of Vision on the Eye Level to locate a second Station Point. From this point project two lines to intersect the Eye Level

to locate two Vanishing Points, one left and one right. The left line is parallel to the long side of the floor plan and the line on the right is parallel to the short side. From the two points where the 30° Cone of Vision intersects the Picture Plane two lines are dropped down to intersect the Eye Level. One more line is dropped down from where the front corner of the rectangle touches the Picture Plane. A number of measurements are now made to the same scale as the squared floor plan, on this line which represents the front corner of the grid. From these points, lines are projected which converge to the Vanishing Points left and right. The same procedure is adopted as with the previous one- and two-point perspectives by using diagonals to subdivide the walls into 16 by 8 squares. The same result can be achieved by projecting points (shown in blue line) from the plan view if desired.

Two-point exterior perspective grid drawings.

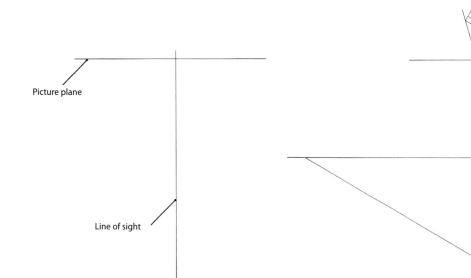

Picture plane

Line of sight

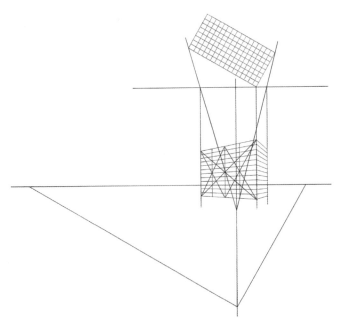

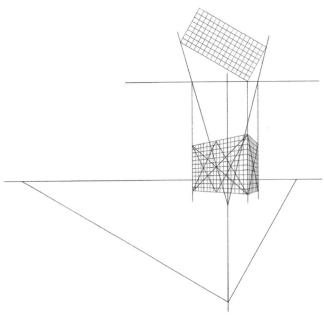

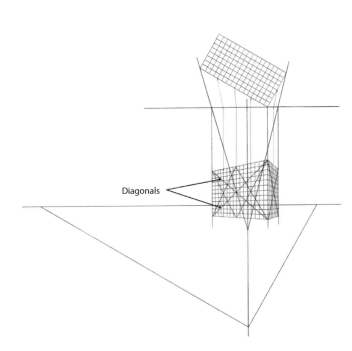

Diagonals

Casting shadows

The part of an object that cannot be reached by light rays is said to be in shade and the resultant shadow is caused by the interruption of light rays by the object. The science of shadow casting is an essential part of expressing architectural shape and form and, armed with a basic understanding, it can provide further information concerning depth within a picture. Even with the ease of setting shadows in 3D programmes like SketchUp, a basic knowledge of the theory can anticipate problems and enhance the finished illustration. Also, to be able to add convincing shade and shadows in a concept sketch will contribute significantly to a drawing's credibility and to that of the artist! In broad terms, there are two types of light sources that cast shadows: sunlight and artificial light. For practical reasons, the sun's rays are considered to be parallel; artificial light, in its most simple form, radiates from a single point. A good starting point is to look at adding shadows cast from the sun's rays to an elevation drawing.

An elevation drawing with depth cues such as shading and cast shadows can reveal further information about a building's design and structure. The easiest method is to place the relevant plan view below the elevation drawing and using a convenient angle (often 45°), project selective points vertically from the plan to intersect on the same surface on the elevation. The angle can vary to suit the subject matter and, in the case of complex shapes, the plan view can be dispensed with and, in the hands of an experienced

illustrator, the shadow 'guesstimated' from the information available. The most important factor is consistency when judging depth of shadows.

Applying shadows to a perspective drawing (when not using a 3D programme), requires the plan of the vanishing point to be identified on the eye level (Horizon line). The theory behind this is the same as that of an inclined plane in perspective, that is, the raised or lowered vanishing point will be vertically above or below the (plan) vanishing point on the eye level. These two points can be used in conjunction with each other to project points of the object to form the shadow. In most cases the sun's position would normally be behind the viewer, which means that its vanishing point would be vertically below the vanishing point on the eye level. In practice, only the vanishing point for the plan on the eye level would be used, mainly due to time constraints and complexity that can sometimes inhibit creativity in composition. Once again, the old adage 'theory informs practice' is applicable here, as it is to most areas within the graphic arts and, with time, acquired theoretical knowledge will improve aspects of an illustrator's work. The cast shadow is a really effective way to communicate a

building's design but slavishly adhering to its construction should be avoided in favour of a more aesthetic approach. This applies to all types of computer generated drawing as well – if it looks wrong, it is wrong!

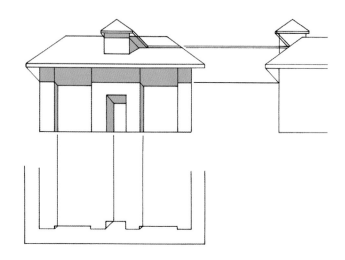

Casting shadows onto an elevation drawing by using plan and side view with the sun's rays at 45° to horizontal.

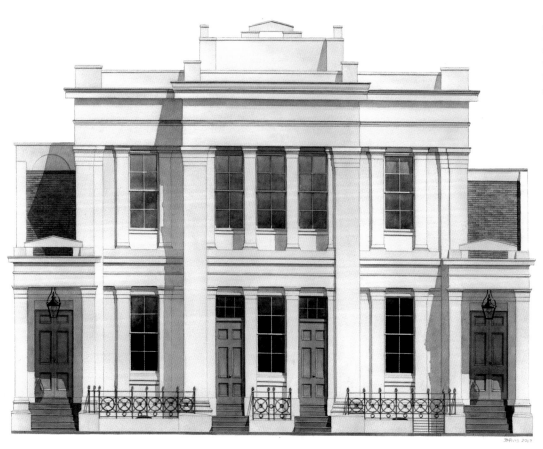

Almeida Theatre, Islington, London. Rendered elevation showing a more freehand method of applying cast shadows. (Image courtesy of Luke Johnson.)

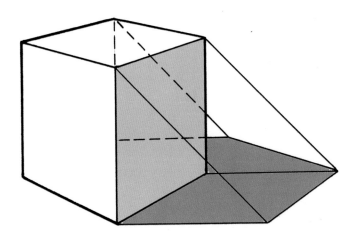

Casting shadows in perspective using the most simple application with the sun's rays at a 45° angle to the object and plan of shadow horizontal.

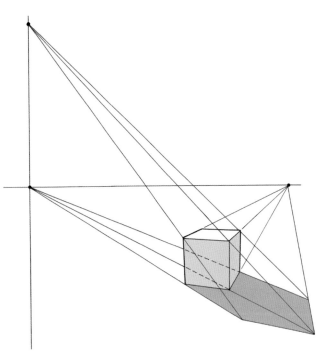

Casting shadows with the sun in front of the spectator showing the VP of the object on the same HL as the sun's rays in plan. The position of the sun is located on a vertical line above the sun's VP.

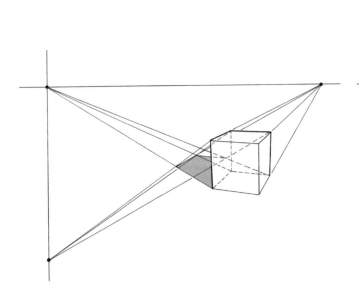

Casting shadows with the sun behind the spectator showing the sun's VP on a vertical line below its VP in plan.

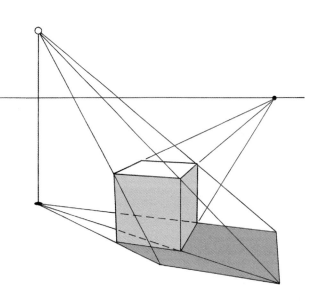

Casting shadows from artificial light showing the 'base' of the light in plan vertically below the light source itself.

The geometry of reflections

The construction of reflections is a logical extension of 2D and 3D projection and drawing systems. A mirror image, whether reflected in a horizontal or vertical surface, shares all the characteristics of its original form, i.e. vanishing points, foreshortening etc. Observations from life and on location demonstrate this and it's worth seeking out examples in the urban and rural landscape and recording in a sketchbook. Making sense of phenomena in the natural world will aid short cuts when working on live commissions in the studio. However, as with all creative outputs, it's worth studying the basic theory first. The principal point to remember is that no matter what positions the object and reflective surface are in, the reflection will always appear to be the same distance within the reflective surface. In other words the reflection is a continuation of the object, albeit as a mirror image.

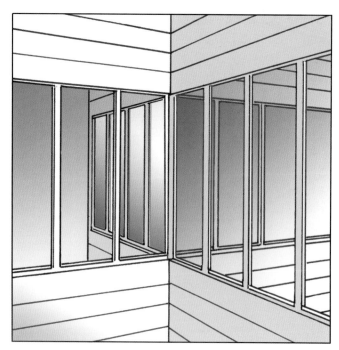

The reflections in these windows can be confusing if not carefully rendered. Notice that the reflection is just a continuation of the perspective of the windows themselves.

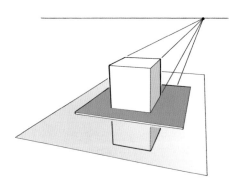
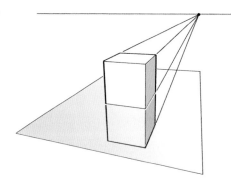

The diagram on the left shows what happens when the reflection of an object is arrested by a surface on the same plane. The reflection stays the same but there's just less of it to be seen.

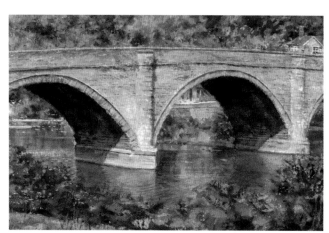

Enlarged detail from a watercolour of Dinham Bridge over the River Teme at Ludlow. The reflection of the underside of the arches includes the cast shadow which loses its intensity on reaching the water's surface.

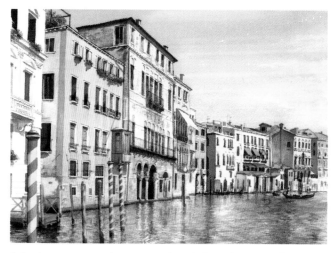

Reflections on water surfaces can vary hugely depending on the flow, tides and how clear the water is. In this view of Venice, the reflections of the buildings are fragmented due to the rippled surface.

Using 3D modelling

Most architectural illustrators have their own personalized method of setting up a perspective drawing and these days most methods will include some form of digital construction. With a large residential or commercial project it is very likely that you will be supplied with a 3D model which has been produced by an architectural technician using one of several packages on the market. The digital 3D illustrator will work from either 2D plans or a 3D model or a combination of the two and create a finished CGI (computer-generated image). The process of achieving a realistic CGI requires a high level of technical skill and knowledge which is outside of the scope of this book. However, there are 3D drawing programmes that are very accessible and easy to use at a basic level when completing an illustration in traditional media. One of these is SketchUp, which is currently used by most architectural practices and it is this programme that features here as part of a case study. SketchUp is free at the time of writing although there is a 'Pro' version with additional features that can be subscribed to. Like other programmes, it is based on an X, Y and Z axis grid which is colour coded and offers a range of prompts whilst drawing between each axis, and in this way is very intuitive to use. On average, after around 5 or 6 hours' practice with on-line tutorial help, you should be up and running with this software.

Creating a 3D model offers a very flexible approach to making a perspective drawing. As mentioned earlier, a building's dimensions can be entered into the programme and the perspective drawn from scratch, or a floor plan can be imported and used together with elevation drawings to build the model. The initial first draft of the drawing is normally emailed to the client for approval and once confirmed, the rendering stage can begin. The drawing and rendering process may be carried out entirely within the programme but it is more likely that these would be separate operations using different media. Some illustrators will offer a service in both traditional and digital illustration and the end result is dependent upon the client's wishes and the subject matter concerned. The process behind a finished watercolour illustration may have involved a 3D digital model, where the advantage to the illustrator is the ease of changing viewpoint and making amendments prior to starting the final rendering. Where a project is clear and straightforward in terms of viewing angle and viewpoint, it may be more appropriate to make the drawing by hand.

To construct a perspective drawing in a 3D programme such as SketchUp, the first step is to create a floor or site plan. As mentioned previously, this can be done by importing the floor or site plan, making sure you are in the correct scale, and then working over this with a 'line' or 'rectangle' tool. Once done, the same procedure can be adopted for each elevation resulting in a 'card-like' model. The same result can be achieved by starting your drawing with the 'rectangle' tool and typing the dimensions into the appropriate box. Typically there are many different ways of working when creating a 3D model and trial and error often forms part of the process used. In SketchUp, the facility of being able to rotate the model using the 'orbit' tool is a great advantage to viewing the building from any angle. Here, the 'position camera' tool replaces the station point so that the desired viewpoint can be achieved either by guess work or by using accurate dimensions. Depending on how detailed the drawing needs to be, the model can be completed with doors, windows and other features by using a combination of tools including the 'push pull', 'line', 'offset', 'follow me' and others too numerous to mention here. There is also a '3D warehouse' which is a free on-line depository of various models to download and edit, with the opportunity to improvise always an option to achieve the desired end result.

CASE STUDY

Walled garden, Mottisfont Abbey, Hampshire

Context

The commission for this project had come from a landscape designer who was shortlisted in a major competition to design a garden within an existing unused walled space in the grounds of a former priory. The new garden space would also provide access to an existing rose garden and the proposal was to incorporate some existing outbuildings and greenhouses within its design and layout.

Illustration brief

The illustration brief was to produce three watercolour illustrations: one aerial view showing the design proposal of the entire walled garden and two standing views from within the space. These were to be used as part of a design submission alongside orthographics, photographs, sketches and other presentation material.

The process

The client's designs were provided in the form of a site plan created in AutoCAD together with a variety of reference material including photographs and plans superimposed onto Google satellite maps: these were particularly useful to understand the orientation of the garden and its surroundings. The first task was to make a site visit to take photographs and make a few sketches (in the event they turned out to be a lot more than sketches, but that's another story.). Even if an illustration can be carried out from plans alone, a site visit, where possible, can really shed light on any issues concerning viewpoint, etc. The next stage was to import the site plan into SketchUp and start to model the existing buildings and layout features and then add the new proposal elements such as the greenhouses, benches and central water feature. To do this was very straightforward by using a combination of the 'line' and 'rectangle' tools

tracing over the plan and then extruding heights and other dimensions with the 'push pull' tool. The trees and planting were modelled as simple shapes – just enough to scale the overall dimensions which would then be traced over in the later pencil stage. There was no need to outline the paths and water rills as the image, as seen, would be printed and traced over in pencil. Before the model was traced, it was emailed to the client for feedback on the overall viewpoint. Once approval was given, a pencil draft was made using a lightbox to trace over the printout and, once again, emailed to the client.

Having already modelled enough of the garden to make sense of the overall design, it was time to move inside and select viewpoints for the two interior illustrations. This is simple in SketchUp and it's just a matter of using the 'zoom' tool to move inside the garden and the 'orbit' tool to orient towards the correct position. The default standing figure in SketchUp is useful to obtain the correct eye level and it was then down to achieving the best angle and viewpoint without too much distortion. Again, these were traced in pencil and emailed to the client for approval. The client's brief was always to produce watercolour illustrations but at this stage the basic models could be completed in any other media, traditional or otherwise. Finally, the figures were added to give a sense of scale and interest to the view, taken from photographic reference to suit the position and perspective of each viewpoint.

Each drawing was subsequently traced through onto 190gsm NOT watercolour paper using a light box, the translucency of this weight of paper being perfect for detailed work. Working this way allows controlled freehand drawing when working over the top of a perspective construction, with enough accuracy to be convincing without losing scale or proportion in the final drawing.

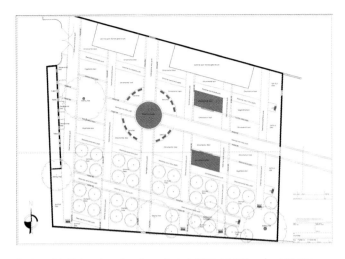

Designer's initial garden plan drawn in AutoCAD at 1:100 scale at A0 size. (Images 89–101 courtesy of Daniel Lobb Gardens.)

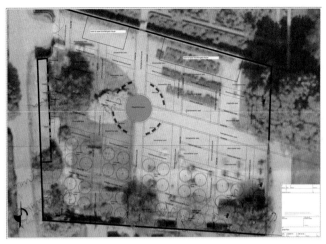

Designer's garden plan superimposed onto an aerial photograph of the site.

Garden plan imported into SketchUp ready for modelling.

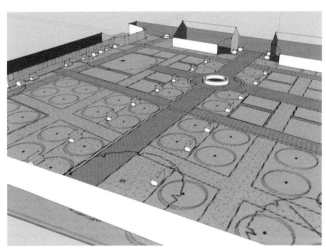

Enlarged detail of the initial component modelling.

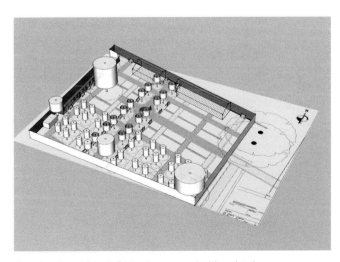

Completed model ready for tracing over and adding detail.

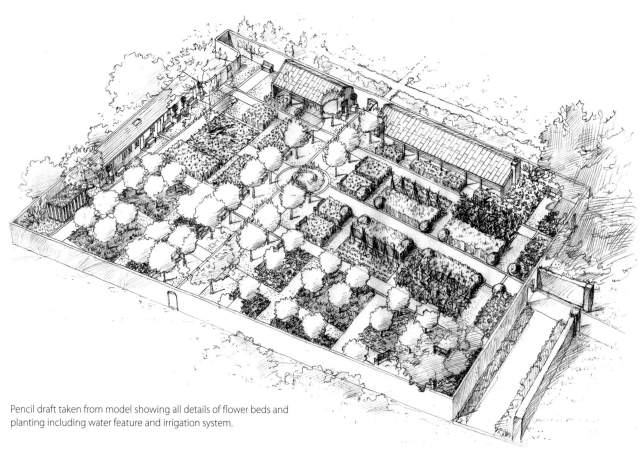

Pencil draft taken from model showing all details of flower beds and planting including water feature and irrigation system.

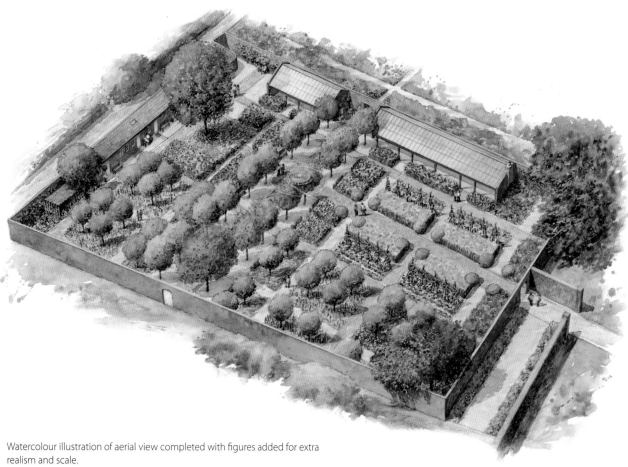

Watercolour illustration of aerial view completed with figures added for extra realism and scale.

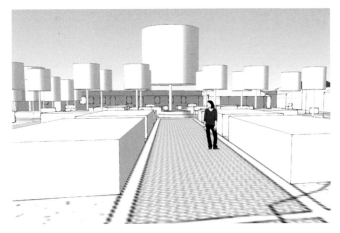

Interior view of model looking west.

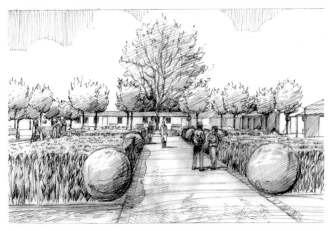

Pencil draft taken from model showing figures and relevant details for sending to client for approval.

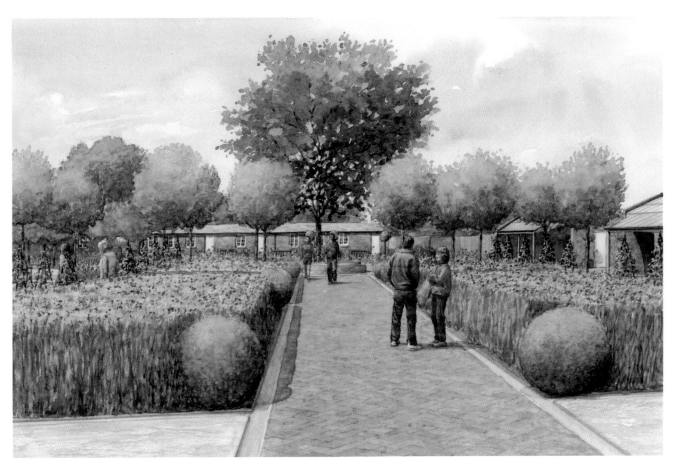

Completed watercolour illustration of interior view.

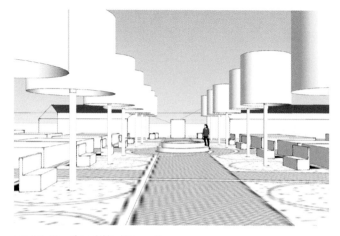

Interior view of model looking north.

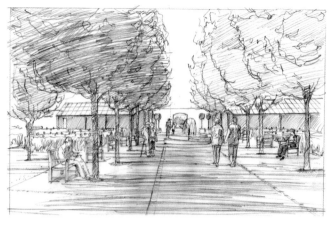

Pencil draft taken from model showing a variety of figures sitting and walking around the space.

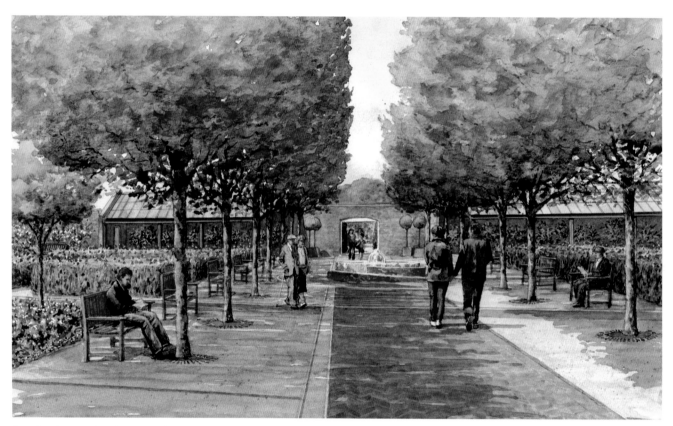

Completed watercolour illustration of interior view.

Joseph Robson

Joseph Robson studied Architecture at undergraduate and postgraduate levels before starting teaching at the University of Bath on what has become the acclaimed Digital Illustration Course. He drew his first commission at the age of 14 and has been happily making a living from illustrating architecture ever since. Whilst teaching, Joseph helped establish the research group CASA (Centre for Advanced Studies in Architecture) and after leaving Bath had a number of architectural and illustration jobs in London. He founded AVR London in 2006, and alongside his team of colleagues Joseph provides architectural and urban planning illustrations and advice to institutions, developers and architects. The majority of this work relates to large-scale masterplanning and building design sub-missions (including in London: New Wembley, Nine Elms, Chiswick, Canary Wharf) and the design of individual buildings, some tall and often located in, or visible within, sensitive historic settings. One such example is The Shard, in which Joseph's work formed part of the submitted evidence at public inquiry, and his marketing images from 2008 are still in use to this day despite the building being completed in 2013.

Things have moved on technically since my teens; however, I still maintain the link directly between hand and artwork. Pencil on paper became pen and ink, which became computer rendering, which then became more about 'painting' the finished image up in Photoshop using a Wacom tablet connected via a computer and screen. All my work nowadays is drawn directly on the monitor – a large Wacom screen is my artistic weapon of choice and something I use for all Photoshop work, 3D modelling, and general computer work. I haven't had a mouse plugged into my computer for 15 years and it feels alien when I hold one now!

At the start of a project I would set up the 3D model and test some view compositions; once fixed I would experiment with lighting directions in the 3D model to give the most suitable time of day to instruct the photographer. We have a couple of full time photographers at AVR London now, but I used to shoot all my own backplates, and occasionally still do. Regardless of how well you brief a photographer there is no substitute for being behind the shutter yourself to get exactly what you need.

Once the backplate and 3D render have been composited together the fun work starts in Photoshop. In order to place people, cars or textures into the scheme I will generally try to photograph these specifically for each view – this ensures I am getting exactly the correct perspective, lighting, and style necessary to match the final image, and goes a long way to avoiding the entourage looking 'pasted in'. Once these are complete, the final balancing will be done again in Photoshop mainly using adjustment layers, blending modes and masks to paint texture, light and emphasis into the image. The final image is then checked for composition and re-cropped if necessary. Rough competition images can be done in as little as a few hours sometimes, whereas complex polished marketing images can take weeks, but each image undergoes roughly the same process.

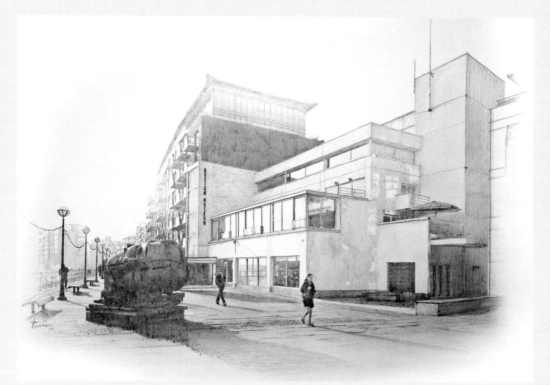

10×10 London, West End 2012 for Article 25 charity auction. The Old War Office Building was my subject and due to the diversity along that stretch of Whitehall I decided to use a combination of techniques. Within the composition there are pen and ink, watercolour, dusk photography, retouched photography (people added to increase the busy nature of the daytime street compared to the long shutter tranquillity of the dusk portion) and for the Banqueting House on the right-hand side of the image a combination of 3D model wireframe and photography. A complex but fun piece to do for a great charity.

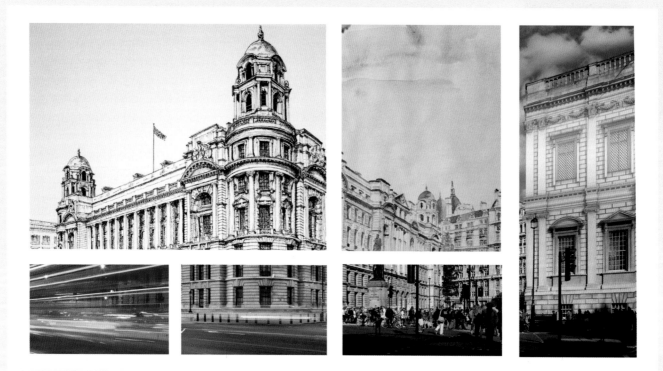

Design Museum drawing. This was a much more of a straightforward drawing; the early morning light coming along the Southbank by Shad Thames takes your breath away and I really wanted to capture that. Within the drawing there are just the right number of people to give a sense of early morning and to help with the directional shadows. The low light glancing off Eduardo Paolozzi's sculpture makes a great composition of lights and darks. Sometimes an image just needs to be about the contrast between these two. I was particularly pleased with how I managed to capture the reflective quality of the glazing with pencil – again just by using the contrast between shading and white untouched paper.

The Shard Plaza View. This was a pretty conventional CGI for The Shard in London Bridge, but quite a good one to show process. Once the camera angle was fixed I produced the base render from the 3D model. I wanted to extend the frame off to the left-hand side and make a long landscape image to show the vast new plaza space, so that's why the render looks 'cut off'. Doing it this way allowed me to keep a more intimate, less wide-angle field of view for the main building whilst allowing a wide shot. The next stage was to work up the materials and glass using Photoshop, focusing the attention on the warm orange entrance lobby to the Shard and trying to emphasize the low warm evening sun glancing off one of the sloping glazed façades. The final stage was to work forwards, completing the trees, people and landscaping; I intentionally kept the centre of the image less populated to draw the viewer's eye into the image – the long directional shadows of the people also reinforcing the single-point perspective.

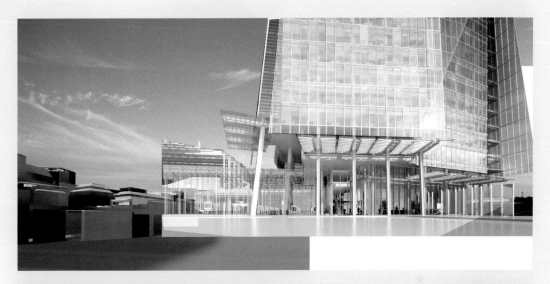

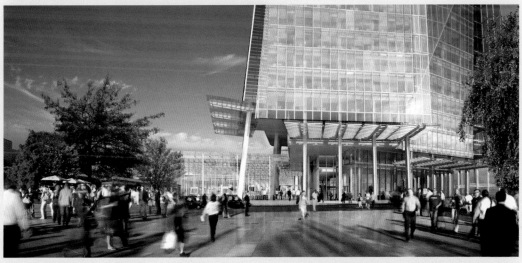

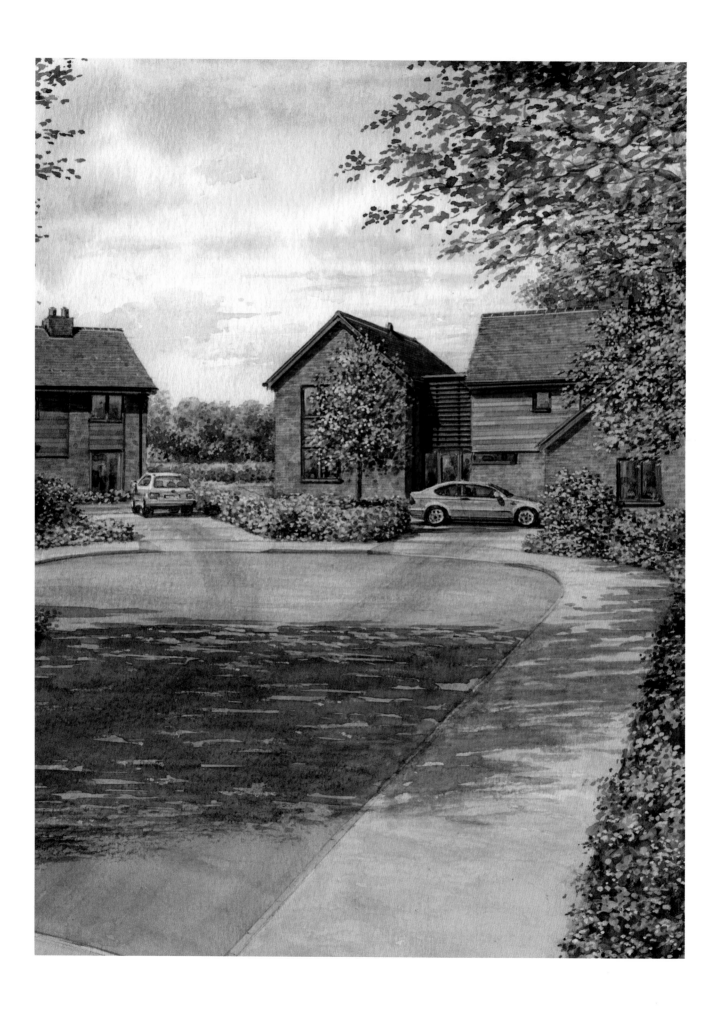

Composition

Composition, the aim of which is expression, alters itself according to the surface to be covered. If I take a sheet of paper of given dimensions, I will jot down a drawing which will have a necessary relation to its format.

Henri Matisse

The skill of composition in picture-making relies on both scientific and aesthetic judgement. The scientific offers a good rule of thumb when it comes to decision-making with respect to the more subjective aspects like balance and proportion. This applies to images in general, be they photographs or paintings, and will give credence to more intuitive responses. We often say that something doesn't 'feel' right when confronted with such an image without quite knowing the reason why. The term 'composition' refers to the elements that something is made from and, in painting, this is determined according to the elements of art, for instance line, shape and form. It is also concerned with the arrangement of these elements and how they relate to each other and can be applied to many forms of artistic endeavour, particularly music. The arrangement of these elements is organized by various principles of art and design, namely: shape and proportion; balance and harmony; colour; contrast; lighting and perspective, etc. – the principles will vary according to a picture's subject matter and content. The placement of a picture's elements and their relationship to each other affects how a picture is viewed. There should always be a centre of interest or focus in a picture and this can be achieved through the application of these principles.

In architectural illustration the focus would normally be, by definition, on the architecture. However, this is often not so simple, particularly where there are significant environment or landscape issues associated with the project. These could be related to the consideration of adjacent buildings, landmarks or natural features that need to be taken into account in the composition.

PICTORIAL CODING

In order to understand a two-dimensional representation of three-dimensional space, the viewer must be capable of interpreting the visual symbolism inherent within a picture. The visual information that we receive through familiarity with the shape and form of everyday objects enables us to understand and make sense of our vision. During first-hand experience of reality, we are able to use all our sensory awareness including movement: this enables us to make adjustments to our viewing position which will, in turn, give clarification and further understanding of what we are seeing. In secondary representations such as drawings and photographs, this is not possible and to achieve effective communication the image must incorporate appropriate and accepted secondary coding. A combination of depth cues to give the illusion of a third dimension will affect how convincing a representation is. This includes linear and atmospheric perspective, object size and scale, compositional elements, colour and texture, and light and shade.

Perceived accuracy of pictorial codes will vary according to the type and nature of a project, its method of

The entrance to a proposed residential development.

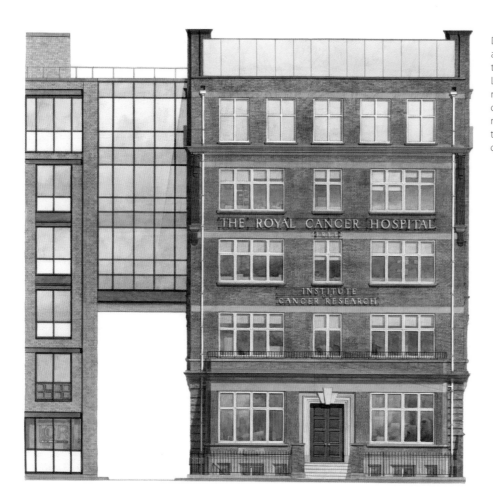

representation and the view depicted. For example, the lighting conditions of an interior space may combine both natural and artificial light sources, whereas the usual conditions of an external view would be in normal daylight.

Linear perspective

The laws of linear perspective enable us to make sense of our world and are derived from the natural laws that dictate how we perceive and respond to our environment. Perspective theory relies on a single viewpoint and is highly subjective. It demands a certain faith about the world around us and as such has to be learned. Compared to the way we see and interact with our environment, a perspective representation acts as a compromise relying on our acceptance of the laws of perception. The power of perspective in dictating how a picture is viewed should not be underestimated. Artists such as Raphael of the late Renaissance period in Italy became expert in using perspective to influence people's reaction to a painting by using vanishing points to lead the eye through and around a picture. In 1754 William Hogarth produced an engraving entitled *Satire on False Perspective* for a pamphlet on linear perspective, which showed how a lack of knowledge could produce outlandish results. Later, in Victorian times, artists used perspective in order to emphasize the narrative in a painting, and in more modern times, the graphic artist Escher used perspective to create illusions.

The location of a viewing position is the starting point for both hand-drawn and digital perspectives although, as mentioned in Chapter 2, in the case of a digital model, the final viewpoint would be considered towards the end of the modelling stage. Once a suitable position has been identified, consideration can then be given to other factors, such as position of picture plane and the height of the eye level. In the selection of a viewpoint care must be taken to ensure that any distortion is kept to an acceptable minimum or is appropriate to the subject matter. Interior perspective views can explore perspective distortion to the limitations of normal (monocular) field of vision, whereas external views need more careful consideration. One of the reasons for this is the difference in our visual experience of internal and external space. When we are inside a building the enclosing space will fill our entire field of view and extend beyond normal optical boundaries. This usually means that

to create a meaningful picture in our minds, we need to move our line of sight constantly with each view presenting additional information. The periphery of our vision gives extreme distortion that is out of focus. When we observe drawings or photographs of similar views, periphery distortion is accepted by our mind as a mimesis of this reality.

When viewing buildings from an external position the emphasis can be quite different. To appreciate fully the appearance of a single structure say, in a landscape setting, one tends to gravitate to a viewing position whereby there is little or no need to re-adjust one's line of sight. Such a position may be a significant distance from the building of interest and command a view that includes other buildings and landscape features. Where there are similarities to interior space, for example in built-up areas or in shopping centres where buildings enclose the viewing position, then the same rules apply.

In external perspective views of buildings, a wider angle of view can often be utilized if the setting is of natural features only. This is because distortion is less obvious in elements of the natural landscape than with architectural forms. Where accuracy is a prime factor, as in a perspective of a proposed building, adherence to the accepted rules and norms are important to its success. In topographical illustration this may be less important, where aesthetic appeal has a greater emphasis.

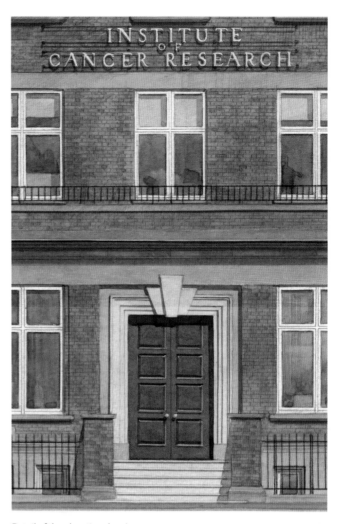

Detail of the elevation drawing.

Street view of a proposed apartment block in Cambridge. Although not an orthographic view, this illustration shows how cast shadows can help to explain the depth of the projecting gables as well as the entrance and openings to the underground parking.

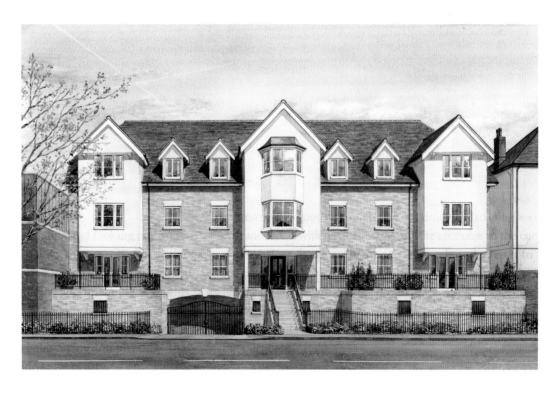

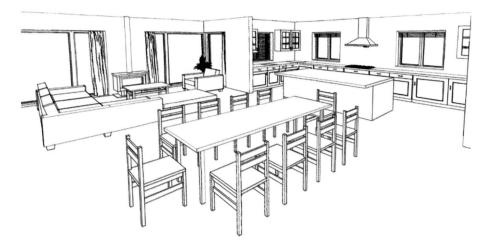

Interior perspectives can take advantage of a wider angle of vision than exteriors. This is due to our mind's acceptance of distortion within an interior space which will often encompass our entire vision. This drawing was made using ARCHICAD software.

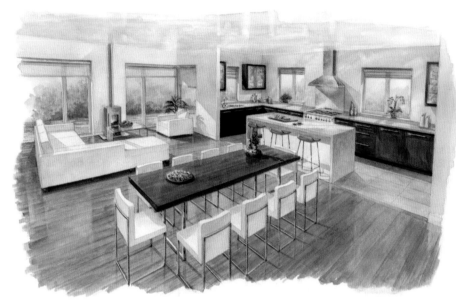

This illustration shows the kitchen rendered in watercolour. To complete the illusion of 3D the use of cast shadows and reflections helps to provide a realistic impression of an interior space.

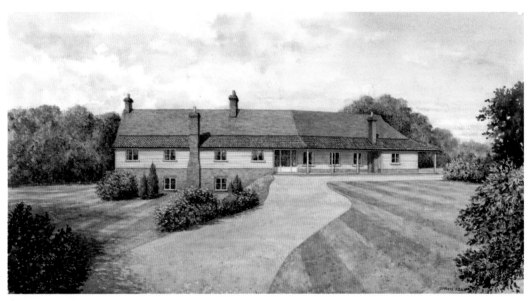

The drawing of this proposed split-level house was set up with a wide angle of view at about 70° to give the building a more dynamic feel, which would show distortion on each side if the building filled the frame. However, as perspective is less discernible in landscape features, any perceived distortion is minimal.

Atmospheric perspective

Depth coding is enhanced by variations in strength of line and tone techniques that give indications of distance within a picture. Atmospheric perspective, also referred to as aerial perspective, is the phenomenon which is most apparent in reality when viewing over a great distance at dawn or dusk on a clear day. It relies upon the study of light and colour and has no geometrical or mathematical basis. Natural atmospheric conditions affect clarity of vision and, even over short distances, give visual clues to recession and depth. Detail becomes less clear as recession occurs – a useful device in artistic representation. In colour applications, the dilution of hue from foreground to horizon, together with change of emphasis from warm to cool colours, reinforce the illusion.

Scale and proportion

The relationship of objects within a picture gives the viewer important clues as to their size and scale. In perspective, objects placed within a picture will diminish according the rules employed. This conforms to our visual experience of reality and our relationship to objects within it. For example, an object placed very close to one edge of a picture's foreground can be instrumental in promoting our ability to experience other pictorial depth codes.

The terms 'scale' and 'proportion' can mean many things but in art and design both refer to relative size. Something that is 'out of scale' is considered to be too large or small and if something is 'out of proportion' it is seen to be at odds with itself, with both terms relating to their surroundings. In general, the main difference between the two words is that 'scale' refers to accuracy in size whereas 'proportion' relates to an object's aesthetic. In art and design, the relationship of our bodies to objects and the environment around us has always been considered as significant. Physical ergonomics is the study of how our bodies interact with our surroundings and can be traced back to Ancient Greece. It was Leonardo da Vinci who, in around 1487, created the world-famous drawing of the Vitruvian Man, sometimes referred to as the Canon of Proportions. The drawing shows a male figure in two superimposed positions with arms and legs apart inscribed within both a square and a circle. The drawing is on paper and is accompanied by text based on the work by the Roman architect Vitruvius (d. 15 BC). It represents the correlations of ideal human proportions with geometry and the Classical Orders of Architecture taken from Vitruvius's treatise *De Architectura.* In this drawing and notes we see da Vinci's first attempt to understand the proportions of the human body, including in relation to its surroundings. Even

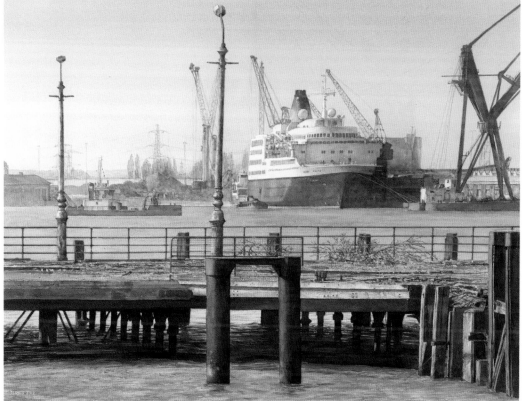

Although not strictly architecture, this view showing the derelict Royal Pier and cruise ship in Southampton's docks, is a good example of aerial perspective. The watercolour was made from location sketches and photographs taken early one spring morning. Notice how the colours fade into the distance as the damp atmosphere breaks down into tints of cool hues onto the horizon.

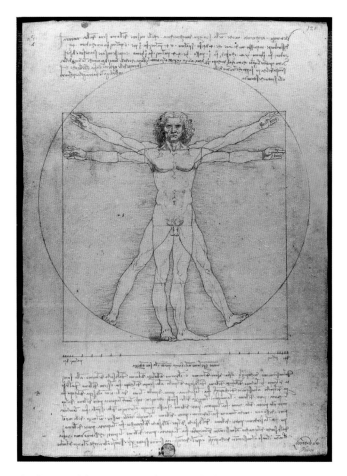

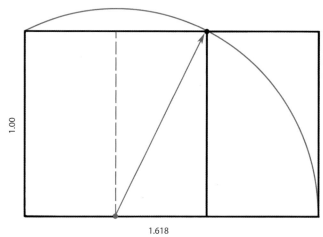

The Golden Rectangle shows a square divided in half and the centre of an arc positioned on the lower side to create a rectangle with the ratio of 1:1.618 – the significance of which was laid down by the Greeks and Romans in the time of antiquity.

The drawing of the Vitruvian Man by Leonardo da Vinci represents the work of the ancient Roman architect Vitruvius in which he describes the geometry that relates the human body to the classical orders of architecture.

older than this is the geometry behind the Golden Mean or Golden Section. Starting with a square and finding the mid-point of one side, an arc is scribed with its centre on the mid-point to extend this side, thus creating a rectangle with a ratio of 1 to 1.618. The Greeks and Romans used this ratio in their architecture, which continues in new buildings even today. It is considered to be pleasing in its proportions and, alongside other ratios, is used as the basis of design in many products.

Traditionally, the scale rule has been the most important item of equipment used in making and taking measurements from a set of architect's plans. Architects' drawings use metric scales from 1:2500, used on location plans, to 1:5 which may be used on-site to construct from. In general, the larger the scale, the more accuracy can be achieved and communicated to a third party.

Rule of thirds

'Rules are made to be broken', or so the old adage goes, and in the context of the visual arts this is clearly the case. The

subjectivity that surrounds the aesthetics of visual communication has had a profound influence on the arts in general and on commercial art in particular. At the end of the Middle Ages, the commissioning of art moved away from the church and into the public domain through individual and often wealthy patrons. This meant that artists were free to portray subject matter in a more personal manner and without the rigid rules imposed by the church. Before this time the hand of the artist was unimportant, as most religious art was created anonymously. During the Renaissance in Europe, artists and scholars began writing treatises on the creation of art and in particular the laws that affected how paintings should be composed. In the late eighteenth century the rule of thirds was first written down and this has been adopted by artists, photographers and film makers ever since.

The rule of thirds is applied by dividing a picture into nine equal parts by two equally spaced horizontal lines and two equally spaced vertical lines. In landscape painting, the horizon line or significant feature (a line of trees, for example) should be positioned on one of the two horizontal lines, depending on the view required. Other features should be positioned on intersections of these lines in order to create a balance of different elements within the picture. The main reason for this rule was to discourage placement of subject matter in the centre, or for the horizon line (or any other important lines) appearing to divide the picture in half. The rule of thirds can be seen as a guideline for composition and, like most rules, may be superseded by personal judgement.

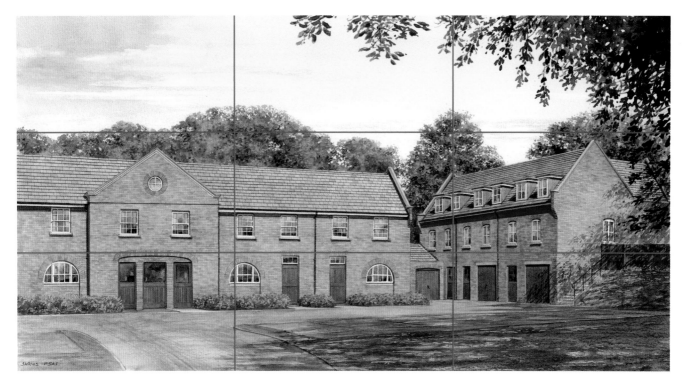

This illustration of proposed apartments generally fulfils the rule of thirds in its overall composition. The grid has been overlaid to show how this works: the buildings and tree line beyond take up two thirds from the lower edge of the picture. The main gable sits comfortably within the left third of the grid and close to an intersection. The right-hand block is well positioned over an intersection and occupies most of the right-hand third of the grid. Intersections are helpful in directing the viewer to important elements of the illustration.

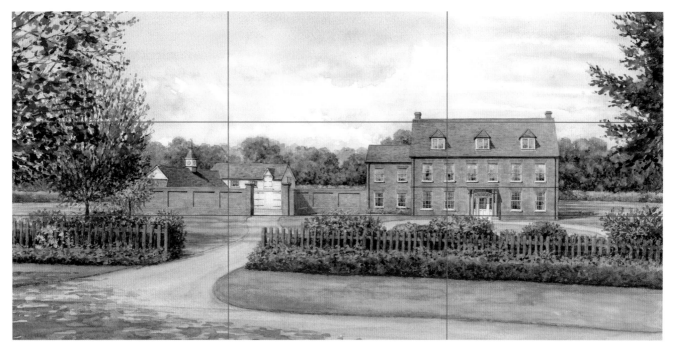

A perspective view of a proposed house and outbuildings in a traditional Georgian style viewed from the opposite side of the lane to show entrance and front boundary. Here the buildings occupy the centre third of the grid with the entrance driveway filling the left-hand third, giving the whole composition a good sense of balance.

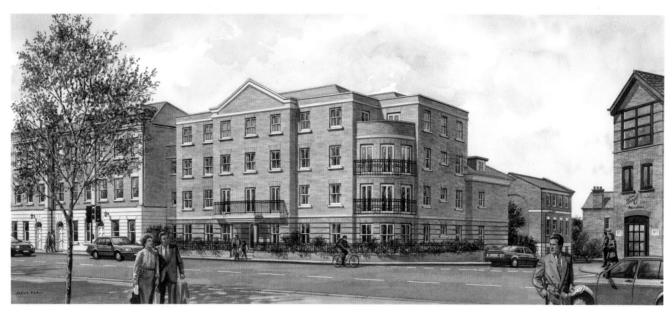

In this perspective street scene the central building, a proposed student housing scheme, is shown in context with existing buildings and entourage elements. The street is close to a busy city centre and therefore it is important to represent some activity without detracting too much from the illustration's purpose.

Compositional elements

Selection and use of entourage elements to form an interesting composition can contribute to the illusion of depth through appropriate placement. Superimposition of figures, cars, trees and other urban and landscape elements will create a sense of capturing a moment in time. In drawing this can be achieved by using images acquired from various references. In the context of a city centre environment, photographs can be taken at the actual site location and used in the composition. Effective use of compositional elements can contribute to the plausibility of an illustration as a credible representation. Fixed objects such as urban signage and street furniture can provide compositional devices in picture design and contribute to the overall balance. Placement is key in achieving a convincing composition and this relies on a good appreciation of how we, as spectators, look at pictures. As outlined earlier, the law of thirds is a good rule to start with and a basic understanding of image analysis will help even further. There is good evidence that there are three steps in our brain's processing and making sense of what we see and these happen almost simultaneously. First, the mind identifies elements with which we are familiar such as drawing, colour and form. Second, it looks for recognition of information that gives definition to objects, people and places. Last, based upon this information, a comparison is drawn with past experiences and an interpretation is made. In film making the term *mise en scène*, meaning 'putting things in the picture', is used to describe how elements are arranged within a 'frame' where each element will contribute to an image's overall meaning.

Colour and texture

Appreciation of colour and texture in man-made and natural forms relies on one's prior experience and awareness, both visual and tactile. Acquired knowledge enables us to make assumptions about the nature of objects we see. Pictorial coding which represents colour and texture depends on this knowledge in the creation of secondary images. Texture becomes less defined as objects recede into the distance and our ability to interpret information relies more heavily on colour to distinguish one form from another. A slate roof in the distance may only be recognizable as such due to its blue/grey colour and proximity to other landscape features, whereas in the middle ground its surface texture will be better defined.

Colour and texture are indelibly linked and if one is experienced separately it can provide clues to the nature of the other: representational style and technique will demonstrate this. In semi-abstract or impressionist styles of rendering, surface texture may be ignored totally, reliance being placed on the application of colour to stimulate recognition in the viewer. Conversely, in black and white pen drawings or in engravings, detailed portrayals of texture will give visual clues as to its likely colour.

This watercolour shows a view through an open gate into a field leading to a farm building beyond. It uses both aerial and linear perspective to give the illusion of depth. The gate, fence and foreground are all well defined but more distant features become less so as we are drawn into the picture. The building looks to be of red brick with an old slate roof – this we can deduce from suggestions of colour and texture.

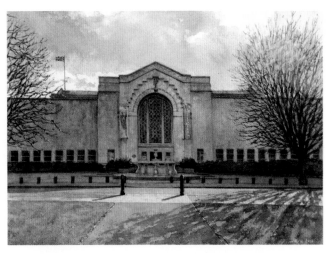

The façade shown in this watercolour is the north facing entrance to the art gallery in Southampton's Civic Centre. The stone colour can change from warm to cool across the elevation, depending on the lighting conditions, and this can be seen in the use of burnt sienna and ultramarine to reflect both colour and texture. (Image courtesy of Les Buckingham.)

Tone and contrast

One of the most important factors in achieving a good composition is the consistency of tonal values, and getting the appropriate range within a picture can be tricky for the novice. Tone and contrast work together to give a picture the right atmosphere depending on lighting conditions. With an interior view the tonal range relies on how the lighting is applied in and around a space and will often be affected by a combination of artificial and natural light sources. With exterior views, tonal values are not only dependent on natural lighting conditions but also on weather and time of day. This could range from dull or overcast to strong sunlight, and from early morning to late afternoon, each having a direct effect on an illustration's composition.

Light and shade

In portraying scenes in natural daylight it is important that indication of light is consistent across all the elements within a composition. In certain circumstances it may also be important to the accuracy of a representation that the sun's position is in keeping with the orientation of a structure, which would be noticeable through the use of cast shadows. If the structure exists then actual evidence of the sun's movement throughout the day can be witnessed. Where the subject matter is proposed then the position of the sun in relation to a structure's orientation can be predicted. Accuracy and variation of shade and shadows in

pictures will depend on site conditions, the type of structure to be portrayed, and the purpose of the artwork.

Cast shadows are a useful means of describing three-dimensional form in two dimensions. Linear perspective has limitations, just as actual vision does, in making sense of hidden or disguised objects, and shadows cast from buildings can communicate additional information. Skilful indication of shadows portrayed as if cast from trees or buildings outside the picture's perimeter will contribute to the overall illusion of defined space, the boundaries of which are perceived as less rigid. Intensity of cast shadows will indicate the strength of sunlight and therefore give clues to a variety of implied conditions. Subdued lighting and soft shadows will portray a more subtle image with a reduced range of tonal values.

The use of light and shade in pictures can be a conscious attempt to create atmosphere or just an appropriate device to portray the subject matter. Successful representation of building interiors often relies on a combination of natural and artificial lighting. Here, several shadows may be cast from a single object that is affected by a variety of light sources all combining to create atmosphere and effect. Secondary light sources and reflected light can all add to interior atmosphere and, as in reality, be accepted by the viewer without contention. A total lack of natural light, and night-time representations using artificial light to show illuminated forms, can create a sublime effect in architectural illustration.

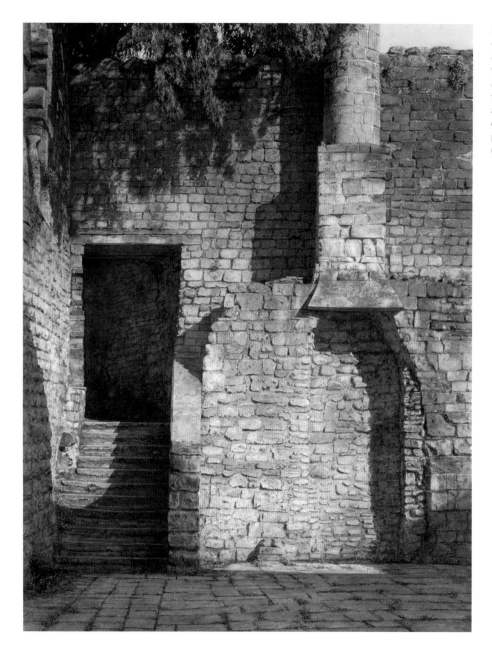

King John's Palace, Southampton, is part of a ruined Norman merchant's house and a Scheduled Ancient Monument. This watercolour shows how light and shade and particularly cast shadows can help to describe depth in a picture. Observing architectural form in this way will impact on the way light and shade can be used on perspective work for proposed architecture. (Image courtesy of Edward Chaney.)

Reflective surfaces

Indication of reflective surfaces in architectural illustration can 'lift' an otherwise dull composition, particularly if the architecture is less than inspiring. Armed with a solid understanding of the theory of perspective geometry, reflections can be applied to any reflective surface with ease. Reflections in windows can help to add interest and with buildings featuring many or large glazed areas, it can also help to define architectural design details. Reflections shown on wet roads and pavements can really help the composition to be convincing as this effect is something we are aware of but take for granted. The great architect and illustrator Cyril Farey was a master at this technique and the majority of his illustrations were shown as if it had just rained, giving added depth to the composition. Reflections that occur in natural landscape features such as ponds and lakes should always be represented as a darker version of the original form or colour. Reflection of shapes conforms to the perspective and foreshortening of the original shape. Many great watercolourists of the eighteenth and nineteenth centuries were masters of the reflection in their work. In his two works, *Greta Bridge* (*c*.1805) and *Crambe Beck Bridge* (1805), John Sell Cotman (1782–1842) shows how the reflection in landscape painting can 'anchor' a structure to its surroundings by its very presence.

Channel 4 Headquarters, London. This watercolour illustration shows the building, designed by Richard Rogers, devoid of all entourage elements other than street bollards. Its innovative design was an opportunity to explore how light, shadows and reflections work across different surfaces and materials. The drawing was corrected from site photography and was set up as an accurate two-point perspective. (Image courtesy of Luke Johnson.)

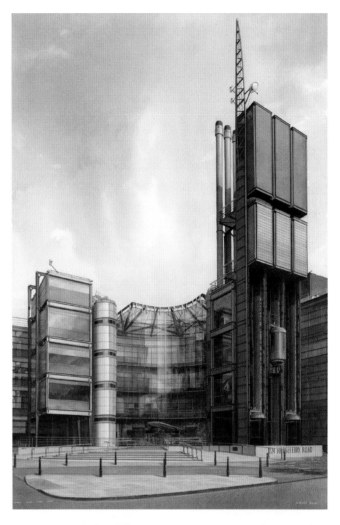

Detail showing reflections and rendering technique.

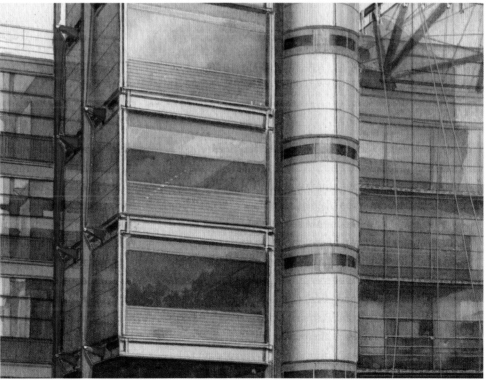

CASE STUDY 1

The Bargate, Southampton

Context

The Bargate stands between Above Bar Street and High Street in Southampton and was the main gateway to the city during medieval times. It was built *c*.1180 as the gatehouse to the old walled town, much of which is still standing, and is a Grade I listed scheduled monument. Its uses have been varied over time but most recently it served as an exhibition and event space managed on behalf of the City Council by A Space Arts. It is constructed of stone and flint and has been the subject of recent restoration to replace the Portland cement mortar with lime mortar and to waterproof the parapet to prevent further leaking.

Illustration brief

To produce three illustrations as part of a planning application to modify the use of the building to include the following changes: the upper floor interior space to create a café area for visitors; to convert the existing storage spaces within the ground floor to retail outlets and fit tinted glazing to within the arches; and to create an outdoor seating area adjacent to the entrance steps.

The process

After reaching agreement with the client to confirm the nature of each viewpoint, the first task was to make sketches and take photographs from the outside of the building to assess the potential for two external views. The next stage was to take measurements of the interior to produce measured drawings in the form of a floor plan and two elevations. These would then form the basis of an interior perspective view to show the design proposal for the café area.

External perspectives

The main view of the building was to be of the south side to show the entrance steps and eating area. The Bargate now stands in a pedestrianized area and therefore there wasn't the opportunity to show vehicles in the view, and so it was important to the composition that there were figures positioned in both foreground and distance, in order to portray the effect of depth and scale. One would also expect, in a busy city centre, the presence of people going about their business and this adds to the overall composition. This

view was produced to show information in two ways: first, the addition of tinted glass to the existing arches on the ground floor as well as the eating area to the right-hand side; and second, and maybe more important, the minimal effect that any changes would have on the façade as a whole – an important factor when dealing with listed buildings, and the first thing that the planning committee would want to know.

The composition almost took care of itself as the building is so dominant, but the inclusion of the street market stalls just within sight, but cropped on either side of the building, as with a photograph, gives the impression of more activity outside the field of view. The illustration was based upon photographs taken during a site visit and the best view offered a good amount of perspective and foreshortening. However, working directly from a photograph always shows in the way the camera records a view, depending on lens settings, and there is always the need to correct distortion. In this example, as with photographs of tall buildings taken from ground level, the noticeable distortion was the vertical vanish and foreshortening. This is easily adjusted in Photoshop by using the 'perspective crop tool' and applying the grid across the building in question. This way you can add more height, which is lost in the photograph, and at the same time correct the verticals.

The next stage was to populate the view with people and activities: in this case those walking through the main archway and those sitting in the café area. Having taken dozens of photographs with plenty of figures therein, it was just a matter of selecting and composing these into a pleasing composition. It's always best to place figures within the foreground, mid-ground and background for maximum effect and good reference is crucial in this process. If a figure is out of perspective or scale it will be noticeable instantly to the viewer, particularly if your rendering style is a realistic and detailed one – as in this example.

Once the picture had been composed it was transferred onto watercolour paper for rendering. The easiest way to do this is by using a light box. For detailed subject matter it is best to use a lightweight paper so that it is easy to see through and trace the original drawing. In this case a 185gsm or 90lb Canson Montval Aquarelle NOT surface was used. This paper has a rugged surface that can

Pencil draft of the Bargate monument in Southampton showing composition and arrangement of entourage elements including a proposed seating area.

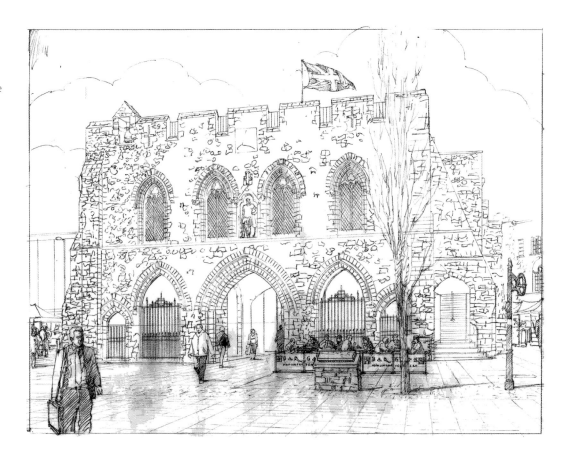

Completed watercolour rendered artwork showing glazed arches for proposed retail units. The statue contained within the apse in the centre of the four windows is of George III in Roman dress, dated 1809.

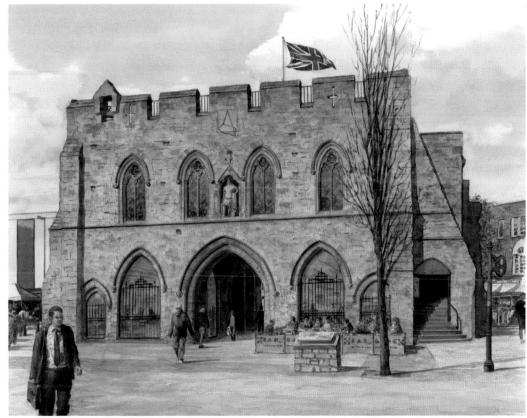

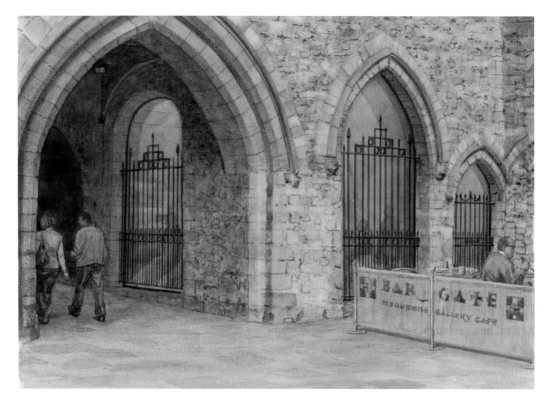

Pencil draft of the proposed retail units behind glazed arches with seating area in front.

Completed watercolour rendered artwork of the retail units. The wrought ironwork was installed in Victorian times and may have been to prevent rough sleepers from entering these spaces; they are currently used for storing items from the street market.

withstand rubbing out and lifting off if changes need to be made. When the drawing was complete it was spray-mounted onto a stiff card to keep it flat when applying washes. The alternative to this is to stretch the paper in a bath of water for around five minutes and, using gum strip, tape this down on all four edges to a portable drawing board. The drawback to stretching paper is that it will

need to dry before applying paint, and this will take several hours at normal room temperature (*see* Stretching and preparing paper).

The second perspective view was dealt with in a similar way and shows a close-up of the arches and the end of the outside seating area. The purpose of this illustration was to focus on the plate glass panels fitted behind the existing

wrought ironwork and the position of the seating area in front. The picture was composed from photographs and assembled in the same way as the main illustration. In this view, it was not necessary to show cast shadows as the emphasis was on the glass panels set inside the arches.

The interior perspective

The view showing the café interior needed careful consideration, both in terms of the interior design itself and the composition of the visual. The client's brief was to create a convincing interior view for illustration purposes only as the design stage had yet to be discussed. In order to achieve this it was necessary to make a site visit to take photographs and measurements of the proposed café area, which was on the first floor of the Bargate. One element that had to be incorporated within the scheme was a disabled toilet to be positioned next to the window. On site it was a matter of taking accurate measurements and, with a very high ceiling, a laser measure came in very handy. This, together with other features, pointed to the most suitable viewpoint to set up the perspective.

Back in the studio it was now possible to make accurate scale orthographic drawings – side, end and plan views at 1:50, ready to draw in perspective. With the floor plan drawn with the toilet in place, the rest of the floor layout was fairly straightforward. The servery counter fitted well, positioned beneath the apse containing a statue of Queen Anne, with tables and stalls on the opposite wall. The opposite end had fixed seating with tables and stools, which completed the layout.

Interior views, as mentioned previously, can be composed to take a wider cone of vision than exterior perspectives, but even then the narrow width was problematic and so a position was selected just outside the building so as to include the fixed seating area in the foreground. Although this kind of set-up would normally be avoided, it was considered to be justified in order to show the space in one illustration rather than two. The viewpoint, or station point, was positioned to be perpendicular to the end wall and directly opposite the original window. This meant that with a one-point perspective set-up, a cone of vision of around 60° would take in the extent of the intended

Site measured orthographic drawings with an indication of the angle of view for the interior perspective illustration, showing proposed floor and furniture plan.

view required. The vanishing point, or centre of vision, was placed at a standing eye level height and on the left side of the central window mullion. Offsetting the centre of vision in one-point perspective is usually desirable and will produce a more interesting asymmetrical view; in this case it also helps to focus on the left wall and describe the detail around the servery counter. At the time of execution the Bargate was used as an art gallery and cultural events space and the right-hand partition wall was to be shown as a hanging space with framed pictures *in situ*. The rest of the interior was to be a café and should show people eating and drinking at the counter and seating areas.

The approach to colouring the drawing was to combine natural and artificial lighting using soft and cast shadows and shading, with reflections on the timber flooring, and the variety of surface materials, tones and textures all adding to the composition without losing clarity and credibility as a representative view. The use of watercolour as a rendering medium offers the ability to blend colour washes across surfaces and in doing so creating subtle colour changes whilst at the same time representing surface textures.

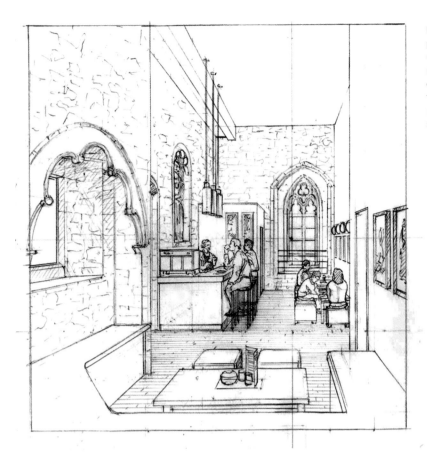

Pencil draft of one-point perspective view with figures in place. The viewing position was placed just outside the building so that the foreground table and bench seating could be shown without distortion.

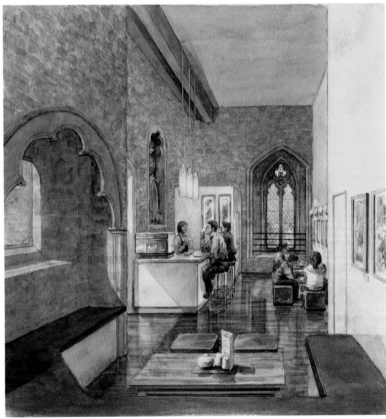

Completed watercolour rendered view with light, cast shadows and reflections to help represent atmosphere and ambience within the space.

CASE STUDY 2

Petersfield Mansions, Cambridge

Context

Petersfield was the original name for the family mansion that was built in 1870 prior to a postal sorting office being erected in its grounds in around 1925. It remained in the hands of the Post Office until it was acquired by developers who re-established a change of use back to residential. At this stage, concept designs were submitted for outline planning to build a scheme of modern apartments.

Illustration brief

To provide concept drawings and illustrations working alongside the architects, initially to support the planning application and then for promotion and advertising in the UK and Hong Kong.

The process

An advantage of being commissioned at an early stage of the project was that the developers had yet to begin the demolition of the existing building and, therefore, there were few restrictions during the site visit. With the building having a façade similar in massing terms to the new build design, it offered some clues to the angle and viewpoint to take from the very start. The architects were keen to see initial concept perspectives showing the main entrance and views from the parkland to the front of the building, as well as raised eye-level views from the rear courtyard. Several sketch perspectives were prepared at different stages; these were used by the architects as part of the design process and some were used as part of promotional material.

As usual, the composition of each illustration was dictated by the viewing angle and height of eye level deemed appropriate in each case. The view of the front elevation from across the park needed to be a standing eye-level position, as did the view into the north corner, whereas the rear view was from an elevated position.

Main view showing front elevation

This perspective was the first finished illustration to be prepared to show the entire façade facing the park. The view was based on a position as if standing in the grounds of a leisure centre opposite and would be a view that local people would be familiar with. This was important to impart information to the local community that would give an honest impression of the finished building. Although not a conscious decision, the composition is very much based on the rule of thirds with the large tree trunk on the right and the cyclist to the left, positioned at the intersections of the grid lines. Also the lower horizontal grid line almost coincides with the eye level of the perspective, which all helps to create balance and harmony within the picture. The perspective portrays an autumnal scene with the trees supporting a sparse canopy of leaves and fallen leaves on the ground. Apart from creating atmosphere, this enables the building to be seen, which would be obscured in such a view during summer months. The inclusion of figures helps to contextualize the view, showing children playing in the park setting and various people moving across the scene –including the ubiquitous student cyclist which Cambridge is renowned for. The sun is positioned fairly high and to the left of the view casting a shadow from a tree just out of view, helping to balance the composition with the darker areas to the right-hand side. The suggestion of elements outside or to the edge of an illustration is a useful way of describing objects and activities that exist beyond the picture frame.

North corner view

This illustration was requested by the senior planning officer to help describe what impact the new building would have on the existing Victorian terrace that forms part of a conservation area. To lessen the visual imposition of the corner tower, a parapet to the first floor was designed at the same level as the gutter on the front of the adjacent terrace. With facing bricks up to this height and the tower clad with rendered panels it was designed to lessen its impact. The composition of this illustration was mainly dictated by its purpose but it also showed part of the new affordable housing in the centre of the picture. The central tree was a useful element that helped to tie the composition together. Once again, cast shadows from outside the picture frame helped to widen the view.

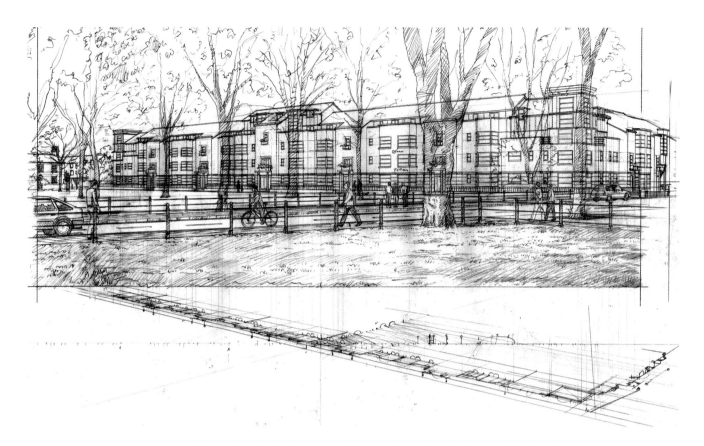

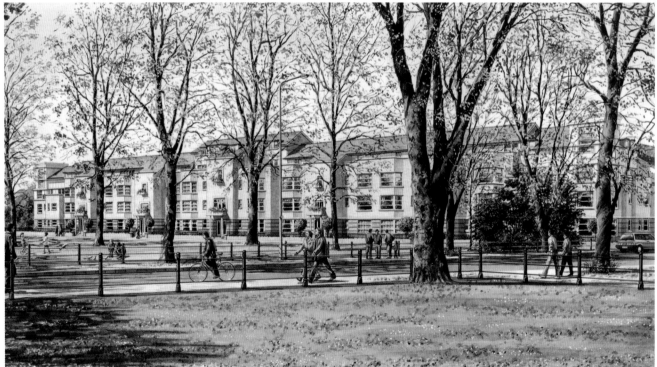

Perspective view of proposed apartments looking across the park area. The view would be obscured by trees in full summer foliage, so the view represents an autumnal scene. Note how the mature tree trunk is positioned at about one-third in from the right-hand edge of the frame for balance and proportion.

North corner view showing the relationship of the proposed corner tower design to the existing terrace.

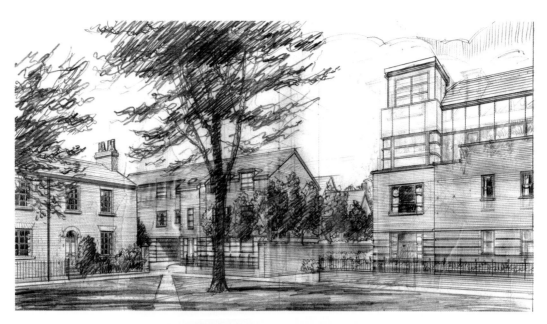

North corner view showing the relationship of the proposed corner tower design to the existing terrace.

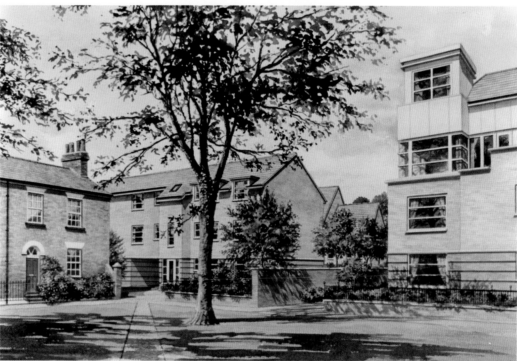

Rear courtyard view

This view was set up as if standing and looking out from a second floor balcony overlooking the courtyard and taking in the pedestrian access and entrance to the underground car parking. The footprint of the apartment block was in the form of a capital letter 'E' and the composition required that the majority of the picture would be the proposed building with mainly hard landscaping and planting. The perspective was a fairly wide angle of around 60°, which represented a good portion of the building, landscaping and entrance road with a car showing the far entrance to the car park. Various figures were used to give scale and interest to the illustration. The direction of the sun was from the left-hand side but square enough not to place either elevation in shade. This was important to portray the building in its best light and to its best advantage for promotion and advertising purposes.

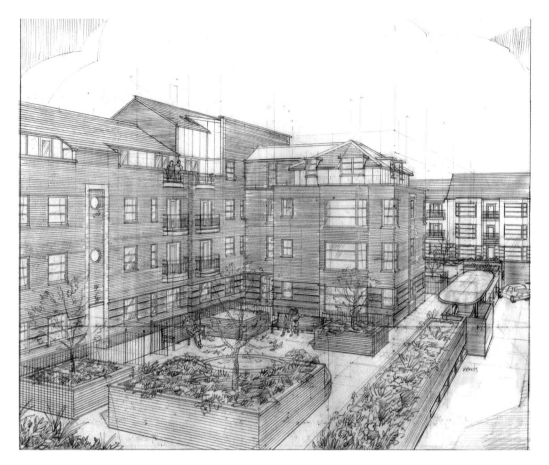

Rear courtyard view drawn to show how the proposed hard and soft landscaping would complement the building design and materials, including a pond, mature planting and seating areas.

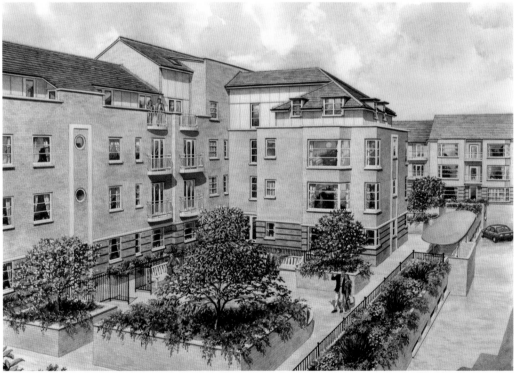

Kate Dicker

I remember seeing watercolour drawings of buildings and architectural details by John Ruskin (1819–1900). It was some years ago now but I still think they are amongst the most remarkable creations. Ruskin's confidence of draughtsmanship and sensitivity with line, together with muted and sometimes vibrant watercolour washes, manage to set off a special beauty and atmosphere in his work. At Camberwell College of the Arts, location drawing was a significant part of my training and, of course, featured buildings of all kinds. Then, when I left college, I concentrated on watercolour drawings of historic houses, working towards an exhibition at Leighton House in Kensington. I loved working outside and would set off with my equipment: 2B pencil, watercolours, large brush, one large sheet of Saunders Waterford paper attached to a drawing board covered with a plastic bag, and a portable stool.

It was interesting to experience each location with its unique social interaction by sitting amongst the crowds on a pavement. In Chiswick a lot of people would be curious and ask me questions. In Kensington hardly anyone took any notice and, in Soho, characters were extrovert, upbeat and busy. I was approached to take on varied commissions: buildings with different styles such as Dutch, Regency, Victorian and terraced family houses. To start the work, the first sitting involved an accurate sketch drawing covered with loose washes before I left the scene. On the next visit I would check over the drawing and start to make definition with brush and colour. All the time I had an eye out for the moment in the day when the shadows were at their most interesting. At home I would bring the picture to its final stage.

As for training, my foundation course gave us some demanding exercises. One of these was to draw a three-dimensional facsimile of Rietveld's *Red Blue Chair*, created during the De Stijl art movement. We had a week to make a perfectly accurate, line drawing of all the planes and their perspective. This intensive exercise contributed to our confidence to tackle any object or subject, as did a later project when the tutor filled the life room with parts of aeroplanes, fishing nets – you name it. For three weeks we developed our large drawings in response to this enormous mountain of metal, plastic and rope.

With the illustrations shown here I start with pencil and nimbly mark out a composition, observing heights, widths and depths of not only the elevations of buildings but also the horizontal planes on ground level, such as the road through Chawton Village. The three dimensions are further emphasized with lights and darks according to the position of the sun. I am aware at an early stage to look for a focal point and a good example is the white, vertical church spire of St Michael's Church, which makes an eye-catching spot from which I relate the rest of the roof line, which happens also to be on my eye level.

After the light pencil sketch I take up the dip pen and waterproof Indian ink and re-establish the sketch and express it with varied lines: fluid, straight, wispy, light or dark, with dots and dashes here and there. There is no need to draw everything, particularly if there is greenery, as I know that the watercolour will fill the shapes of trees or lawns, as it does in River Walk, Winchester. Once the washes have dried I make colours stronger, and shadows darker, to ensure the work has definition.

With the City of London, it was a very hot afternoon. I sat on Hungerford Bridge, which was exceptionally busy with commuters and pedestrians. This topographical view has a noticeable sense of distance from Somerset House on the left to Richard Rogers' Lloyd's Building far right so, to achieve this, I was careful to compare the scale of Waterloo Bridge against the buildings behind. Then, to balance the colours blue and green, I added warmth with the red buses on the bridge.

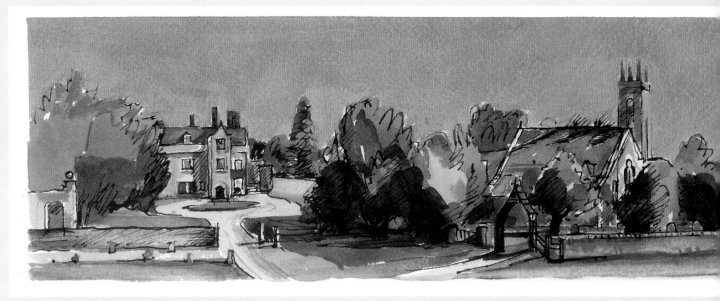

Chawton Village, 10cm × 56cm.

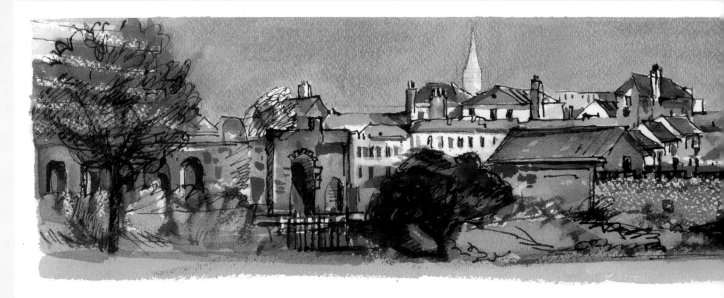

St Michael's spire, Southampton, 10cm × 56cm.

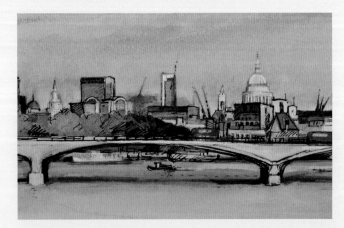

City of London, 15cm × 57cm.

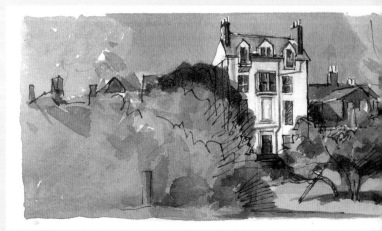

River Walk, Winchester, 10cm × 56cm.

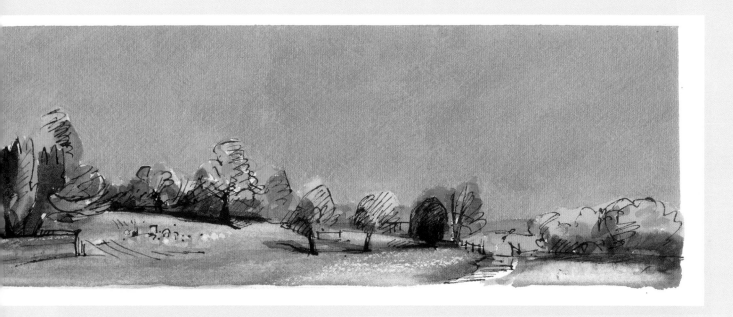

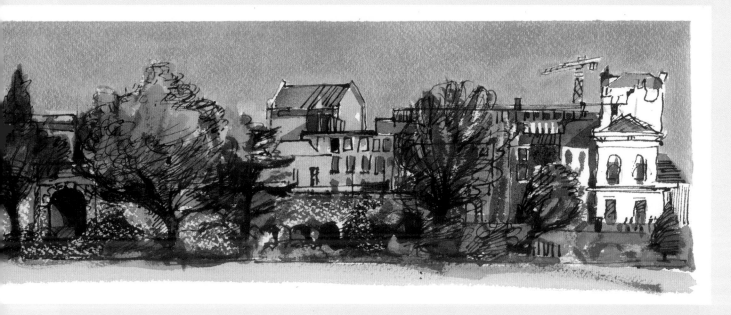

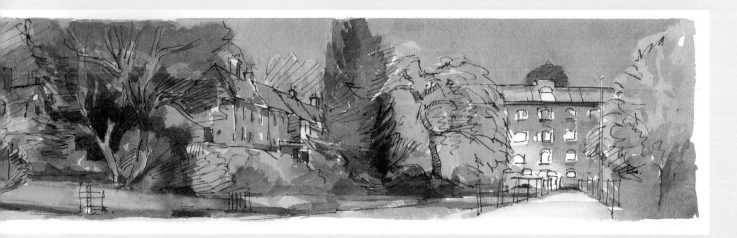

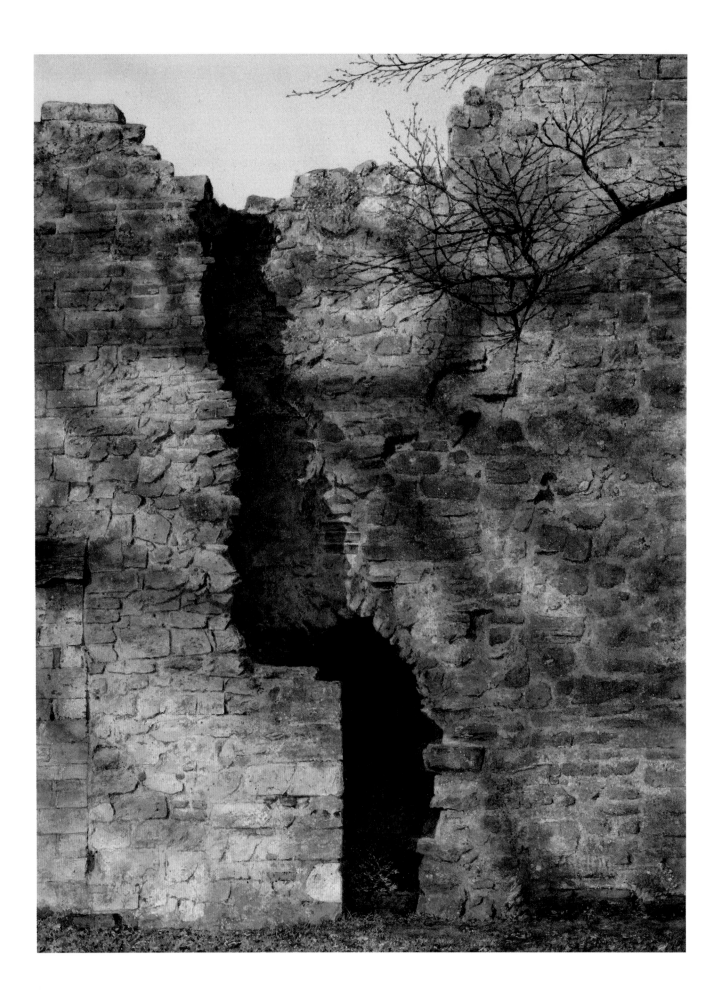

Using Colour

Drawing and colour are not separate at all; in so far as you paint, you draw. The more colour harmonizes, the more exact the drawing becomes. When the colour achieves richness, the form attains its fullness also.

Paul Cézanne

Understanding colour is fundamental to the process of architectural illustration and something that many illustrators take for granted. A good grasp of colour theory and practice can make the difference between a competent illustration and an inspirational one. The perception of colour is problematic inasmuch as we each have slightly different retinal receptors in our brains, which respond to incoming stimuli in the form of light waves. This means that the way we interpret colours is subjective and is influenced by psychological and emotional factors. It was Johannes Itten who, in his book *The Art of Color*, outlined his theories on colour composition in relation to painting. Itten was a Swiss expressionist painter, designer and teacher at the Bauhaus from 1919 to 1922 where he developed his theories on colour. Prior to this time ideas on how we see colour were very much based upon the scientific work of Isaac Newton on the colour spectrum, published in 1672. It wasn't until 1810 when the poet, playwright and novelist Johann Wolfgang von Goethe questioned the validity of Newton's ideas, that a greater understanding of the effects

of colour was achieved. However, we are thankful to Newton for the first arrangement of colours in the form of a circle so that painters and scholars could identify a primary hue and its complementary colour opposite, helping to enhance the opposite's effect through contrast. This arrangement became the standard diagram for subsequent colour systems used by most artists and designers ever since.

Without light there is no colour because it is light that transmits colour through the wavelength spectrum of violet, indigo, blue, green, yellow, orange and red. This is the 'visible light' which corresponds to a wavelength of 400 to 700 nanometers – a very small range of the electromagnetic spectrum which human eyes are sensitive to. Different colours have different wavelengths; white light is a mixture of all the colours and black is an absence of all light. Blue is on the shorter wavelength of the spectrum and red on the longer. Shorter wavelengths are scattered more efficiently than longer wavelengths which is why the sky appears blue during the daytime and, as our eyes are more sensitive to blue, blue light is received through our retinas from all directions. Different surfaces absorb and reflect light in different ways; grass and leaves appear green because these surfaces absorb all the colours of the spectrum except for green which is reflected back to our eyes. Red light is often seen at sunset and sunrise due to it having travelled a longer distance through the atmosphere, where blue and violet have been scattered, allowing the long wave colours to be more easily seen.

Part of the Abbott's house at Netley Abbey, Netley. Built close to Southampton Water by Cistercian monks, the Abbey was founded in 1238 by the Bishop of Winchester. This illustration was rendered using a wide range of colours in order to represent the various materials (stone, bricks and mortar) used in the building's construction. The shadows cast from adjacent trees help to bring out the rich, earthy colours therein. Watercolour over pencil on 140lb Saunders Waterford NOT stretched watercolour paper at 530 × 390mm. (Image courtesy of Southampton Solent University.)

Objects in the world are not really 'coloured' – they simply absorb, transmit or reflect particular wavelengths from visible light. If a collection of objects appears to us to be of different colours, this is because each object differs in the way it responds under a light source.

Johann Wolfgang von Goethe

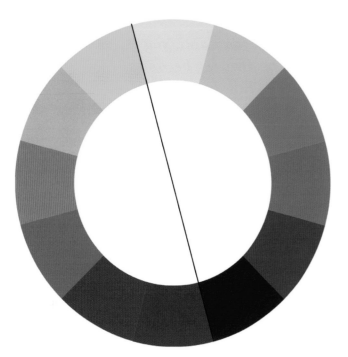

The colour wheel shown here has been divided into two halves: on the right-hand side the colours are cool; on the left, the colours are warm.

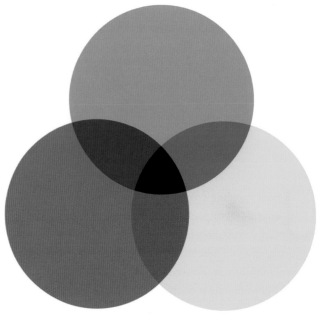

Subtractive colours are only visible when there is light and different surfaces absorb different colours. For example, a surface that is seen as green is said to absorb all other colours in the visible spectrum except green, which is reflected back to the observer's eye. The primary subtractive colours for mixing pigments (i.e. oil paint etc.) are red, yellow and blue, or in CMYK printing terms, cyan, magenta and yellow.

Itten discovered that colours had an emotional effect on our perception and experimented with the subjective feelings that are brought on by different colours. He spoke about blue being cool and red being warm and that certain colours had characteristics that would influence how the viewer felt. He discovered that colour harmony was quite individual and that subjective colours were not the same for everyone.

Pigment colour (subtractive)

Using traditional media, colour rendering is referred to as 'subtractive colour', where the three primary colours of red, yellow and blue are mixed to produce the secondary colours of purple, green and orange. Pigmented colour is best demonstrated with watercolours as these are translucent and can be overlaid to create secondary and tertiary colours. Opaque colour, such as Designers Gouache and oil paints are also subtractive but these colours need to be mixed individually. This method is also used for offset lithographic printing and is referred to as the CMYK system, meaning cyan, magenta, yellow and black (or key) which are process colours. Without black, the three colours can produce a wide range of further colours by offsetting each colour printing plate that has been exposed to a half tone mesh creating dots across the printing surface.

Colour with light (additive)

Additive colour mixing is in contrast to subtractive mixing where colour is presented to the eye by reflection rather than emission. Additive mixing is used in applications

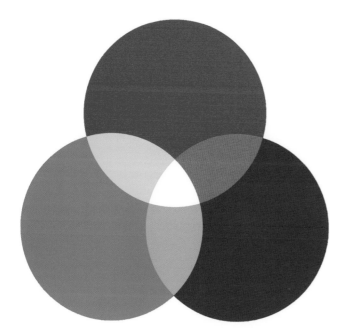

Additive colour uses light as its means of visibility; a good example of this is in stage and theatre lighting. The three primary colours are red, green and blue (RGB) and this is the standard method of colour mixing found in televisions and used in photography. When combined together, the three primaries make white.

Complementary colours react to one another and are opposite each other in the colour wheel. This reaction is more distinct with some more than others, e.g. cyan and orange, where there is a 'vibration' at the point of contact where the colours have a tendency to compete for attention.

where light is the method of projecting colour on to a surface; this can be clearly observed in stage or theatre lighting. The colours used are referred to as RGB, meaning red, green and blue which give secondary colours of cyan, magenta and yellow – the three process colours used in printing. When all three colours are overlapped white is produced. This system is used in photography and all screen-based media that deal with light, thus creating bright and vivid colour imagery. Digital imagery would normally be created in RGB and converted to CMYK for output to print if required.

Complementary colours

Complementary colours are opposite each other in the colour wheel and can be used to enhance or contrast with one another. The complementary colour of each primary – red, yellow or blue – can be obtained by mixing the two other primary colours together. Thus the complementary of red is green (yellow and blue); the complementary of blue is orange (red and yellow); and the complementary of yellow is purple (red and blue). With an object and its cast shadow, for example a cactus in a desert scene, the complementary colour to the yellow ochre of the sand would be a blue/purple for the shadow. Adding a hint of a surface's complementary colour will help to 'lift' aspects of a dull or unremarkable building featured in an illustration.

As a result of scientific colour theory development during the nineteenth century, artists began to experiment with colour giving rise to movements such as Impressionism and Post-Impressionism, which led to modern and abstract painting. Painters such as Monet and Van Gogh used complementary colour theory to great advantage in their work through the technique of dabbing brushwork onto a surface using primary and secondary colours, which, when viewed from a distance, would appear as if paint had been previously mixed on a palette. This principle of deceiving the eye through the placement of colour 'dabs' became the basis for process colour printing used today in the form of offset lithography.

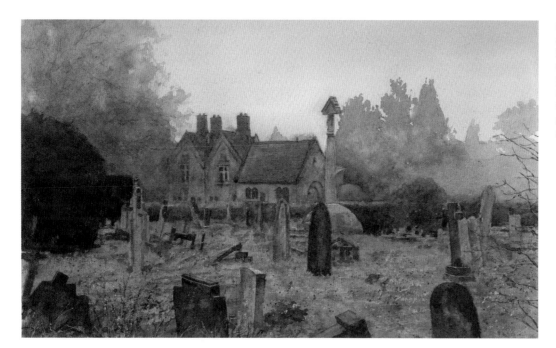

In this watercolour of a damp early morning in Southampton's Old Cemetery, the aerial perspective has subdued much of the colour and tonal contrast, giving an atmospheric quality to depth within the picture.

Aerial perspective

Sometimes referred to as atmospheric perspective, this term is used to describe the concept of how colour changes in relation to depth and recession. This can best be witnessed when looking out from a high vantage point across a land-scape vista. Colours become weaker as they recede into the distance and this is accentuated when moisture is present during early morning or late evening. This, together with dust particles, causes a scattering of light that is particularly noticeable with blue light which is on the short wavelength end of the visible spectrum. This can be seen with distant hills or mountains that tend towards a bluish haze. A general rule of thumb in picture-making is that warm colours come forward and cool colours recede and when combined with other visual effects such as softening of tones in recession and strengthening in foreground, the illusion of depth can be most convincing. The way atmosphere and recession act upon our perception of a view is also determined by our prior experiences to truly appreciate a sense of 'place' when assessing secondary representations. As mentioned earlier, colour perception is a subjective sense that is affected by cultural as well as psychological influences.

Colour theory basics

It appears that, in recent years, we have come full circle with respect to digital drawing and rendering and some clients within the architectural design industry are now looking for that 'hand-drawn' finish. This can be achieved much more easily today using software like Photoshop in which watercolour type 'brushes' can be downloaded for free. Whether using watercolour (translucent), gouache or acrylic (opaque) or digital means, there are basic skills that need to be acquired in architectural illustration. As with most skills, repetition through practice is essential and each medium has its own strengths and limitations that need mastering before more creative applications can be considered. The following exercises have been carried out using the medium of watercolour to demonstrate aspects of colour theory. Clearly, there are basic skills that are fundamental in all media applications and the reader may wish to apply the theory and practice described in this chapter to his or her preferred medium.

Laying a flat wash

Mark out several rectangles on an A3 sheet of 300gsm cold pressed NOT watercolour paper at a size of about 120 × 40mm, portrait format. Tape the paper to a drawing board on all four sides to avoid too much cockling (buckling) when wet, and prop up the far end of the board on your table, using any item (a couple of thick books will do) that will give an angle of about 15 degrees. Using a deep mixing palette, dilute either from a half-pan or tube, a small amount of the primary red watercolour to a 'milky' consistency. Take a large round wash brush (a sable no 8 or 10) and fully loaded, using horizontal strokes, work your way down from the top of one rectangle by picking up the bead of colour left after each stroke. Replenish your brush with watercolour when necessary before it starts to run

A B C

A: A flat wash is achieved by inclining the paper towards you and with horizontal strokes of the brush, allowing a bead of paint to drop down the paper surface. This can be done several times to achieve the required result.

B and C: The process of laying a graduated wash is the same as in a flat wash, but by adding a brush-load of clean water to the mix every other stroke the paint is diluted gradually until it fades to clear water. Here, the graduated blue wash has been inverted and a graduated yellow wash overlaid.

out. Finish at the bottom of the rectangle and start another rectangle, this time using a primary blue wash and the last with a primary yellow.

Laying a graduated wash

Use the same procedure as with a flat wash, but mix a smaller amount of paint to start and after two or three strokes before replenishing your brush, dip into your water pot first and then into the paint – this will dilute the mix – and continue in this way until the rectangle is filled. Once mastered, it's only a small step from the graduated wash to natural landscape and skies. Take the blue wash and turn the paper through 180°. Now choose a colour to blend from the pale end at the top to the bottom of the wash. Now you have the basis for an atmospheric sky. This kind of blending in watercolour is what really makes the medium unique.

Colour mixing

Onto your paper draw three circles, each with about a 50mm radius so that they overlap at the centre. Mix the three primary colours separately onto your palette and test the tone of each to make sure they are equal. Take each colour in turn and lay a flat wash on each complete circle, allowing each wash to dry thoroughly before moving on to the next. This should result in the three secondary colours of orange, purple and green together with a dark warm grey in the centre.

Colour mixing can be done carefully in watercolour using the primary colours of red, yellow and blue to achieve the secondary colours of orange, green and purple.

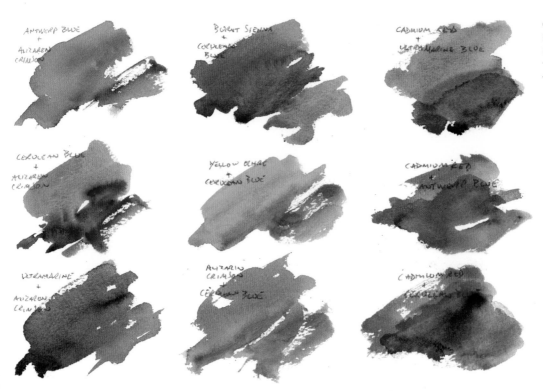

Colour experiments are important in understanding how different colours react to one another when mixed wet into wet.

Colour experiments

The most important way to understand how watercolour works is to be playful and experiment. Think about building up a colour chart with overlays of different colours, not in a random way but using the same colour with different colours and note what results you get. You can draw on this later when you are striving to render specific materials – say copper, which can be achieved by mixing a little Alizarin Crimson with Yellow Ochre. You will also learn how colours react in different quantities and observe how they behave on different paper surfaces. Watercolours are mostly made up from a dry pigment that is finely ground, with a binding agent, most commonly gum arabic, which holds the pigment in suspension. The binder also allows the pigment to adhere to the paper surface and with certain colours a granulation effect occurs when the pigment separates, giving a mottled look – this is especially noticeable on a rough surface and can be put to good effect.

Rendering 3D shapes

There are four geometrical forms that just about cover all the shapes that you are likely to come across in architecture and landscape: these are the cube, cylinder, cone and sphere. In pencil, draw each shape no larger than about 70 or 80mm in any direction and in each case include an indication of a cast shadow. Starting with the cube, mix a sufficient amount of colour to cover the whole shape; then lay a flat wash over the three sides ignoring the lines that separate each and allow to dry. Using the same mix, lay a wash over the two vertical sides, leaving the top side untouched and allow to dry. Finally, lay the same wash over one face and this time include the cast shadow. If necessary, darken the shadow side and cast shadow to suit.

Next, mix a sufficient amount of colour to cover the cylinder and position your paper so that the cylinder is horizontal to your drawing board with the underside of the cylinder at the top. Lay a flat wash as previously described over the entire shape and leave to dry. Next, draw a light pencil line on the cylinder just less than half way up and lay a flat wash to end on the line and include the cylinder end; allow to dry. Finally, draw a light pencil line about halfway along the second wash and lay a third wash including the end and the cast shadow.

Next, mix a sufficient amount of colour to cover the cone and position your paper so that the imaginary major axis (or centre line) is horizontal to your drawing board, similar to the cylinder. With the intended shadow side to the top, lay a flat wash over the entire shape and leave to dry. Next, draw a light pencil line from the point of the cone to about one third of its width at the base and lay a flat wash to this line. Finally, draw a light pencil line from the point of the cone to roughly divide the second wash in half and lay a wash including the cast shadow.

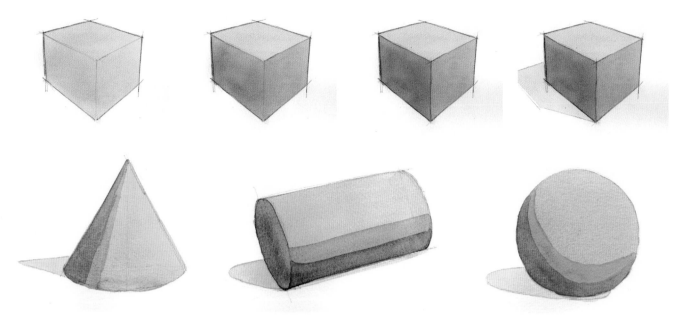

Using watercolour to render the four shapes of a cube, sphere, cylinder and cone will cover most of the 3D forms in architecture.

The last shape is the sphere, which is the most difficult. Once again, mix a sufficient amount of colour to cover the whole shape and position your paper so that the underside of the sphere is at the top. Lay a flat wash over the inside of the circle and leave to dry. Next, draw a light pencil line in a curved shape to cover about one third of the cylinder's surface; lay a flat wash to this line and leave to dry. Next, draw a light pencil line at approximately halfway between the previous curve and the edge of the sphere and lay a flat wash to this line including the cast shadow.

Once these shapes have been mastered using flat washes the reader may wish to use graduated washes, as previously outlined, in order to create a more realistic appearance to each surface. Having achieved a basic mastery in watercolour rendering it is recommended that 2D digital media is considered, which will open up a range of possibilities for exploration and experiment.

Working in Photoshop

Although this is not meant to be a digital rendering tutorial, most illustrators use Photoshop to a lesser or greater degree and in one way or another, and its important to have the basic skills. In 3D computer generated imagery (CGI), Photoshop is often used to add more personal finishing touches to the final piece of work. For basic exercises in colour practice it is ideal and can also be used extensively on other aspects as well as adjusting a finished image created in a traditional medium. There are several ways of achieving good results using Photoshop and most illustrators develop personal techniques and methods of their own. The following narrative explains how a hand-drawn image was rendered. The four shapes were drawn freehand in pencil and then traced over with a fine liner, this is better when using Photoshop, as a pen creates a solid line and a pencil doesn't, making it much easier to work with.

Step 1

The four shapes were drawn as a still life arrangement with some objects overlapping to create a pleasing composition. This was then scanned at 300dpi, a good standard resolution suitable for print or digital output, and saved as a jpeg file.

It's important to have a plan of how to deal with form and lighting before you start to render your subject matter. A rough sketch or value study is invaluable in working out the best light source and how this will affect the form and other aspects of light, shade and shadow casting. Once done, this will act as a reference and key drawing allowing one's attention to focus entirely on the rendering application. The colour palette was limited to just two main hues – one warm and one cool – which were used to mix a range of highlights, tints and shades for all the objects. Although these can be applied to surfaces in any order, as in oil or acrylic painting, the best approach is to use a white

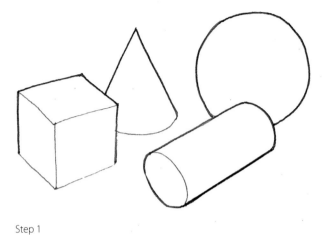

Step 1

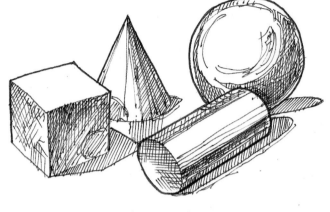

Step 2

This exercise, carried out in Photoshop, uses the same four 3D shapes used in the watercolour task but in a more sophisticated way, using primary and secondary highlights, shading and shadows.

background and work from background to foreground and from light to dark. This means that you can make better decisions affecting the form and lighting of an object, when viewed against the colour or tone behind it and not a white background.

Step 2
Once the line drawing was scanned as a jpeg file it was opened in Photoshop and the contrast was adjusted by clicking on Image, scrolling down to Adjustments and using the slider in Levels. When painting onto a line drawing it is good practice to make the background transparent so that subsequent layers can be coloured but without obliterating the lines. In this case it wasn't so important as the lines were painted over in the final image. To make the background transparent double-click on the word Background in the Layers window, which is automatically locked, and in the New Window which opens, give it a new name, for example, 'Line art'. This means that the layer is now editable. Next, create a new Layer 1 and click on the Paint Bucket Tool from the tool bar and set the foreground colour to white and fill this layer by clicking on the window. This new layer can now be moved to below the 'Line Art'

layer. Select the new Layer 1 and click on the 'eye' icon which turns off the layer visibility. Select the 'Line art' layer and open a Layer Style window by double-clicking on the 'Line art' icon. The 'Blend if' top slider can then be moved to the left until the background disappears to reveal a 'checkerboard' background. Now turn the new Layer 1 visibility back on and this will show a white background again.

Step 3
With the 'Line Art' layer selected, all the objects were masked out using the Quick Selection Tool by clicking, holding and dragging across the background until the contours of all the shapes were masked. The background was painted using the round Brush Tool at different sizes and degrees of hardness until the required effect had been achieved. Although easier to control using a drawing tablet, the entire rendering was completed using a mouse only, which is adequate for simple shapes with few textures. The surface was to be reflective and so a few suggestions of this were added, together with soft cast shadows to add to the overall effect, although at this early stage, it was kept to a minimum until all the objects had been rendered.

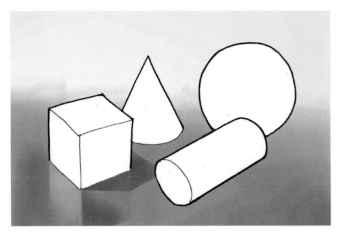

Step 3

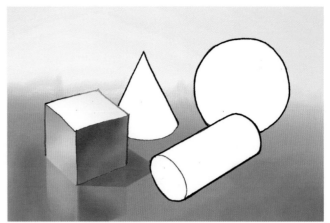

Step 4

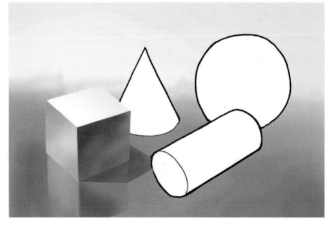

Step 5

Steps 4 and 5

Limiting the colour palette to just two hues, a warm brown and a cool blue, meant that the emphasis would be on the contrast and tonal value which, especially with architectural subject matter, is instrumental in the description of shape and form. The first object to be rendered was the cube which would help in establishing the tonal range across the whole image. This was done by using the Quick Selection Tool in the same way as previously used on the background by clicking, holding and dragging, this time across the three faces of the cube. The colour selected was a light warm tint and this was done by clicking on the Set Foreground Colour square icon at the bottom of the vertical menu bar. A window titled Colour Picker will open and the colour can be selected from the colour bar. A fairly large size Brush was used to create a flat tint with the Opacity slider set to a percentage of around 30 of the colour's intensity; this way you can always darken the tint which is easier than lightening it. Once there was an overall 'base' colour the three faces were rendered separately and in the order of top face, left face, which was to be the mid-tone, and then right face, which was to be in shade and casting a shadow from the left-hand light source. The brown and blue hues were used across both vertical faces to give interest as well as realism to the objects. The black lines around each object shape were ignored until each shape was rendered and then the lines were covered using a combination of Brush Tool and Clone Stamp Tool to colour pick or copy the colour close by, and was a combination of both sides of each line. Again, by varying the Opacity, Size and Hardness of the tool in use, the end result can be most convincing in its representation of shape and form.

Step 6

The remaining shapes were treated in the same way but, with curved surfaces, a greater brush control was applied. The easiest shape to start with is the cylinder which was brushed with consistent stroke widths, back and forth until the required effect was achieved, in this case a polished surface. One way to keep control when using the Brush Tool is by holding down the Shift key and clicking on the start

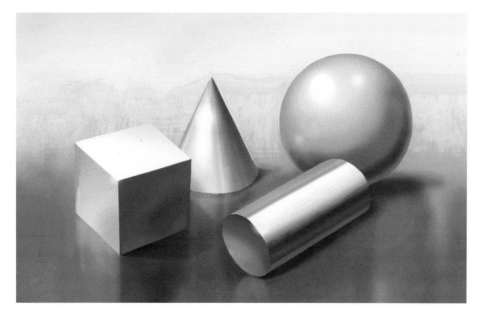

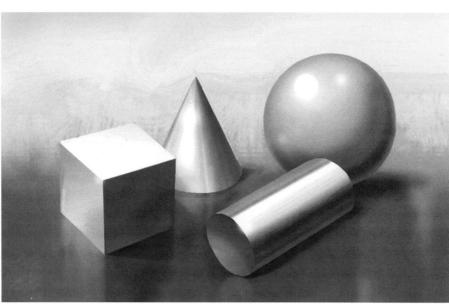

To the novice, working in colour can be overwhelming at times when dealing with light and shadows, colour tints and shades, and reflections all at the same time. Working digitally means you can check the colour palette and tonality whilst rendering, and it's a good idea to convert your image to greyscale before completion, which will help when assessing contrast.

position of the stroke and then clicking to the end point, which will give a straight line automatically. The surface shows a dark primary shadow area with a reflected highlight and secondary highlight and shadow on the opposite side. Reflected highlights are useful in representing shiny surfaces as with chrome or polished metal. The end face was treated in a similar way to that of the cube. With the cone it was necessary to paint the tints and shades from the base to the point using strokes which become finer towards the top and with this it's a matter of practice. Again, holding down the Shift key when brushing a stroke, as described above, will make this task much easier. The final shape to be rendered was the sphere and, once again, practice makes perfect – or in this case, competent. A large brush was used

to create the overall form and then smaller sizes to build up the density with each stroke and finally a large highlight with a few smaller reflections to add interest.

With much of the rendering done on all the objects it was a matter of returning to the foreground and background. Keeping the contrast and tonal values consistent across an image is central to its success and much time was spent adding reflections and shadows etc. to the foreground surface whilst still keeping to the restricted palette of two hues. The background area, where the colour changes from brown to blue, was painted using a textured brush from the Brush menu to give some interest in the change from foreground to background. Finally a few reflective 'flares' and 'haloes' were added to complete the illusion.

Location sketches of Southampton

Context

Southampton was awarded city status in February 1964 and to mark its golden jubilee, Urban Sketchers Southampton was formed in 2014. As part of the world-wide Urban Sketchers' mission to draw on location, the group soon became popular and within a year had over 200 members in its Facebook group with a nucleus of around fifteen to twenty active sketchers. The group has prospered since with a membership of over 400 at the time of writing. 'Sketchcrawls' are once a month with extra evening sessions during the summer months. With the focus on an exhibition in Southampton's City Art Gallery to celebrate fifty years of city status, there was an incentive to have as many sketches as possible included for selection by the judging panel for exhibition. The work seen here are examples produced for the show.

The process

Creating personal work is an ideal way of practising with colour when there's no client and therefore less reason to be concerned about the end result. Experimenting with new techniques can be quite stressful whilst working on a commission so keeping a sketchbook for location work can be helpful when trying out new methods. It's also valuable when applying colour from direct observation rather than from print or screen-based reference material. The examples here show how drawings made from life can be rendered using both traditional and digital means. The drawings were made using a fine liner pen in an A5 sketchbook on Canson Montval Aquarelle watercolour paper with a NOT (not hot pressed, i.e. cold pressed) surface. Working directly with a pen is a good discipline to master as it makes you look longer and harder before making a mark, as a pen line cannot be removed. The paper has a tough surface and will stand up to any amount of scratching and scrubbing during watercolour applications without losing its texture.

Each drawing was scanned at 300dpi and saved as a tiff file for top quality and then imported into Photoshop and converted to a jpeg after colouring. Once saved, the original could then be coloured with watercolours using photographic reference taken at the location. The paper will cockle slightly but without soaking the paper with very wet washes it stays fairly flat. Using a waterproof ink pen to draw with means that the lines will not move or run when washes are applied. Water-soluble ink pens can give an interesting result, however, if used cautiously and after spending time practising before using watercolour applications. Using a pen rather than pencil to draw with means that much of the detail can be indicated and will show through even the darkest of washes. This type of colouring is less painting and more 'staining' the paper, so can be kept to simple wash work and allowing the line work to show through. Before the invention of colour photography black and white photographs were hand-coloured this way using watercolours, inks and dyes depending on the paper surface. This was very popular during the mid-nineteenth century and covered a range of subject matter including portraits and landscapes. Today there is still a demand for hand colouring of antique etchings and engravings.

God's House Tower

The best way to apply colour to a drawing is by starting with the background, usually the sky, and working forward. God's House Tower, shown here, was drawn on a sunny day and cast shadows are indicated in line which makes it easier to apply washes over the top. The general colour palette used comprised Antwerp Blue for the sky and mixes of Cerulean Blue, Light Red, Yellow Ochre, Lemon Yellow, Alizarin Crimson and Neutral Tint. Using black should be avoided as it tends to dominate other colours and can look dull on the paper. Also, a mix of either Payne's Grey or Neutral Tint will produce a cool or warm shade that has a more interesting effect than black when used over other colours to represent shaded areas. The best approach to applying colour is to start by laying washes of what is to be the lightest areas of a picture, in this case the far wall with the arch below. This is lit by the strong sunlight, which casts shadows from the right-hand side of the view. Colour washes can be mixed in the palette or on the paper and usually a combination of both. The stone colour was a very pale mix of Yellow Ochre and Light Red, which was applied over all the stone faces and left to dry. Whilst one area is drying other parts can be coloured and it's a matter of keeping washes 'alive' through a combination of adding and removing colour to and from different parts of the drawing. With experience, the novice will come to know his or her

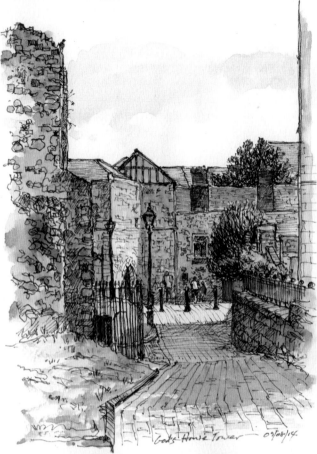

God's House Tower, Southampton. This series of step-by-steps starts with a pen sketch with watercolour and illustrates how Photoshop can be used to apply colour in very simple applications. The final view shows just colour without the line layer.

palette of colours and which ones stain the paper, and which are easier to remove. For example, Light Red is fairly easy to remove whereas Hooker's Green is very permanent. By wetting the paper with clean water and, using an older brush, colour can be removed by working over the surface and pressing hard with a tissue until the paper is back to white again. By adding and removing colour this way the picture should begin to work as a whole in consistency of tonality and colour balance. In a way, using watercolour is more akin to staining the paper than painting with brush strokes, a technique which is normally associated with oils or acrylics. Of course with an ink line drawing, it's the line that holds the work together so less work needs to be done in creating tone and contrast.

As the work gradually takes shape it's a matter of trying out colours by adding pigment, wet into wet and experimenting by introducing paint at different stages of the drying process. After paint has started to dry, the use of

dry brush techniques can add to the overall aesthetic of a picture. This is done by dragging a loaded brush across the surface so that paint misses the troughs in the paper's surface and creates a mottled effect. This is much used by watercolour artists as an effect but can be over-used and needs restraint to have an impact.

Digital rendering

Using digital means to colour a drawing offers a wide range of possibilities and, surprisingly, can be tackled in much the same way. With the line drawing scanned and saved as a 300dpi jpeg file the white background needs removing and this was done as previously described with the geometric shapes by double clicking on the layer word Background and renaming the layer 'Line art'. Next create a new layer by clicking on the paper icon at the bottom of the Layers window. The layer will appear above the 'Line art' layer and this must be dragged to be below. Now click on Set

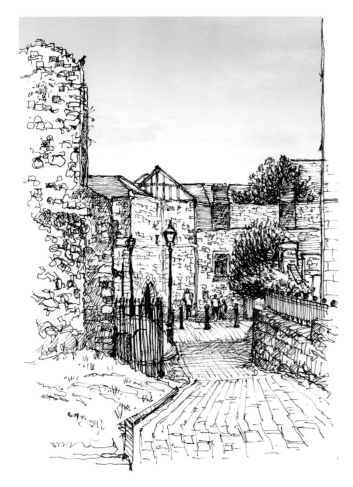

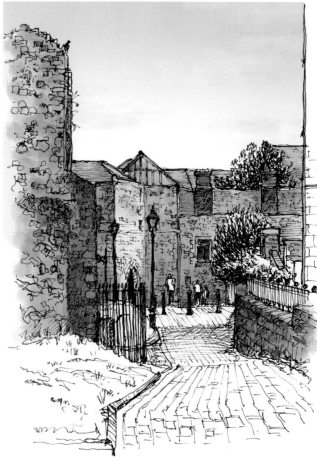

Foreground Colour in the menu toolbar and colour pick white. Next click on the Paint Bucket Tool and then click on the new layer which should be selected. Now double-click on the Line art icon and a new Layer Style window will open. Make sure the Preview window is ticked and move the top slider in the Blend if box to the left until the white background is replaced by the checkerboard or transparent background. Now it's ready for colouring. Keep adding layers for different parts of the drawing and keep the Line art at the top. This will show how the rendering layers look with the line drawing as the top layer. The colouring can be approached in the same order as with watercolour, starting with the sky. With the Line art layer selected, using the Quick Selection Tool, drag and open a 'window' which is used as a stencil to colour through. Then open a new layer and rename it 'Sky'. Click on the Brush Tool and the Set Foreground Colour to open the Colour Picker window and select a colour. Click on the Brush Preset Picker above the tool bar and select a brush size and Hardness. Now adjust the Opacity at the top of the window to the desired

percentage and painting can begin: the rest is down to individual style and personal flair. The final image shows the finished colour layer separated from the line drawing giving an indication of how lines can hold a sketch together – particularly when drawing architecture.

Bugle Street

This sketch shows a view looking down Bugle Street which is in Southampton's Old Town. The perspective gives depth to the drawing and 'pulls' the viewer into the picture starting with the end of the town houses on the left and moving down the street. The drawing was completed in ink on location and the colouring was added later in Photoshop. This has been kept quite simple as the line drawing describes each element with clarity and the tendency sometimes is to overwork digital colouring. The sky fades off into the distance which adds atmospheric perspective and depth to the drawing. The original drawing was done in an A5 sketchbook on heavyweight cartridge paper using an Edding 1880 0.3 fine line pen.

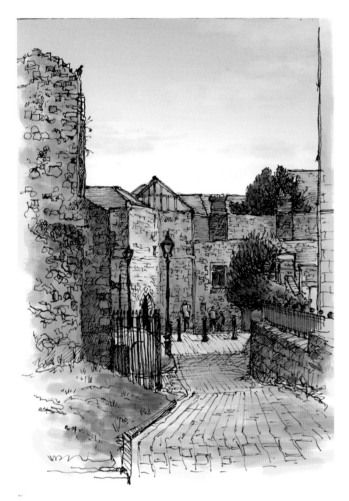

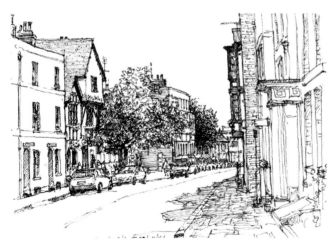

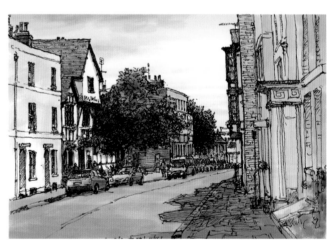

Bugle Street, Old Town Southampton from a pen sketch with added colour in Photoshop.

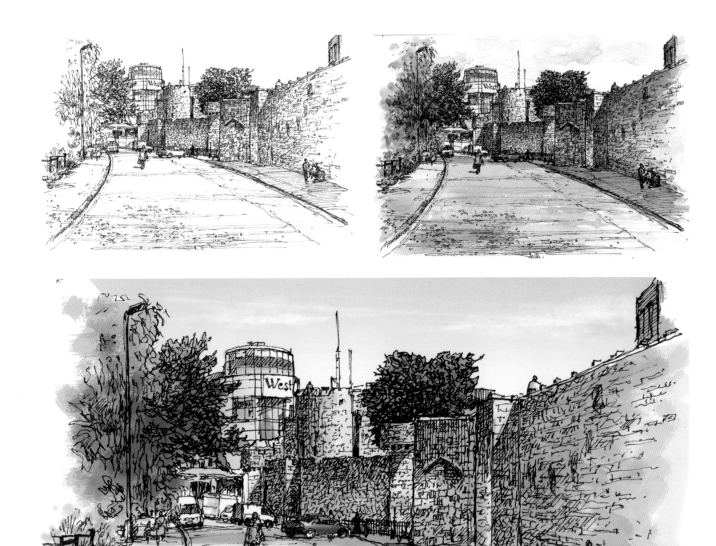

Old Town walls, Southampton, showing a pen sketch with watercolour and Photoshop rendering.

The Old Town walls

Once again, this view relies on perspective to give depth and composition to the drawing. The immense wall on the right is foreshortened dramatically as the vanishing parallels converge to a single vanishing point on the horizon. The drawings shown here are the ink line drawing completed on location and two colour versions, one in watercolour and one using Photoshop. The drawing was done in an A5 sketchbook on 90lb Canson Montval watercolour paper using an Edding 1880 0.3 fine line pen.

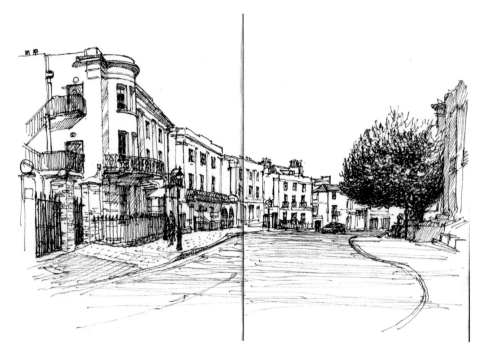

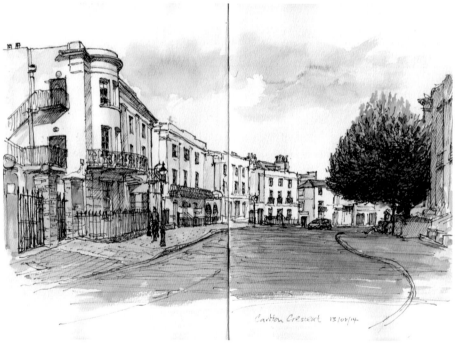

Carlton Crescent 15/04/14

Carlton Crescent

Forming part of a designated conservation area, Carlton Crescent was built in the mid-nineteenth century with elegant houses that are now mainly offices. The road curves round to the right with each building positioned at a slightly different angle as it does so. This means that each block would have a different vanishing point as the vanishing parallels of each converge to the horizon line or eye level. As a proposed development, a perspective would be time consuming to set up traditionally from a site plan and would necessitate a digital 3D model. The ink drawing was sketched on location using a 0.3 Faber-Castell PITT ink pen with watercolour applied in the studio. It was drawn across two pages of an A5 sketchbook on heavyweight cartridge paper in about an hour.

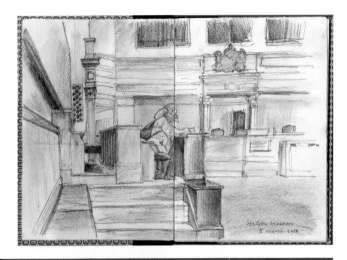

SeaCity Museum, Southampton, showing the location pencil drawing and the later version with added watercolour.

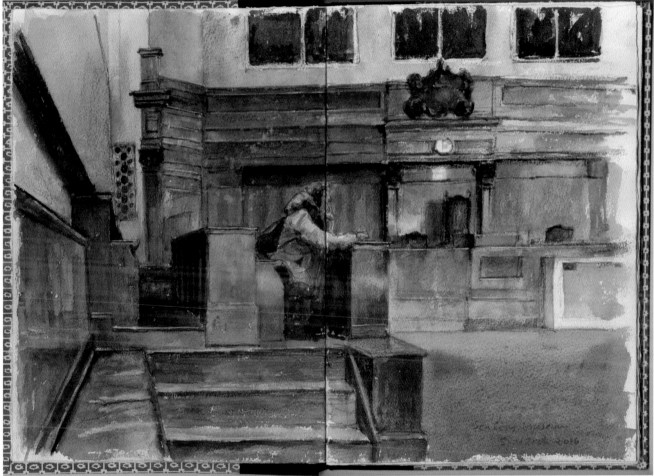

SeaCity Museum

The SeaCity Museum was opened on 10 April 2012 to mark the centenary of the *Titanic*'s ill-fated departure from the city. This drawing was done in the original courtroom which is reconstructed in the museum and used to recreate the London Court of Inquiry which was held into the disaster. The sketch was done, in somewhat gloomy lighting,

using a 2B pencil in an A4 sketchbook over two pages of Arches 90lb NOT watercolour paper in just over an hour. The colour was applied in the studio using reference photographs taken on the day. The colour palette mainly consists of Burnt Sienna, Alizarin Crimson, French Ultramarine and Payne's Grey with a little Yellow Ochre for the lighter parts of the polished wood.

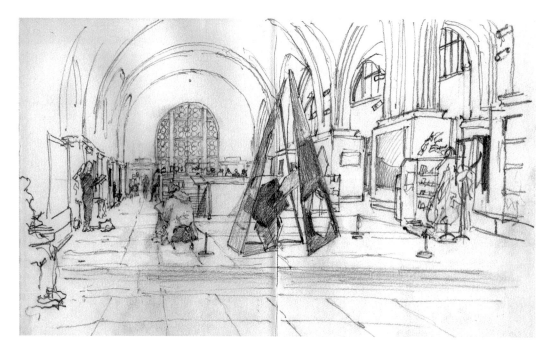

Southampton City Art Gallery, showing the pencil and watercolour sketch done on location in around two hours in an A4 sketchbook.

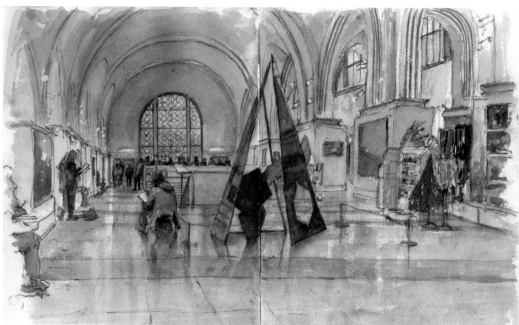

Southampton City Art Gallery

The City Art Gallery in Southampton was opened in 1939 and built as part of the Civic Centre complex which houses the Guildhall and library. The sketch shows a view on the first floor of the building looking towards the gallery window on the north elevation. The huge arches were a challenge to draw in proportion and accurately but worth the effort in the colour version where the surface reflections and lighting add to the overall representation. As the central feature, where the eye is naturally drawn to, the window was an important element in creating a contrast with the outside light. Once this was achieved it set the tonal range for the rest of the interior. The sketch was drawn and watercoloured on location on Arches 90lb NOT surface paper in an A4 sketchbook in pencil across two pages in just over an hour and a half.

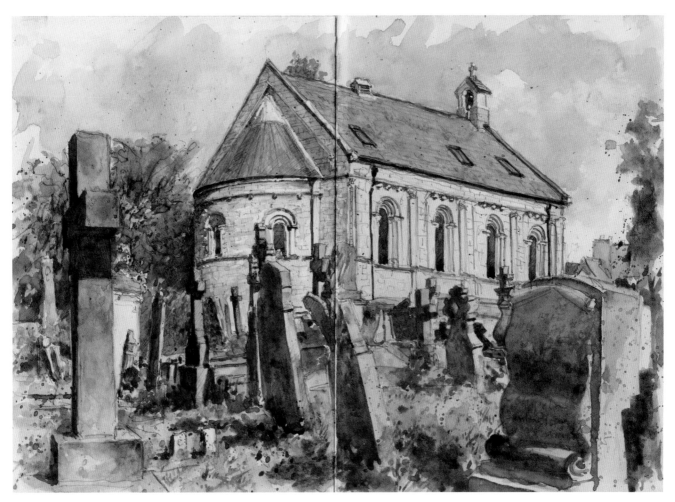

The Chapel, Old Cemetery, Southampton, completed in pencil on location and colour added later – from inside the chapel!

The Chapel, Old Cemetery, Southampton Common

Southampton Old Cemetery dates back to 1846 and contains three chapels: the one seen here, which is the Church of England chapel built in the Norman style; a non-conformist chapel built in the Gothic style; and a Jewish chapel built in the Elizabethan style. The Church of England chapel is used as studio and office space for a number of businesses, one of which is the author's, providing suitable accommodation for over ten years. The view seen here shows the east round or apsidal-end and the bellcote on the ridge of the west end. The drawing was done on a hot summer day, hence the strong sunlight and cast shadows. The slate roof colours change from a pale blue grey to purple and yellow ochre, each helping to portray an aging and weathered look against an Antwerp Blue sky. Warm and cool hues have been used to represent the lichen- and algae-covered headstones, which have settled over time at a variety of angles.

The drawing was done in pencil on location in around an hour and a quarter with watercolour added afterwards in the welcome cool inside the chapel! It was across two pages on heavyweight cartridge paper in an A5 sketchbook.

River Neckinger

This piece was done from a photograph taken from Jamaica Road in Bermondsey after visiting the Design Museum at Shad Thames. The River Neckinger only appears at this point as it rises from a subterranean route that starts at Southwark and enters the River Thames here at St Saviour's Dock. Although a rather forgotten and gloomy part of London, this view lends itself to the very loose and free watercolour technique of flooding areas of the picture with wet-into-wet colour applications. By first wetting the entire paper surface, colour can be introduced at varying times as each area of the paper starts to dry. This encourages the paint to bleed across from one area into

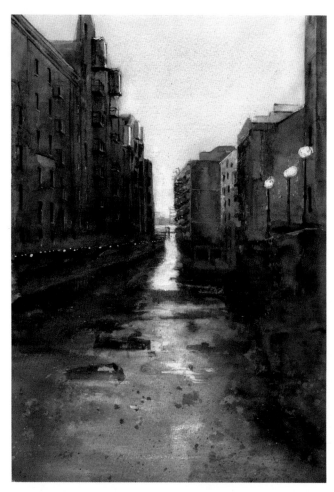

River Neckinger from Jamaica Road was an experiment in applying watercolour using the technique known as 'wet-into-wet' allowing colours to mix and blend on the paper. Artwork size: 430 × 300mm on stretched 140lb Arches NOT watercolour paper.

WATERCOLOUR PAPERS AND STRETCHING

Most papers these days are made from cotton rather than wood pulp because it will not discolour and is archival, in other words it will stand the test of time as with oil canvases. The surface is sized with a gelatin liquid so that water will not be completely absorbed like blotting paper. This allows watercolour to dry partly on the surface depending on how heavy the sizing is; a heavy size will repel more water than a light size. This will affect the drying time and the permanence of a colour wash and how easy it is to lift from the surface once dry. Different makes vary in how much size is applied during manufacture and this affects the way paint will behave depending on the surface texture and paper thickness.

Watercolour paper comes in three types: Hot Pressed (HP), which has a smooth surface where the fibres have been heavily compressed; Cold Pressed or NOT (Not hot pressed), which has a medium pressed surface; and Rough, which has a loosely compressed surface. Most papers come in 22 × 30-inch sheets and three main weights: 90lb (or 190gsm); 140lb (or 300gsm) and 300lb (or 638gsm). This means that a 90lb paper has been compressed by 90lbs per ream or 190 grams per square metre. A large sheet of 90lb paper would need to be stretched before laying washes on, especially if the intension was to work very wet. A 140lb paper can be stretched if preferred, but even when working with copious amounts of water, as long as it's taped to a stiff board, will stay fairly flat and once dry will flatten out completely. A 300lb sheet will not buckle at all but is very thick and takes a lot of water to work with successfully; it is also very expensive.

Some illustrators avoid stretching paper as soaking in water can remove some of the gelatin size but, with care this shouldn't happen, and in any case the paper can get just as wet during the painting process.

When stretching paper it's very important to be organized with everything laid out to hand to avoid mistakes and the paper not stretching correctly. Getting hold of the best quality gummed paper is essential for success and it's worth enquiring at a local picture framers for this if possible. The most suitable width is 48mm which will suit most paper sizes. Cut these to size so that they overlap at each corner when applied to all four sides of the paper and have these ready to stick down when the paper has been soaked.

Most papers will need soaking for about five to ten minutes in a bath or suitable container so that the paper can lie

another, giving a background to work on in more detail once the surface is dry. Although this technique can be 'hit-or-miss' on occasions the rewards can be worth the effort, giving atmosphere and mystery to the picture, often with surprising results. The paper needs to be kept damp in order to explore this way of working and to do this a small garden sprayer is very useful and won't affect the dry areas of the work. After laying a graduated wash for the sky using a mix of Ultramarine and Alizarin Crimson, the picture was turned upside down and the same method was applied using Yellow Ochre. This made the distant view of the Thames the lightest area and a focal point of the picture. Next, the left side buildings were treated with a wet-into-wet application of Burnt Sienna, Yellow Ochre and Ultramarine, as was the right side with the addition of Light Red and Lemon Yellow for the foliage at the bottom. The river itself used a combination of the previous colours with a touch of gouache Permanent White for the highlights.

flat. Then drain off the excess water by holding one corner until it just drips. Lay the paper on a suitable plywood or block board of about 10 or 15mm thickness and using kitchen roll or towel, dry around the edges of the paper to a width of about 30mm – this will stop the gum strip from lifting whilst in place if the gum becomes too diluted. Finally, wet each of the four pieces of gum strip by soaking a sponge in cold water and holding it against the surface of a drainer and gently pulling the gum strip through, making sure it is thoroughly wet, without too much pressure, which might remove some of the gum. Lay strips on all four sides with about half the width on the board and half on the paper. Position the board on a flat horizontal surface to ensure even drying, which will take three or four hours depending on paper thickness and room temperature. Once dry it should be 'as tight as a drum' and will stay that way throughout the painting, no matter how much water is applied.

ARTIST PROFILE

Keith Hornblower

Keith Hornblower lives and works in his town of birth, Hitchin, Hertfordshire. He followed a rather tortuous path to becoming an architectural illustrator, via mapping, civil and structural engineering and then architecture, qualified in none of the above. He has been an illustrator for 27 years with a wide-ranging portfolio of work and is now in demand as a tutor/demonstrator in the art of watercolour.

Painting and drawing have been my passion since childhood and all my early jobs had a graphic element to them. As a structural engineering technician, I was detailing reinforced concrete and structural steelwork: very technical and hardly artistically creative, but my drawings were the BEST.

I then jumped the great divide into architecture where my creativity could be put to the test, but it was only when we had a visit from Don Coe, also featured in this book,

A conceptual illustration of a hotel interior. Interiors are particularly challenging, as the light sources can be many and varied.

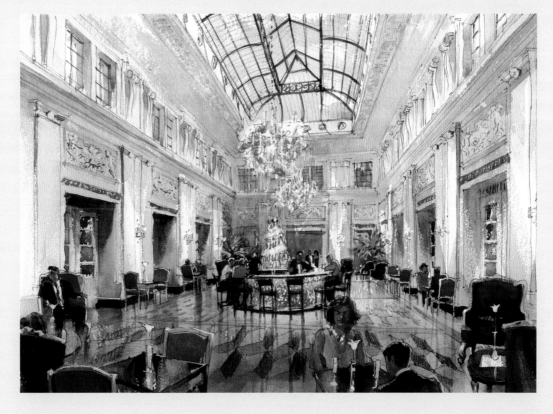

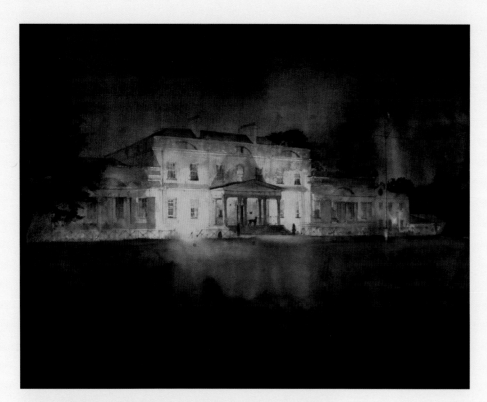

A private commission. The house owner wanted to see his dog standing at the entrance; this proved to be the biggest challenge as the dog was large and very, very boisterous – and not particularly inclined to pose for me.

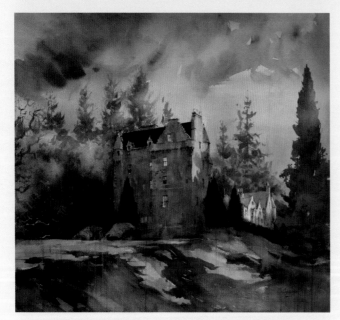

Castle Leod, Scotland, commissioned by the Dalmore distillery for use on the packaging for a limited edition whisky. When I saw the castle, it was a bright, sunny day, the daffodils were in bloom and lawns were neatly trimmed. I had to add the atmosphere!

that I even considered illustration as a viable way to make a living. Don rode up on his motorcycle, sat down with a small watercolour box, a pen and an A4 watercolour pad and proceeded to dash off six superb line and wash sketches of our scheme at lightning speed. He collected his cheque – a substantial amount – and roared off to his next session. It was a revelation. Fortunately for me, the architect realized that another couple of views would have been useful and I bravely volunteered to do them, in Don's style. Sorry, Don.

So that was the start of it. It was the late 1980s, the recession was taking hold, but I decided to strike out on my own any way.

My early illustrations were done by eye, as I still do today for conceptual work – it's a good discipline. I then learned the theory of one-, two- and three-point perspective from books and set up my perspectives by hand as everyone did in those days. Now, I use Sketchup to produce a basic digital model from which I produce a pencil outline drawing by tracing over the chosen model view, adding all the detail from the architect's drawings plus planting, people, etc.

Colour work is the biggest challenge, the set-up and outline being a largely mechanical process requiring little artistic input. It's all too easy to resort to 'colouring-in' with flat washes, but the result can be dull, flat and uninspiring, so I try to approach it with a little flair, mixing colours on the paper, using wet-in-wet as well as dry-brush and spatter techniques. I like to see lost and found edges to add a little mystery and fire up the imagination. Playing cool colours against warm, light against dark, opposites create interest – Yin and Yang. Watercolour is my medium of choice, in common with most other illustrators. It's fast, convenient,

easily handled and the originals can be rolled up and posted easily in a cardboard tube. I can also work on site or in the client's offices with a minimum of kit.

My ideal illustration is something you'd ultimately like to hang on the wall and nothing pleases me more than when the client requests the original painting, as renderings these days are usually delivered only as a jpeg. This leaves me with a mountain of old watercolours, which I gather up periodically and destroy. They've served their purpose.

I take my inspiration from the great illustrators of the past, and in particular William Walcot. I also study the work of watercolour masters including John Singer Sargent, Turner (of course), Arthur Melville and, more recently, Alvaro Castagnet for his raw passion and Joseph Zbukvic for his sublime command of tonal values, to name but a few. I have shelves full of artists' monographs, which I still thumb through occasionally when I think things are getting a little stale.

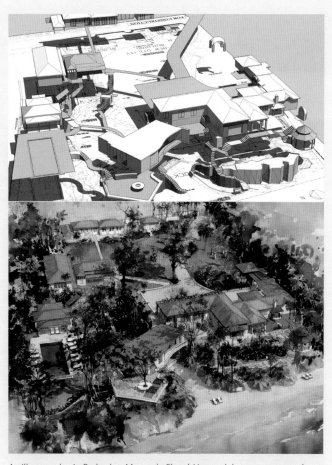

A villa complex in Barbados. My crude SketchUp model was constructed from a site plan with the help of videos taken on site.

Yas Island Golf Club, Abu Dhabi. A concept sketch which, I'm pleased to say, bears close resemblance to the finished development.

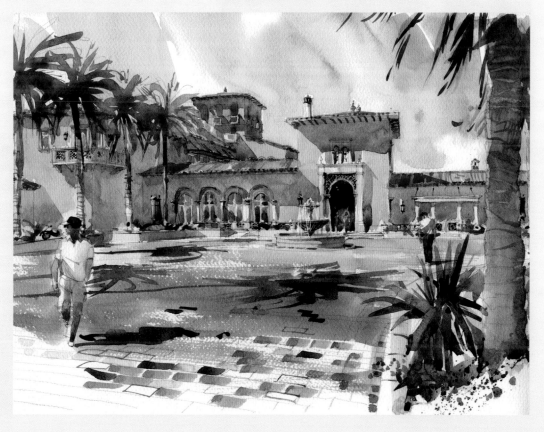

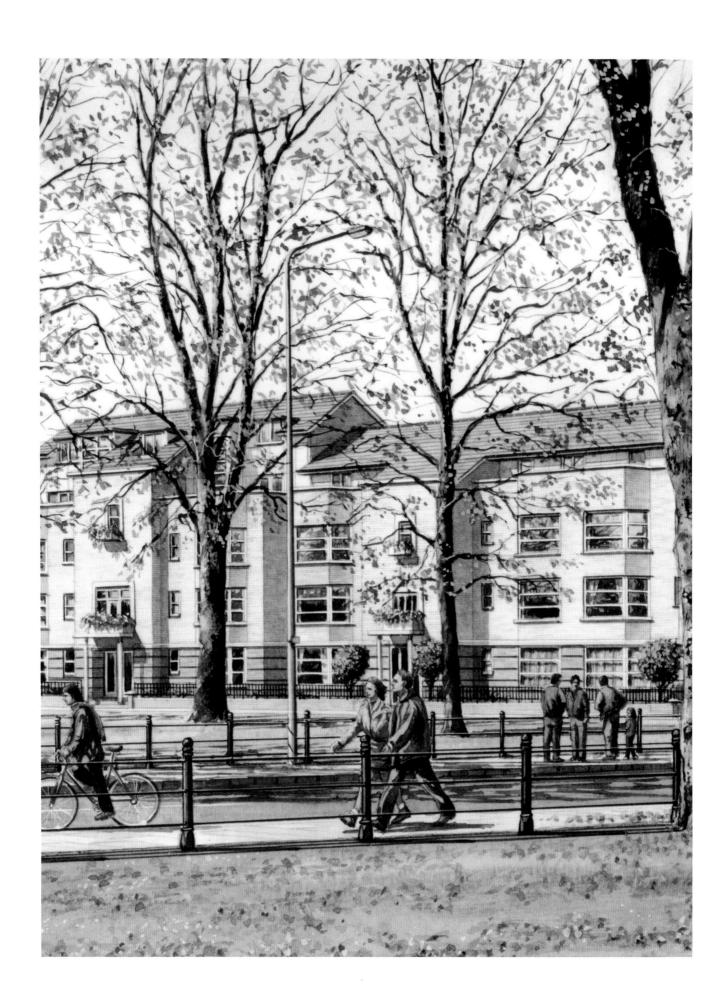

CHAPTER 5

The Street View

Perspective is nothing else than seeing a place behind a pane of glass, quite transparent, on the surface of which the objects behind the glass are to be drawn.

Leonardo da Vinci

In this quotation, Leonardo da Vinci (1452–1519) summarizes the theory of perspective drawing in just one sentence. At a time when there was a resurgence of interest in all forms of art and, particularly, in the art of classical antiquity in Athens and Rome, many scholars published treatises on the subject of linear perspective. In Western Europe, it was Brunelleschi (1387–1446) who was, above all, responsible for the rediscovery of perspective, the laws of which had been lost throughout the Middle Ages. It is clear from evidence that only the Greeks and Romans had understood how to represent three dimensions both in sculpture and on a two-dimensional surface. From this time until the start of the Renaissance, evidence of perspective in art is rare and it wasn't until the early medieval period with the likes of Giotto (1266–1337) that artists began to understand how to represent depth and recession in a painting.

In modern times, artists and draughtsmen have developed different ways to simplify how to depict perspective through various mechanical means, grids and charts. The camera lucida is an optical device that was patented in 1807, the theory of which is based on looking with one eye through a half-silvered mirror reflecting an image from in front of the artist to a base-board under the mirror. David Hockney popularized this a few years ago when he did some research into artists such as Ingres (1780–1867),

offering evidence that pointed to its use in painting at that time. Up until the early 1990s perspective grids and charts were in common use by commercial illustrators and it wasn't until the advent of computer modelling that those uninitiated in the subject could create the most complex of shapes in 3D. Another way of creating perspective drawings of buildings was to cut out the orthographic drawings, paste these onto card to make a 3D model and take a series of photographs to trace from. However, it's the perspective drawing that offers the most flexibility and, in the right hands, is still a viable method today particularly with small- to medium-sized projects.

SETTING UP A PERSPECTIVE

A traditional method

When working traditionally, the first step in setting up a perspective is to locate a viewpoint or station point on the site plan. At this stage the first decision to make is the maximum angle of the field of view, otherwise referred to as the cone of vision, and this will depend on several factors. On an exterior view, an angle of between 30° and 55° should be used to encompass the lateral extent of elements from the site plan. An angle of less than 30° will give a rather 'flat' view without enough perspective, and a larger angle will be distorted. On an interior view this is likely to be at around 50° to 60° giving a more realistic feel to the drawing. The most convenient way to do this is to use an adjustable

Enlarged detail of a street view showing the proposed redevelopment of a postal sorting office in Cambridge (*see* Chapter 3).

set-square at the desired setting, placed on the plan to enclose the required extent of the drawing. The position of the viewpoint (or station point) can then be located and marked. Where the intent is to prepare a standing eye-level perspective this is straightforward; however, if an aerial view is proposed then the height above ground should be considered in order to avoid periphery distortion. The angle should now be divided in half with a line of sight and the picture plane (PP) drawn at 90° to this at a convenient position on the plan. The angle of the majority of buildings on the site plan can be measured off to the right and left when projected from the PP, which should together add up to 90°. The next stage is to mark the eye level onto the elevation drawings and prepare to start the set-up for a perspective drawing.

There are two main methods for setting up a perspective drawing: by projection or by using measuring points. Both methods require a solid understanding of geometry and perspective theory and accurate drawing skills, with the former needing a more structured approach and a large drawing board or desk to work on; the latter needs less space and can be drawn at a convenient size to suit available working space. In addition to this you may be working with large-scale plans and elevations that need to be laid out for study and examination, the size of which will depend on the project. For demonstration purposes, the measuring point method is used here to explain the construction of two fairly straightforward and modest-sized commercial projects using one- and two-point perspective construction.

Using one-point perspective

This drawing of a large detached house was set up using one-point perspective, sometimes referred to as parallel perspective, when the elevation of a building is parallel to the picture plane (see Chapter 2). The site plan shows the footprint of the proposed house and garage in the context of its land boundaries. The client specified a viewpoint from the road and looking over the hedging to the front boundary. This meant that the eye level needed to be raised to be able to view as much of the ground-floor window bays as possible whilst still retaining a plausible view of the entrance drive.

The majority of calculations were done on the site plan and the basic set-up (in red) shows the picture plane and the line of sight which is perpendicular to the front elevation and positioned opposite the path between the house and garage. A well-balanced composition, using a single-point perspective view, can best be achieved by off-setting the viewing position in order to create a more interesting picture. As discussed earlier (see Chapter 3), it's best to avoid symmetry in an illustration, as this will often produce a dull end result. In this instance, the vanishing point is just left of centre, which also helps to define the building's shape. The next stage is to enclose the two buildings within an approximate angle of 45° to 50° with equal angles either side of the line of sight (in blue). In doing this the viewpoint should be located somewhere on the line of sight. In this case the right-hand angle doesn't quite enclose the building but falls within acceptable limits for this drawing. If the building had a tall tower feature or raised roof height on the right-hand side, then this would not have worked and a two-point set-up might have been necessary.

The next stage is to decide on the height of the eye level, normally between 1.5 and 2 metres if standing on flat ground. In this example, however, the eye level was raised to approximately 4 metres to take into account the height of the front boundary hedge, which was to be around 2 metres. It was important to show as much of the ground floor bays as possible without raising the height too much and a quick way to ascertain what the eye level should be is shown on the site plan (in green). Working on top of the site plan (but in elevation), draw a horizontal line, to no particular length, from the viewpoint (or station point), to the right of the line of sight – this will represent the height of the eye. Now draw a horizontal line on or close to the boundary line marked on the plan, to the scale length of 2 metres – this represents the height of the hedge. Finally, measure to scale the height from the ground which will represent the extent to which the building will be seen over the hedge (this was just under 1 metre from ground level). Now join this point to the height of the hedge and project this to the horizontal line representing the height of the eye. This can now be used to measure the eye level on the perspective drawing. A way to think about this is to imagine the height of the eye level, the hedge and the height on the building in plan, all swung by 90° to the horizontal. This measurement was then transferred to the architect's orthographic drawings and the front elevation used to set up the perspective view. It was also useful to mark the position of the line of sight in order to establish a starting point for the perspective.

Now all the information can be transferred to the perspective drawing at a convenient scale – this drawing was made to the scale of 1:100 but other scales can work too, depending on the size of the buildings involved – although 1:200 can be too small to draw very much detail. The first

The site layout for this detached house and garage shows the position of the viewpoint and the line of sight and vanishing point (in red) looking between the two buildings. The eye level is raised slightly to see more of the ground floor bays and front door.

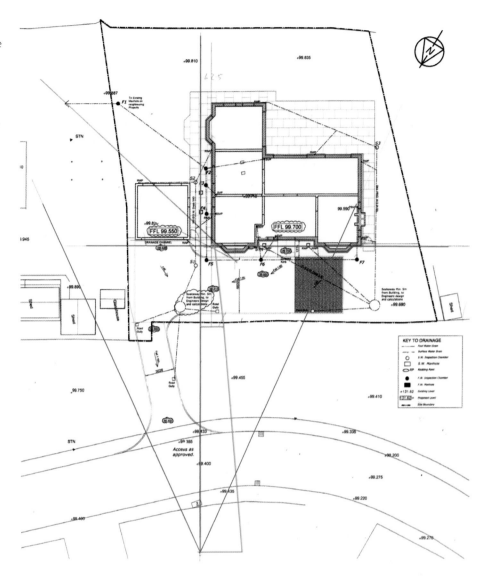

Front elevation showing the position of the centre of vision, vanishing point and raised eye level.

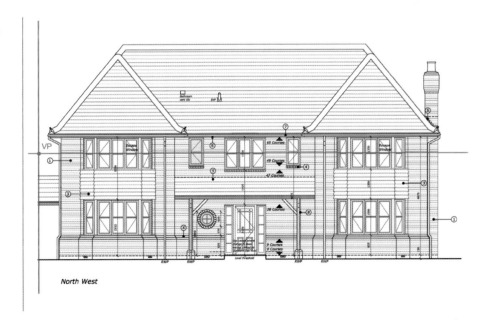

North West

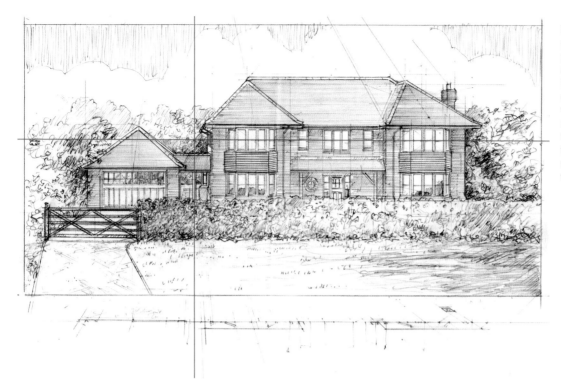

line to draw is the eye level (or horizon line) which should be positioned in the top half of the paper to allow for drawing the plan in the lower half. Notice the position of the eye level shown in its raised position drawn through the middle of the upper floor windows. Next a vertical line was drawn to intersect the eye level to the left-hand side representing the centre of vision and vanishing point for all the lines and surfaces which are parallel to the line of sight and perpendicular to the picture plane. Finally, two points are needed to scale off the depth measurements, one each side of the line of sight, and these are located by simply taking two 45° lines from the viewpoint and marking the points where they intersect the eye level. These measuring points, sometimes referred to as 'distance points', are also the vanishing points of diagonals within squares which are parallel to the picture plane and this forms the basis of the theory behind this method of construction.

Because the eye level is positioned on the picture plane (in plan) it means that where this is placed, all the measurements are true lengths and can be taken directly from the elevation drawing. In this case, the picture plane has been positioned on the walls of the two projecting gables for ease of construction and projection back and forth from the vanishing point. The picture plane can be positioned anywhere convenient depending on the building type and design.

As can be seen from the pencil draft, a horizontal line was dropped down to clear the perspective construction and provide more accuracy to measurements.

All the measurements can be drawn here in plan and projected up to the perspective drawing to make this procedure much easier. There are numerous shortcuts and ways to reduce time and effort in this, and much of the latter work was added freehand. A good knowledge of the size and type of building materials used in modern architecture will also speed things up so there is less need for recourse to reference material.

Applying colour

Once the pencil drawing has been approved by the client, the details can be added ready for colour work. It's important to keep to the right scale and proportion when adding architectural detailing and this will affect the size that the drawing is to be coloured. With a single house type the scale can be quite large making it easy to count roof tiles and bricks to the correct number. With larger drawings of, say, a street view of several buildings, this would require just a suggestion of individual materials' size and proportion. It's always best to request from the client a schedule of external materials and colours and the product manufacturers used. This will ensure that the illustration will represent the architect's intent regarding style and

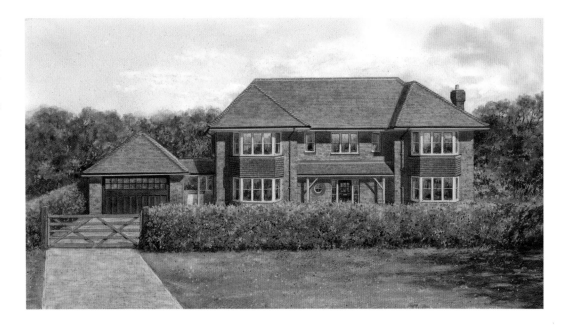

The finished watercolour illustration. The shadows were cast from right to left indicating trees just out of frame and to help balance the composition with the field gate and drive on the left-hand side.

materials, especially if it has had local authority approval to blend with existing buildings within the vicinity. In this example the house was designed to be a classic 1930s style with plain clay roof tiles and tile hanging to the front bays.

In order to take the drawing through to colour the image will need to be drawn onto a suitable surface and at a suitable size. This was done using a light box and tracing the drawing onto watercolour paper. Most light boxes have powerful enough lights to see through papers up to 140lb (300gsm) and this is a convenient and efficient method. Once the finished drawing has been traced through it can be spray mounted (using a spray booth) onto a thin card or, with heavier weight papers, just taped round the edges onto a portable drawing board; this works almost as well as stretching, which is time-consuming). In this case a 90lb NOT surface Canson paper was used which is ideal for commercial work, as the surface will hold up even when subjected to the most rugged treatment. It's a fact of life that most jobs require some form of amendment at the end and this will stand up to the hardest eraser with little effect. This, together with judicious use of Photoshop, means that most illustrations, even when subject to extensive amendments, can be salvaged in one way or another.

When planning the application of watercolour it's always best to start with the sky and work forward to the foreground. This means that a wash of paint is always applied against the colour behind and can be judged more easily in terms of hue, tone and contrast. There will, of course, always be the need for correction later, but it helps to structure how paint is applied, with each translucent wash adding to the colour beneath. Watercolour can be applied in two ways: mixing the desired colour in a palette, and mixing separate colours on the paper. In practice, this will occur simultaneously once a level of competence has been achieved. With the front elevation facing southeast, the cast shadows were projected from the right to left across the façade, helping to describe the projecting gable ends and the porch roof.

The range of colours used were: Antwerp Blue, Cobalt Blue and Neutral Tint for the sky; Light Red and Cerulean Blue for the roof tiles and facing bricks, with a little Indian Red added to the tile hanging on the bays; Yellow Ochre for the window frames and fascias; Lemon Yellow, Ultramarine, Burnt Sienna and a little Payne's Grey for much of the foliage and landscaping; and Alizarin Crimson with Ultramarine and touches of Burnt Sienna for the entrance driveway. The finishing touches on the trees and hedge were highlighted with Permanent White gouache mixed with some of the watercolours. Brushes used were Rosemary and Co sizes 2, 6, 8 and 10; Caran d'Ache black and white water-soluble pencils were used for final touches.

Beginning with the sky, plain water was first washed over the area with a large wash brush carefully avoiding too much seepage over the roof. Then the blue was washed in using a medium-strength mix of Antwerp Blue and Cobalt Blue. A few clouds were then indicated by dabbing the surface with a tissue whilst still wet and adding a wash of neutral tint to these and to the dark clouds on the right-hand side. Once this was dry, the line of trees on both sides of the house were added with strong washes of Lemon

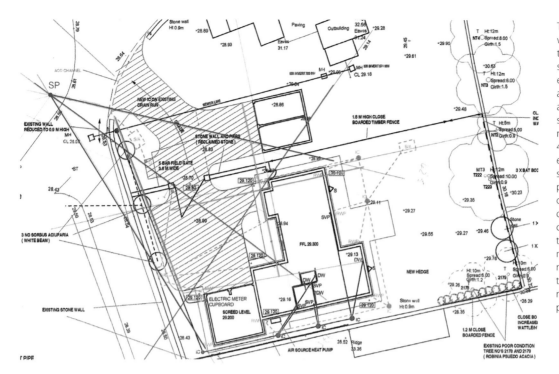

The angle of view (in blue) was measured at 45° from the viewpoint and can be seen on the site plan to enclose the entire house and garage. This allows for additional features either side to be shown without noticeable distortion. The 45° angle is divided in equal parts by the line of sight to which the picture plane is drawn at 90° at a convenient position, in this case touching the left-hand corner of the house. At this point true height measurements could be made. The two angles of the building (in green) were measured from the picture plane (in red).

Yellow, Cerulean Blue and Yellow Ochre, blending and mixing whilst still wet. The use of a gardening plastic water spray bottle can be useful here in keeping the paper wet whilst introducing colour washes. By selecting the area for dampening and masking out the rest of the drawing, a fine spray of water can help to keep the paper wet, allowing for the introduction of colour washes.

Once the background was complete, the next stage was to move forward to the main roofs, the facing bricks, tile hanging on the bays and lower roofs, before tackling the windows and doors and the small area of drive in front of the garage. Finally, the hedge, field gate and foreground were washed in with indications of light and shade where appropriate. The main shadow to the right foreground was a useful device in suggesting trees just outside of the field of view and helped to balance the darker area to the left side of the garage and its black door. A few 'spatters' of paint and selective use of body colour for lights and darks completes the illustration.

Using two-point perspective

The example shown here is of a proposed detached house sited within a plot bordered by existing stone walling on three sides. The client wished to see a view looking across the boundary wall and through the entrance giving a three-quarter view into the parking area. As with the one-point perspective example shown previously, the cone of vision enclosing the buildings should be around 45° depending on the type and number of buildings. In this case the double garage to the left was not part of the property and was not considered in the set-up although needed to be shown for reasons of accuracy. A line of sight was then drawn from the viewpoint to bisect the 45° angle and another line drawn at right angles to this at a convenient position to meet a point on the plan – in this case the left-hand corner of the projecting gable. This would now be the picture plane (PP) to which any point on or projected to, could be measured directly as a true-length line. The distance from the PP to the viewpoint or station point (SP) was taken and both measurements transferred to the perspective set-up.

Once again the eye-level needed to be raised slightly in order to view the house and garage doors over the walls and this worked out, using the same method as with the previous one-point example, to be just under 3 metres high. This measurement was applied to the perspective set-up by dropping a horizontal line, or ground line, below the eye level together with an auxiliary ground line below that for clarity of measuring. Next, the two angles of the building in plan against the picture plane were measured and marked from the horizontal either side of the station point. Two lines were extended from these to the eye level to locate both vanishing points and the measuring points were found by taking the distance from VP1 and VP2 to

NOTE : DRAWING TO READ
IN CONJUNCTION WITH
STRUCTURAL ENGINEERS
CALCULATIONS

Front and side elevations showing eye level and vertical true height line (in red).

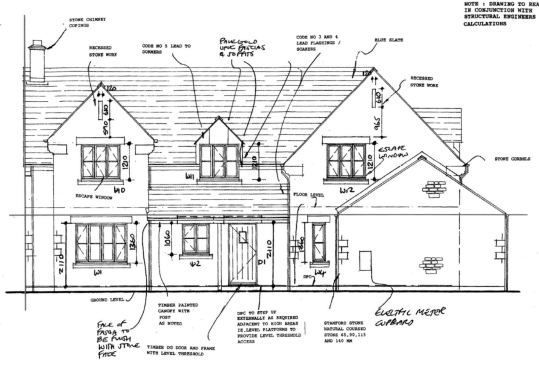

IN CONJUNCTION WITH
STRUCTURAL ENGINEERS
CALCULATIONS

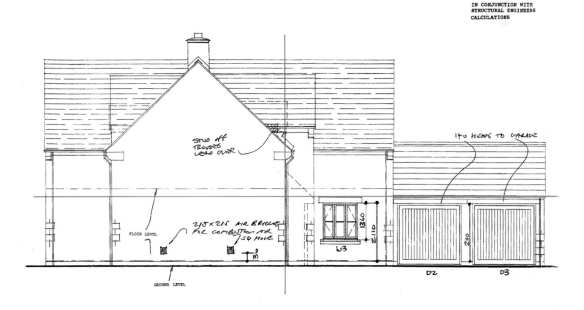

the SP and marking each point on the eye level. The floor plan was then plotted either side of the true height line where it touches the auxiliary ground line by making true measurements and taking these back to the appropriate measuring points MP1 and MP2 giving foreshortened distances within the picture plane. An easy way to think of this is where a line vanishes to VP1 use MP1 and likewise with VP2 and MP2: with a little practice this becomes second nature. Once the floor plan has been drawn on the auxiliary ground plane the points can be raised to their correct position on the ground plane above and using the true height line, projected around the building to complete the various architectural features. Other true height lines can be achieved by projecting points within the picture plane from a vanishing point and onto the ground line or auxiliary ground line.

Once the outline of the floor plan has been drawn on the auxiliary ground plane, measurements can be taken from the plan and marked off onto the auxiliary ground line. This will include the position of window and door openings,

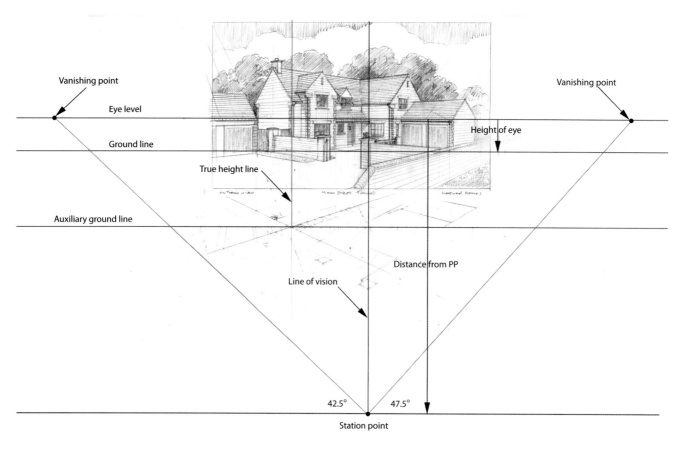

The basic perspective set-up with completed drawing showing all measurements taken from the site plan. The vanishing points were located by the two angles measured from the station point which were taken off the site plan. The auxiliary ground line was positioned at a convenient distance below the ground line for accurate measurements.

projecting gables, chimneystacks and other features including external walling and outbuildings, in this case the garages.

Having a solid knowledge of building and construction methods and architectural detailing is central to the success of an illustration and its credibility as a faithful representation of architectural design. The proportions of building materials need to be correct in relation to their size and nature; understanding how tiles are laid onto a roof pitch is important in achieving a convincing end result. When faced with a new or different version of, say, a slate tiled roof, it's always best to take measurements and ensure that these look in proportion. In the case of this example, the roof is of natural slate with cemented verges and lead valleys. Slates come in various sizes for different roof pitches. Here the roof pitch is 50° and about 4000mm long with the tiles laid on battens at a gauge of about 250mm. This means that dividing 4000 by 250 gives 16 rows of tiles. The

same thing applies to brick and stone courses and boarded fences – it's all a matter of scale. This is where the practice of sketching from architecture and drawing on location comes into play, as a way of familiarization with buildings and their construction.

There are, of course, a number of variations and short-cuts to this method of perspective drawing and much can be said of a more freehand approach to drawing perspectives once the fundamentals have been internalized. Often, an accurately drawn aspect of a building may look wrong, in which case it is wrong and should be corrected by eye. Sometimes the perspective will appear too great or not enough – often arising from a building's design, especially if there is a high tower or chimney feature close to one end. This often causes the perspective to distort and needs free-hand adjustment – the motto here is, 'If it looks right, it is right!' Another reason for freehand intervention may come from the client who may be surprised or unhappy with the

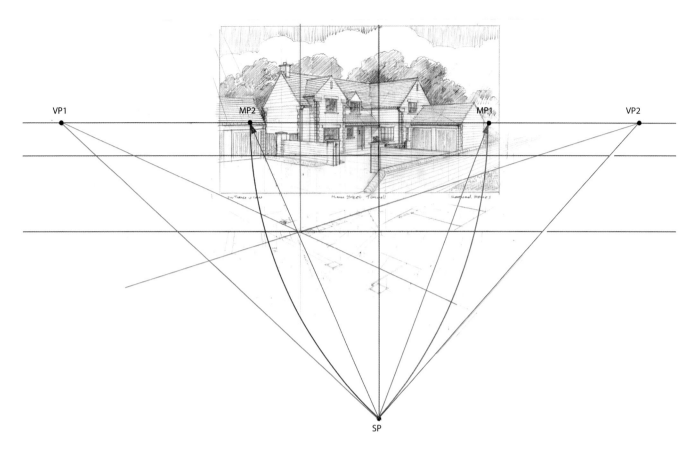

The final stage of setting up, showing the location of measuring points. The left vanishing point (VP1) is used as the centre point to scribe an arc to mark off the right measuring point (MP1). The same process is used to locate the left measuring point. The two axes (in green) are shown touching the auxiliary ground line at the true height line (in red) and vanishing to VP1 and VP2.

emphasis of a particular feature and wish it to be softened or subdued rather than going 'back to the drawing board'. Although uncommon, it does arise from time to time and is usually solved by taking action of aesthetic licence or compositional judgement to maintain the illustration's (and your) credibility.

Often, and particularly with larger buildings and developments, the perspective drawing will be supplied to you in the form of a 3D digital model, in which case the decisions regarding viewpoint and height of eye level will already have been made. However, with smaller projects and one-off residential buildings, the draft perspective may be the first time your client has seen the building in 3D. Prior to this an early concept sketch may have been prepared for discussion alongside orthographic drawings, but viewed by an inexperienced client these can be misleading. It's at this time in the process that details of view and build materials need to be confirmed to avoid last minute changes through

poor communications, often against pressing deadlines. Most building materials can be found through search engines and many sources have downloadable pdfs of suppliers' brochures. Google Images are a convenient source of reference materials in photographic examples, which greatly helps with colour variations in natural settings and weather conditions, especially if you are searching for that weathered-oak look.

Applying colour

As with the previous example, the pencil drawing was constructed at a scale of 1:100 which was too small to colour and the drawing was enlarged to 200 × 360mm using a photocopier. The photocopy was then traced through onto Canson NOT watercolour paper and spray-mounted onto card for colouring. It's really important to plan out how colour is to be applied to your drawing, taking into account the position and orientation of a structure and how light will

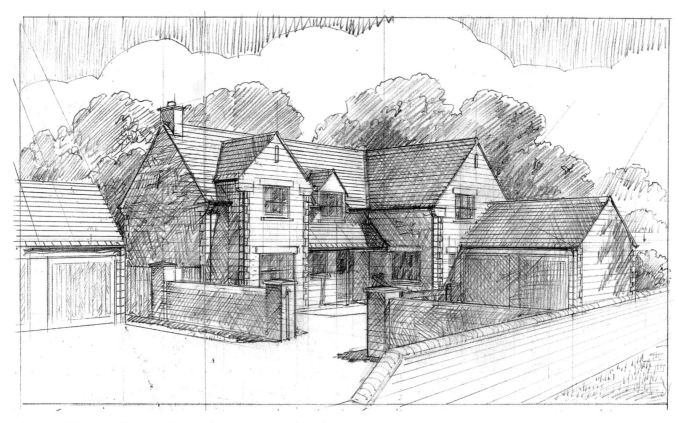

Prior to applying colour, it's a good idea to work out the direction of sunlight and resulting cast shadows on a copy of the pencil draft. Here, the sunlight is coming from the right-hand side, illuminating the front elevation and casting shadows to the left.

fall across its surfaces. Lighting is the single most important factor in the success of an illustration and its effects can help to add atmosphere as well as define shapes and surfaces. It will also dictate how an illustration is received by an audience. More dramatic lighting can be applied to add a touch of drama by creating long cast shadows as if early in the morning or late evening. In the case of this example the front elevation of the building is west-facing and therefore will catch the light during the afternoon and evening. This worked well with the building's design and the two projecting gable walls (a main feature) are shown bathed in afternoon light. The sun's position was kept deliberately high to avoid over-complex cast shadows – particularly in the foreground, which can be distracting. It is good practice to work out the sun's direction and produce a key drawing or overlay of the pencil draft, indicating the tonal values across a drawing and how the shadows will work best to enhance its design features.

The existing background trees provided a useful backdrop to the building and, as previously, these were washed in prior to the building itself, so that the roof and gable walls could be better assessed regarding tone and colour. The schedule of external materials included slates to the roof and traditional stone walls. The roofs were coloured using a mix of Payne's Grey with a little Neutral Tint to dull the 'blueness' and touches of Yellow Ochre to individual slates here and there. The sides away from the light were subject to another darker wash of the same mix to indicate a shaded surface. Once dry, using a no. 2 size brush, the slate courses were lined in to show the lower edges using a strong mix of Payne's Grey, a technique that helps to represent strong sunlight. The stone walls were washed over with a weak mix of Yellow Ochre and, whilst still wet, touches of Burnt Sienna were added. The drying time of a wash will vary depending on the weight of paper, surface and ambient temperature but it's worth investing

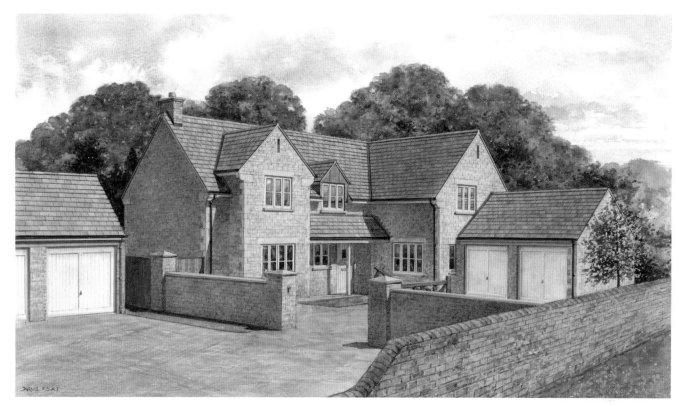

The existing background trees were rendered using a dark blue/green wash adding to the illusion that accentuates the light falling on the natural stone walls.

in a small hairdryer to speed things up. When dry, a no. 4 round brush was used to pick out individual stones using a slightly stronger mix of Yellow Ochre and Burnt Sienna. It was at this point that the cast shadows were indicated, using the key drawing prepared earlier. Once completed, a darker wash of the same colour was mixed with a little Payne's Grey and washed over all the shaded stone surfaces. This was left to dry and a second application given but this time to show gradations of tone, which really helps to give realism to the darker surfaces. The cast shadows projected onto the roofs can also be applied at this stage.

Of course, much of the application of colour is done without adhering to strict order and sequence, but the basic technique of light to dark and background to foreground still applies. In practice it's the process of applying colour to wet and dry surfaces that helps to breathe life into the illustration as it develops, with attention to detail at important stages. As previously mentioned, colour mixing can be done on the palette or on the paper and it's a combination of both methods that, in practice, contributes to an illustration's overall success. The process continued with the windows, fencing, driveway and grassed areas, the front boundary walls and gate and the existing wall in the foreground. The nearer the subject matter to the viewer, the more detail is added to give form and texture, all of which needs balancing to give an overall effect of depth and realism.

CASE STUDY 1

Street view of proposed and existing town houses

These illustrations were commissioned to accompany a planning application for a development of new town houses set back from a busy road behind an existing wall and mature trees. The planning officer for this development was concerned about the effect the new housing blocks would have on the existing building and urban landscape. The client's brief was to portray a street view of the proposed development in three ways: (i) without trees; (ii) with trees but without foliage as if in winter; and (iii) with trees in full

leaf. The initial pencil draft was approved by the client and the drawing taken to colour stage without the trees *in situ* and scanned on an A3 flat bed scanner. This was saved as a tiff file at 300ppi for future use. The next stage was to create an original artwork in watercolour of the trees based upon photographs taken on-site but without foliage. This was fairly straightforward as the reference provided included photographs taken in the summer and winter months so it was just a matter of tracing over these. This artwork was

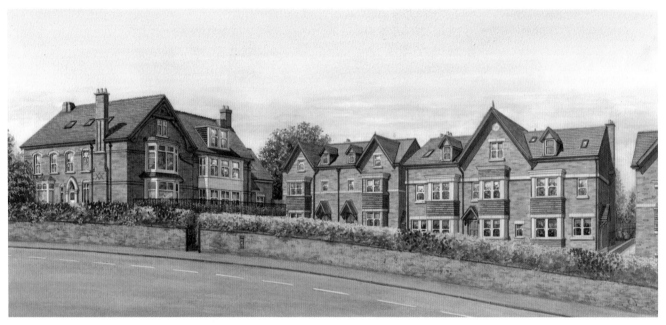

This illustration of a proposed development of refurbished and new build apartments shows the view without the mature trees in situ, as requested by the planning committee.

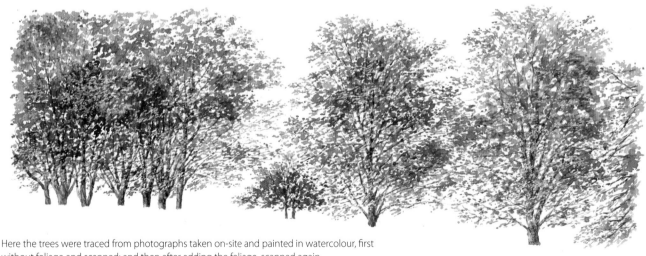

Here the trees were traced from photographs taken on-site and painted in watercolour, first without foliage and scanned; and then after adding the foliage, scanned again.

then scanned and the white background removed and made transparent. There are several ways of doing this but due to the delicate nature of the brush marks of the branches the following method was used.

As with the buildings, the artwork was scanned as a tiff file at 300ppi and saved. Both scans were opened in Photoshop and with the 'trees' scan selected, in the Layers panel, the Background layer was unlocked by dragging the Lock icon in the layer panel to the Trash can. This meant that the layer was now editable. The method used to make the background transparent was to go to Select on the top menu bar and select Colour Range and then to choose

Highlights from the drop-down menu. All the trees were shown as selected and masked and the background was made transparent by pressing the Delete key. If you press Command D (on a Mac), all will be deselected. Once this was done the layer was dragged off the main window by dragging the window 'tab' and releasing and then dragging back onto the open window of the building scan. The trees were positioned onto the building and tidied up using the Clone Stamp Tool. The image was then flattened by going to Layer in the menu bar and selecting Flatten Image. The process was repeated after having painted the foliage onto the trees artwork and rescanning.

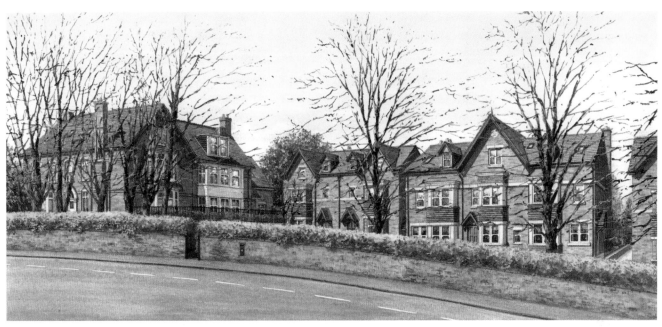

This illustration shows the view seen during winter months when the trees are bare. The scan of the trees was taken into Photoshop after the background was made transparent, and superimposed carefully over the original illustration.

After the trees artwork was completed with added foliage, another scan was made and superimposed onto the original illustration as before and retouched to carefully blend with the artwork.

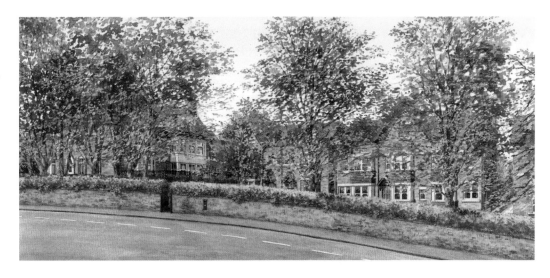

CASE STUDY 2

Street view of a proposed care home

This commission was to illustrate a proposed residential care home for use as part of a planning application. The client wished for the building to be sympathetic to surrounding houses in build materials and colour and requested that there should be people included and parked cars in the parking area behind. The architects had already produced a 3D model in SketchUp and this was used to establish the viewpoint. Once this was confirmed, the 3D model was printed to a suitable size and the adjacent buildings and entourage elements including figures and cars were drawn in at the appropriate perspective angle, and a pencil draft was sent to the client for approval. Having the SketchUp document (rather than a jpg or pdf) meant that the file could be opened in the 3D programme and manipulated to obtain the best viewing position. The pencil draft was completed to include suitable figures and cars

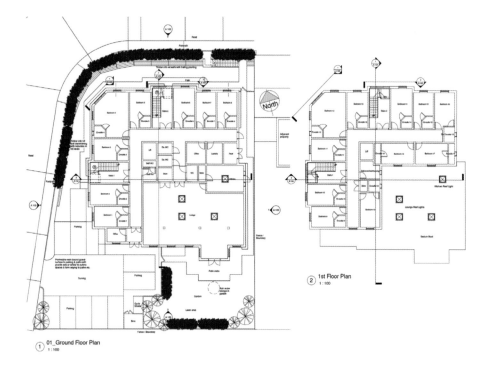

Floor plans showing the ground and first floors of the care home which were imported into SketchUp for creating a 3D perspective view.

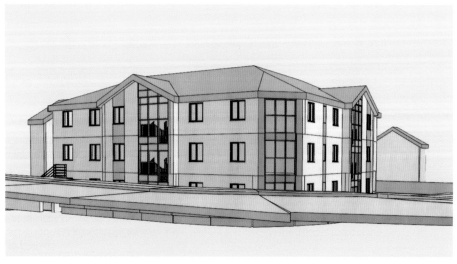

The 3D perspective angle was agreed with the client and used as the basis for the final pencil draft.

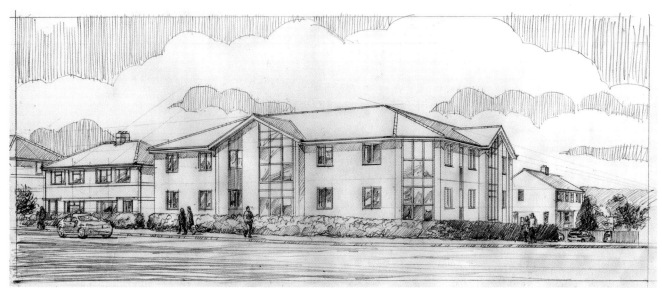

The pencil draft showing the adjacent buildings either side of the care home with entourage elements.

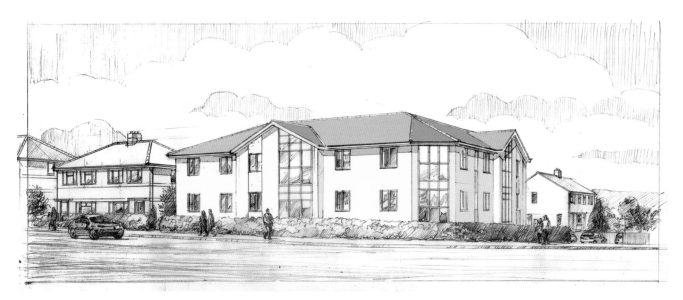

Here, the pencil draft was used to present different colour schemes to the client by rendering in Photoshop.

taken from photo reference sources available on-line. It's a good idea to build up your own reference 'library' of various entourage elements, and figures in particular. The same figures can be used on different illustrations to save time researching, but it's better to avoid too much repetition – especially if it's for the same client.

The pencil drawing was enlarged to a suitable size for colouring and traced through onto watercolour paper using a light box. The first decision to make was the direction of light and although the elevation selected was north-facing and in reality would receive minimal sunlight, it was

considered that in this instance, artistic licence would be permissible! As usual, the colouring started with a suitable sky and, in this case, it was important to get the scale right. Skies, and specifically clouds, are subject to the same rules of perspective as everything else and with a wide view such as this, it's crucial that the scale is in proportion to the picture as a whole. Such a sky can be very helpful in adding to the existing depth codes present in a picture and contribute to the overall illusion of 3D space. Before tackling a large sky, it's useful to have some reference for inspiration rather than working from memory. A good sky can affect

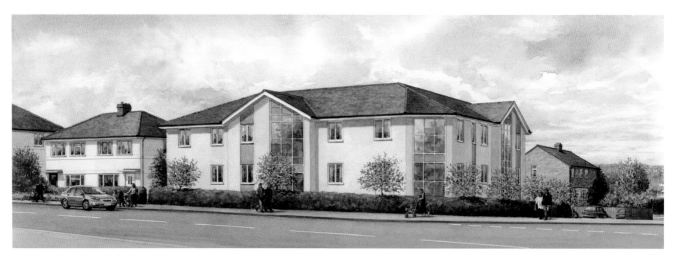

The finished illustration as presented to the client. The figures and cars were added to bring some life to the composition and to reflect the normal activities in such a street view.

Enlarged detail, showing entourage elements and activities.

the mood of an observer and may, subconsciously, have an influence on a scheme's approval. In watercolour, an effective method for creating a convincing sky is to dampen the paper with water, let it dry a little or blot some off with blotting paper, and then start to add a colour wash. Creating a successful sky is less about painting and more about introducing colour to, and taking colour away from, a surface while still wet, without overworking with a brush. This sky was created using Antwerp Blue, Payne's Grey and a little Alizarin Crimson. With the paper at an angle of around 20°, the wash of blue was introduced to the top of the paper and, by adding more water, allowed to drop down the surface, as if fading into the distance. Whilst still wet, a small amount of Alizarin Crimson was added to the wash and used for the underside of clouds and on the distant horizon.

Working from the distant horizon on the right side to the existing red brick house, the direction of sunlight was established and all the left-facing elevations and surfaces were shown sunlit. It's important to maintain consistency when representing light and shade otherwise certain elements may be over-emphasized and be a distraction to the viewer. It is noticeable when observing this in reality, how cast shadows vary in intensity depending on the surface in shadow: darker surfaces will appear darker and lighter surfaces, lighter. This can be seen here in the contrast between the rendered walls when compared with the red brick house and the fencing, and also with the darker shade of the hedge as it curves around the street corner.

CASE STUDY 3

Street view of two proposed houses

This proposed development of two detached houses presented an interesting problem due to the land gradient and fall from the access road. Positioning buildings on different levels is quite straightforward but the main decision to be made is the height of the eye level. This will depend on factors concerning existing man-made and natural features within, and surrounding, the site as well as viewing position. Without visiting the site to take photographs, it was a matter of relying on photographs held by the client and Google Maps, Street View and Satellite View. Street View was particularly helpful here as the viewpoint and height of Google's vehicle-mounted camera was almost exactly the preferred position for setting up the perspective. To start with, the site plan drawing was used to position the view or station point to take in the lateral extent of the site. The existing entrance was to be retained for vehicular access and an existing boundary fence to be replaced with

a 1200mm-high wall, using reclaimed bricks to match the existing wall. The viewpoint was positioned to look through the entrance to take in the front door and garage door of plot 1. The next stage was to decide on the eye level to take in both houses and some of the driveway. This was done by using the architect's street scene/site entrance drawing, in a similar way to the method used previously in this chapter.

With all the information to hand it was only the matter of positioning the picture plane on the site plan and this was done for ease of measuring by intersecting the corner of the projecting gable on plot 2. It also allowed for the projecting gable on plot 1 to be extended on both sides to also touch the picture plane and this was used for true lengths for plot 1. Now the perspective view was set up as with the previous case study: using two-point perspective, and an auxiliary Ground Plane positioned below and clear of the perspective drawing for more accurate measurement.

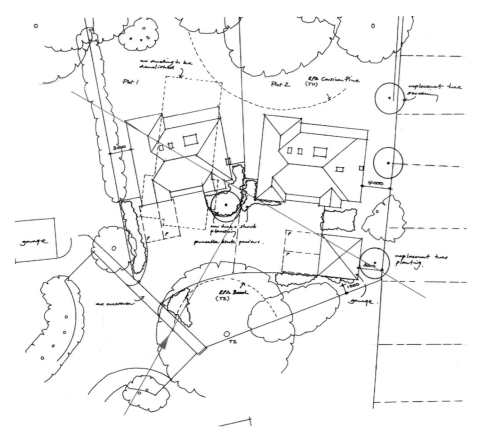

Site plan of a development of two houses showing the line of sight and picture plane in red. The picture plane was positioned to touch the left corner of the gable of the right-hand plot, and a convenient position on the projecting gable on the left-hand plot. The plots are not parallel and therefore each would have its own vanishing points.

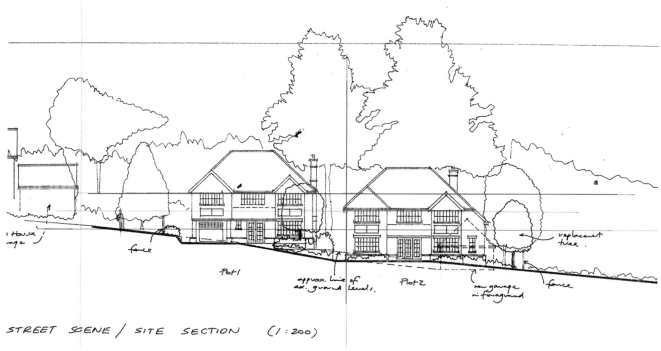

STREET SCENE / SITE SECTION (1:200)

Street scene and site section showing (in red) the different heights of each plot and the vertical true height line on the corner of the right-hand plot.

Google Street View, which gives a good indication of the viewpoint taken and existing landscape features.

The main issue here was that the plots were at different angles to each other and therefore would have different vanishing points. Both set-ups were drawn and plotted for each building. The two true height lines can be seen in blue for plot 2 and red for plot 1. Both floor plans were drawn in this position and then extruded to their respective levels using measurements taken from the street scene/site section drawing. Once both houses and the garage block had been completed then the Google Street View photograph was used to position existing landscape features ready for colouring.

Watercolour was applied in the traditional manner, working from the background to foreground as with previous examples. Again, the Street View photograph was used together with on-line and other information supplied by the client. The brief was to blend the proposed buildings into the landscape and the starting point was to lay a washed sky by adding and removing paint until the desired effect had been achieved. The distant tree line was applied with soft blue/green washes to give an aerial perspective feel and to help give a sense of depth into the picture. Next, the mid-ground trees were added, forming a backdrop to the buildings, then the houses themselves, and finally the foreground and immediate trees and hedging, etc. The large tree on the right-hand side was portrayed in a 'spring-like' leaf so as not to obscure the distant trees beyond. The direction of light was based upon the Street View image and resultant cast shadows were applied using a wash of Ultramarine mixed with a little Yellow Ochre and Burnt Sienna, which helped to soften their impact but provide a sort of framing to the picture, particularly to the lower right-hand side. The road surface was achieved by applying washes of the same mix as in the shadows, but very pale and keeping the surface very wet, to allow the colours to mix and blend on the paper. A hairdryer was used to speed things along.

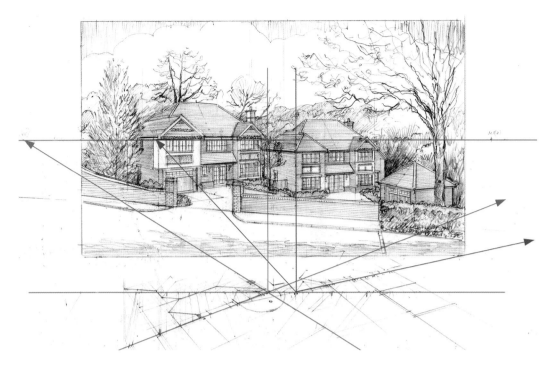

Pencil draft showing the basic set-up with each plot having its own vanishing points as each are set at different angles: in red for the left-hand house and blue for the right-hand house.

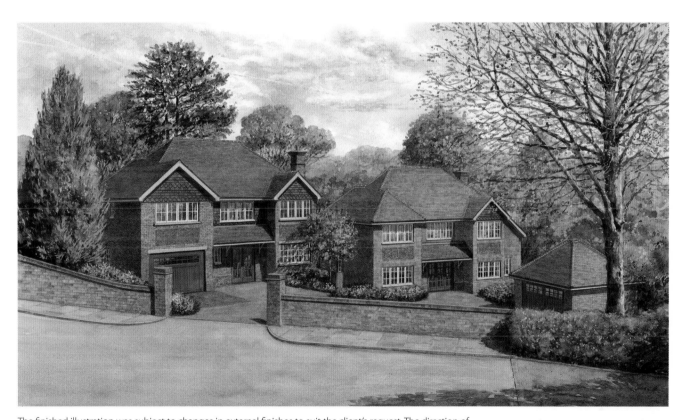

The finished illustration was subject to changes in external finishes to suit the client's request. The direction of sunlight was taken from the Street View image, which fortunately suited the composition, with a strong cast shadow projecting into the foreground creating a good balance to the picture.

Chris Fothergill

Working from my home studio in Great Malvern, Worcestershire, I divide my time between supplying architectural watercolour illustrations for architects and developers, doing house portraits on commission, and sketching and painting inspirationally. I am quite traditional in my use of pencil and watercolour, although I do employ digital means in amending and enhancing the commercial side of my work for housing developments, often cloning in cars and people after the artwork is finished. And often there are alterations and amendments that can only be made digitally. But when the original artwork is important, as with house portraits and paintings for sale, then of course with watercolour there is no 'undo' button!

Before producing any piece of artwork I will always do a preliminary 'rough' pencil sketch. This will be to establish the angle of viewing, the composition of the picture and elements to include or discard. This is especially important in housing developments, to make sure I am understanding what the client requires, and in house portraits, where a telegraph pole or sky dish might offend! It also gives me the confidence to focus on the quality of my drawing and painting without being distracted by uncertainty of content.

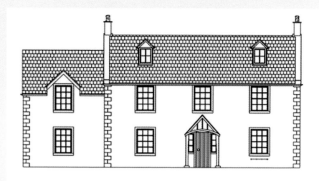

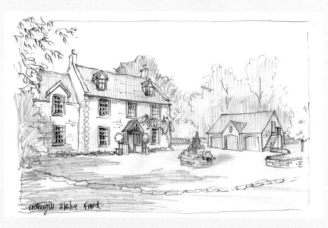

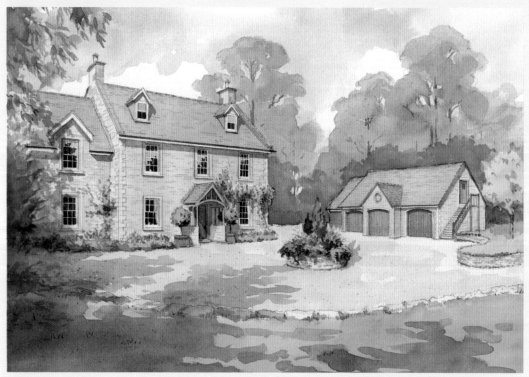

Proposed replacement farmhouse showing the front elevation drawing, preliminary pencil sketch and finished watercolour. The composition is well balanced with the cast shadows in the foreground drawing the observer into the picture, as well as indicating elements outside the picture frame.

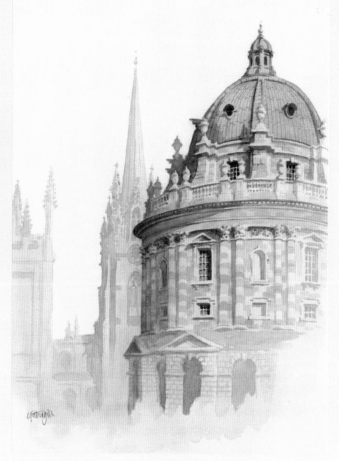

Colour study morning light

7 August 12 *Radcliffe Camera and St. Mary's Oxford*

Radcliffe Camera, Oxford, showing an initial small colour study to work out the composition arrangement and the finished studio painting. Here the softness of the background tower and spires helps to push the main image forward, thus creating depth cues in the picture.

If I am starting a more inspirational 'studio painting' then I may do a little colour study too.

A lot of my architectural illustrations are not urban, so I have chosen an example here of a replacement farmhouse which I was commissioned to depict. The brief was slim: I was given the elevations of the house and the garage block but little else. However, the client wished the house to be shown amongst trees, with planting around, and perhaps a wisteria, so I came up with the 'rough' pencil sketch, and put some tree shadow in for atmosphere. I was given the go-ahead without amendment and so produced the finished watercolour. The perspective of the building was partly measured, and partly drawn by eye – what I would call an 'informal perspective'. I used tree shadow across the

building and foreground, along with soft edged background trees to create a real country feel to the scene. He was so pleased he went on to commission an aerial view from the rear afterwards.

I often feel as though I am 'vinyl in a digital world', but as an alternative to CGI the softness of watercolour can bring an atmosphere to an illustration, which is very helpful to clients for both planning applications and website marketing. Of course this is all very considered and premeditated, not what a lot of people would associate with watercolour painting. Many artists like to paint out of doors, more spontaneously, and I am no exception. Occasionally I close the studio door and set off for a week to foreign parts just with my bag of paints and drawing stuff. Some of the old

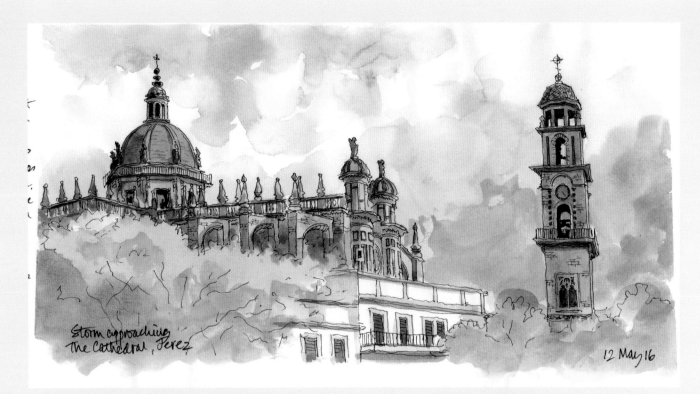

Free sketches done on the spot: a pen and ink sketch of Jerez Cathedral, and a pencil study of the bridge at Ronda, Spain. Taking a sketchbook with you whilst out and about is a good way of forming a habit and really pays off in commercial applications.

cities and hill towns in Spain and Italy are particularly rewarding. There I will simply sketch without preliminary studies, sometimes drawing with pencil but more often directly with a fine liner waterproof ink pen, and then washing watercolour over it to cheer up the drawing. The example here is in Jerez de la Frontera in Spain, where I was dodging showers and storms for most of the week! But it gave some atmosphere to the sketches. The other drawing is a pencil study of the bridge at Ronda in Spain, drawn on the spot sitting in the shade of an olive tree. There I am at my happiest. Some would say there is a difference in worth between fine art and illustration but I think the one informs the other. The discipline of the illustration improves one's free drawing, and the sketching *en plein air* freshens one's formal work. All art is a mixture of head and heart. But enthusiasm is perhaps the most essential ingredient!

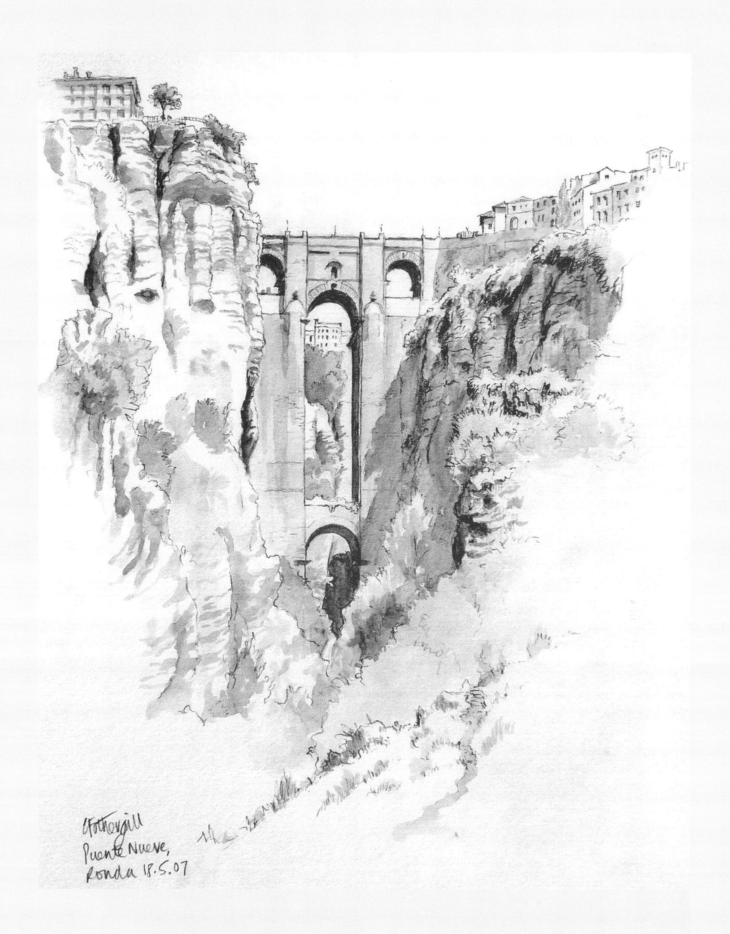

Fothergill
Puente Nueve,
Ronda 18.5.07

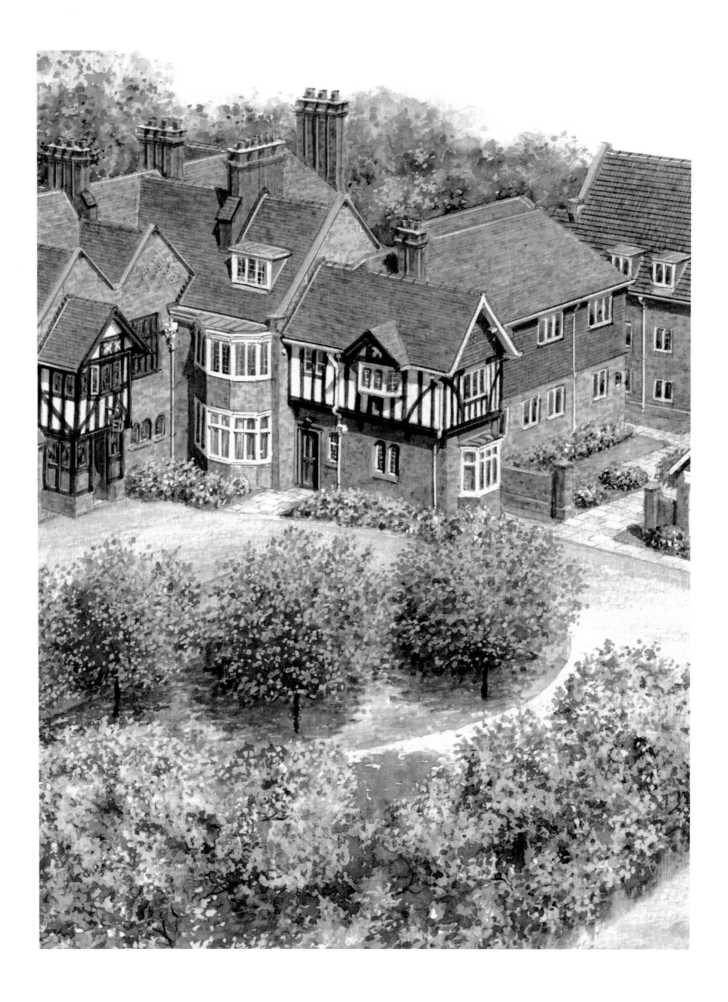

The Aerial View

Every drawing or painting that used perspective proposed to the spectator that he was the unique centre of the world.

John Berger

The aerial or bird's-eye view was a very popular method for illustrating the estates of country houses across Europe during the late seventeenth and eighteenth centuries. It had been a long-standing convention before the Renaissance for representing topographical views and its popularity increased with the rediscovery of linear perspective and the use of engraving in printmaking and mapmaking. Jan Kip (1652–1722) and Leonard Knyff (1650–1722) were the two most notable practitioners of this genre: Kip was a draughtsman and engraver and Knyff a draughtsman and painter. Both were from Holland and their paths crossed when they collaborated on a series of engravings of English country houses. Also referred to as 'prospect views', aerial views became an important part of topography in the visual description of places through accurate representations of specific areas. The British Library holds thousands of prints and drawings of the British Isles ranging from huge vistas of the countryside to individual buildings. The tradition of British topographical illustration reached its height in the nineteenth century and became indelibly linked with the Romantic Movement and the Grand Tour. Even the great J.M.W. Turner (1775–1851), during his early training, was apprenticed to the topographical painter Thomas Malton (1748–1804) to learn perspective, and later as an architectural draughtsman produced drawings and perspectives of proposed buildings. Much of Turner's early work came as a result of the demand for topographical illustrations and prints, and his skill in applying the geometry of perspective was recognized when he was appointed Professor of Perspective at the Royal Academy in 1807, a post he held for some thirty years. During this time Turner was expected to give illustrated lectures on the subject, something that he struggled with at first as he was not a natural public speaker and, on all accounts, he spoke quietly and muttered his words. However, his large artworks constituting diagrams and watercolours more than made up for this deficiency and his later lectures were warmly received.

The aerial view can work on two levels of appreciation – aesthetic and diagrammatic – and, when combined effectively, will perform an excellent service in communicating proposed as well as topographical information. When a viewpoint is elevated it naturally extends the field of view by taking in more of a building's context, be it urban or rural. A client may have commissioned aerial photography if a development is of a certain size or importance, in which case these can be used to help set up a perspective. The height of the eye level will depend upon different factors and end uses: if landscaping and garden design is of prime importance then the selected view should reflect this purpose. Sometimes adjacent land or buildings are major considerations to take into account and these may need to be emphasized or de-emphasized. Elevated viewpoints are tricky to get right sometimes and the use of digital modelling can save time in order to achieve what the client needs.

Enlarged detail showing an aerial view of a Grade I listed property with proposed additional new build.

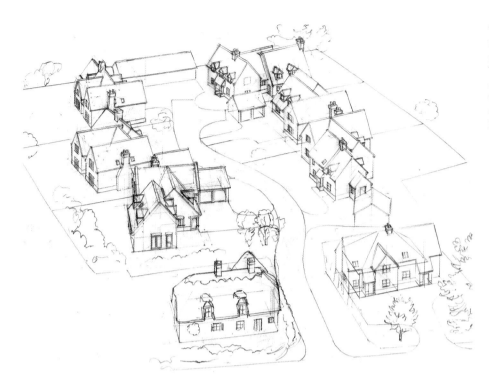

This was the first drawing traced from the initial 3D model, showing a very simple representation of the view for approval. This was the first time the client had seen a drawing and a decision was taken to rotate the drawing anticlockwise for a better view of the end gables of the houses on the left-hand side.

In this first example of a small residential development of six detached houses, two semi-detached houses and an existing thatched cottage, the aerial view was set up using ArchiCAD to create simple house shapes without any doors or window details, etc. This was then traced over in pencil and sent to the client for approval. The view was then changed according to the client's wishes and re-traced to achieve the amended drawing that received approval. The traced sketch doesn't take long to do and has a more aesthetic feel than the digital drawing and is more appealing to a client who may not be versed in such matters. The finished watercolour version was completed with help from Google Maps and some ground-level photography.

The long-standing convention of representing architectural subject matter in one- and two-point perspective has, in the main, ignored three vanishing points. However, since the advent of 3D computer modelling and the ease of drawing in perspective, this has changed. Technical illustrators working in the engineering and transport sectors have always used three vanishing points in representing their subject matter. This is mainly due to the relationship we have with smaller, often moveable, objects and the way they are perceived. Also, because we are continuously moving our gaze from one point to another and not from a fixed point, as in perspective theory, objects drawn using two vanishing points tend to be less convincing to the eye. From a distance, and viewed from normal standing height,

a four-storey building or equivalent will appear to have little or no vertical vanish. Walk closer and this will change as the verticals start to converge to a point above the structure. This can often be seen in computer drawing when the 'camera' is too close to the subject matter, resulting in a distorted view. An architectural photographer of worth will look to counter this effect by using specialist perspective shift lenses or by correcting distortion, post-production, with raw files or in Photoshop.

With the aerial view, using a third or vertical vanishing point can help to give a more realistic appearance, particularly if the subject matter is a large building development when the viewpoint is elevated to be very high above the ground. It can also help with tall buildings and wide-angle views when the periphery of a view may look out of drawing if a degree of convergence has not been used.

As mentioned at the start of this chapter, the aerial view can work as both a diagram as well as an artist's impression, the degree of which will depend on its initial use. The majority of perspectives are commissioned either to accompany planning applications or for marketing and selling and the aerial view can sometimes work for both. Sometimes it's a matter of balance between diagram and realism which works as a piece of visual communication.

The elevated prospect or bird's-eye view of the seventeenth century clearly had great ambition as both a painting and in its documentation of a view. An architectural

This drawing shows the amended view, which includes roofing, windows and doors, and landscaping features.

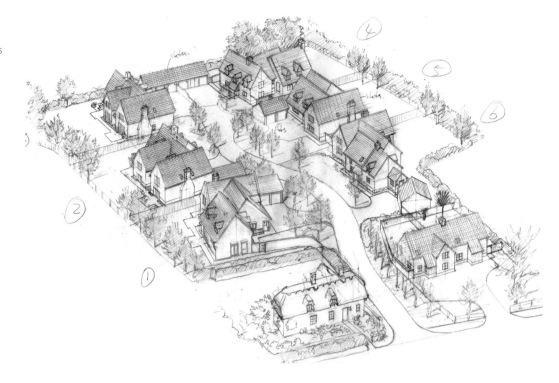

The finished illustration showing the differing materials to the houses, proposed landscaping features and boundary fencing. After planning procedures this illustration was used in advertising and selling material.

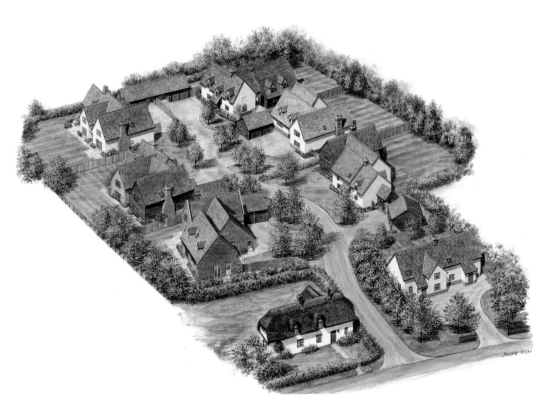

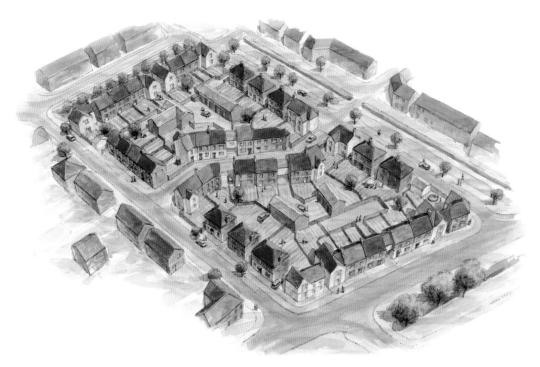

Aerial view of the layout of a proposed residential scheme with entourage elements including people, cars and some landscaping. This illustration works as a diagrammatic site plan as well as giving a realistic idea of the house types and sizes. Notice the vertical vanish applied to the buildings, which adds to the realism and aesthetics of the illustration.

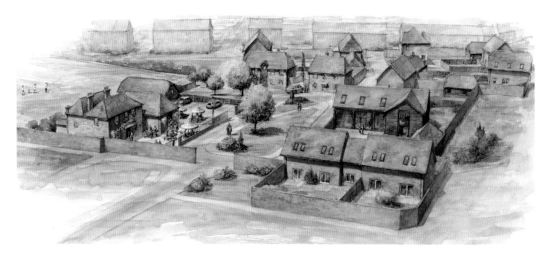

This illustration was initially prepared for planning purposes to show how part of a proposed scheme of houses, public house and cricket ground/sports facilities, would blend within an existing development. It could be used for local consultation and later marketing and selling.

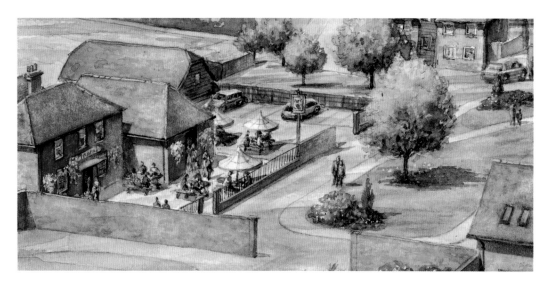

Enlarged view showing public house courtyard and garden.

illustration produced by a competent practitioner of today may, from time to time, transcend its primary value as merely an 'artist's impression' and fulfil other criteria. Many such works attain secondary value through their noteworthy subject matter, sometimes achieving high prices at auction; this was particularly the case during the 1970s and '80s when architectural views were highly collectable. An example comes to mind of a perspective view in watercolour by the talented illustrator Frank Weemys showing the proposed BBC Television Centre at Shepherds Bush. The illustration was exhibited at the Royal Academy in 1956 and over 30 years later, sold at auction by Sotheby's for many times more than the fee paid for its commission.

A distinction can perhaps be made here between architectural illustration and architectural or landscape art or painting. Generally speaking illustration is usually commissioned with the client having some vested interest in its practical value, whereas the latter is often self-initiated and has artistic aspirations other than the communication of its subject matter; some architectural art falls under both categories. Two notable contemporary artists of the genre are architectural painter Ben Johnson (b. 1946) and capriccio painter Carl Laubin (b. 1947). Johnson has created large aerial views in acrylic of panoramas and cityscapes ranging from Hong Kong to Liverpool to great acclaim from within and outside the fine art community. Carl Laubin is best known for his architectural fantasy oil paintings in the tradition of Claude Lorrain (1600–1682) and Nicolas Poussin (1594–1665).

CASE STUDY 1

Barn conversion and garden design

This example shows a proposal for the conversion of a central barn and outbuildings to residential use. The existing tiled roof to the main barn was to be reinstated to its original thatch and other outbuildings restored with clay tiles, including a new building behind, which housed a triple garage and garden storeroom. A garden was to be created incorporating various wooden outdoor rooms and a centrally placed gazebo. The site was on two levels and this was shown in the raised lawn and beds.

After an initial on-site meeting with the client to agree the best approach to take, a perspective drawing was prepared using the traditional method of measuring points. When setting up an aerial perspective the first consideration, after the choice of viewpoint, is the height of the eye above ground. In this case the aim was to select a view looking into the courtyard with the pond on the far side behind the tiled roof. It is important when setting up an aerial view by hand that small details are considered at the start, as a myriad of viewing angles and positions would suffice in its representation. The 'best' view is often the one that does justice to the building type and style of architecture. In this example, the buildings were to be restored to their original vernacular state and the additional buildings designed to blend in using local materials and techniques of construction. A fairly high viewpoint was selected to show the gardens in the foreground and the new garage block behind with a small area of fruit trees sited in the corner. Even with experience, a sketch view using just floor plans to position each building is the best way to avoid spending too much time on detailing if the view needs adjustment.

The viewpoint was positioned on the site plan so that an angle of about 50° enclosed the whole site, and the ground line was positioned to touch the front corner of the extension to the main barn (shown in red). This would be the main line for measuring true horizontal lengths in both directions and projecting back to each measuring point. A vertical line through this point represented a true height line. With the aerial view, the eye level is not within the cone of vision and therefore all measurements are made on the perspective drawing and not below it as with lower eye-level views.

Watercolour was applied, starting with the grass and driveway, then the garage block and trees and working forward from the right to left finishing with the main boundary wall in the foreground. The colour palette and materials are shown in the box.

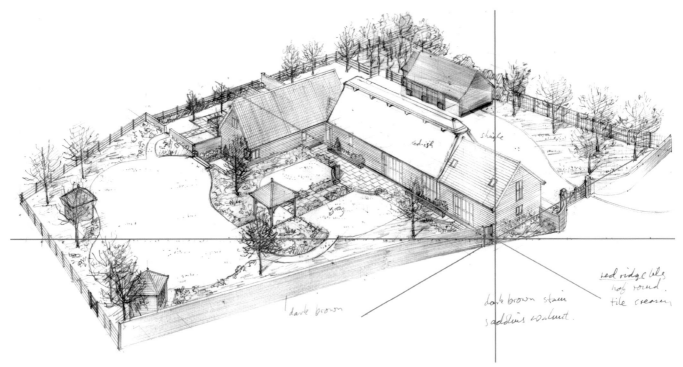

Draft pencil view of a barn conversion and garden landscape design. At this stage the design and layout was finalized with discussions concerning external materials and colours to be used. This pencil drawing was done traditionally using measuring points.

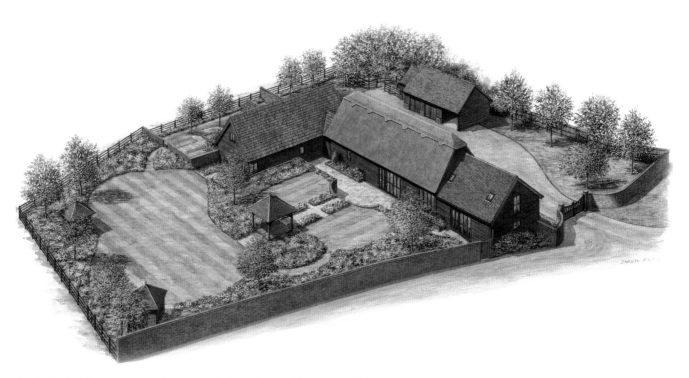

For the finished illustration watercolour was applied over the pencil drawing on 85lb Canson Montval Aquarelle NOT watercolour paper at approximately 310 × 600mm. The client was keen that the illustration also 'sold' the garden design to a prospective purchaser and time was spent rendering the various plants and borders to represent the design in detail. Strong cast shadows help to present the view in full sunlight and describe the different levels of the landscaping.

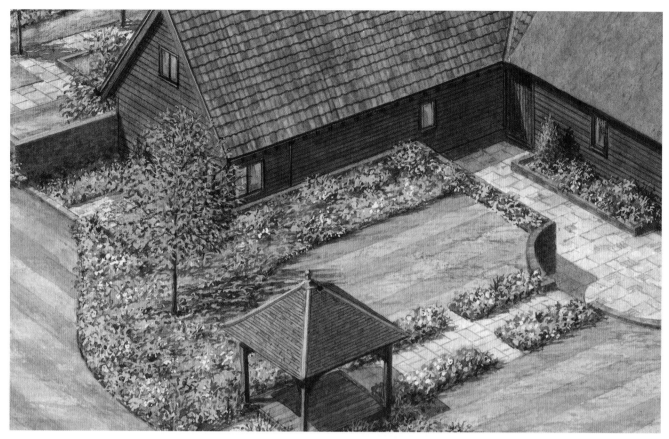

Enlarged view, showing different levels in the courtyard area with pond behind.

BARN CONVERSION COLOUR PALETTE

Grass and trees	Lemon Yellow, Cerulean Blue, Payne's Grey with a touch of Yellow Ochre/Burnt Sienna and White/Lemon Yellow gouache highlights
Driveway	Burnt Sienna, Cerulean Blue, Yellow Ochre
Pantile/tile roofs	Light Red, Payne's Grey with a touch of Antwerp Blue
Thatched roof	Yellow Ochre, Burnt Sienna with touches of Payne's Grey and Alizarin Crimson
Timber cladding	Sepia, Burnt Sienna, Payne's Grey
Brick plinths and walling	Light Red, Payne's Grey
Planting	Various colours and gouache highlights

Tudor house and garden with obelisk

The client for this project was a landscape designer who had been commissioned to remodel the garden of a listed house. Features involved in the design were an outbuilding, swimming pool with steps connecting levels up and down, a covered changing room, greenhouse, vegetable garden, topiaried hedging, a variety of fruit trees and a rill leading to an obelisk at the end of the garden. The drawing was set up traditionally using one-point perspective with measuring/distance points (*see* Chapter 2). The ground line was positioned on the site plan to be just in front of the rill and intersecting the pleached trees on the lower garden level. This meant that the various heights could be measured vertically from this line to avoid unnecessary complication during the drawing process. Another ground line was used to measure the house itself and conveniently placed to the front touching the corner of the projecting gable. The scale chosen to work off the site plan was 1:200 which would have been a little too small for the house detailing if the latter ground line had been used. By placing the first ground line further into the site layout, the house was projected forward and measurements were larger, making it easier to draw architectural details at this scale. Because the footprint of the house was at an angle to the parallels of the garden, the two angles for vanishing points were measured on the site plan and marked off on the eye level (not shown) and used for accurate positioning. With all the elements in place, the various items were drawn in position and the levels indicated with the help of brick steps leading to and from the pool as well as to the vegetable garden. The separate building to the left and behind the house is misleading as the floor plan is not square and the right-hand corner of the gable end subtends an angle of more than 90°.

When considering the application of colour, the first decision to make is the sun's direction, as this will affect how a surface will reflect or absorb colour and light. Without consulting the site plan's orientation, it was clear that, by positioning the sun to the left-hand side, casting shadows from left to right would assist in giving depth clues to the mature trees on the left of the access road and light the front elevation of the house. Cast shadows are the illustrator's most useful tool and, with discerning use, can make an enormous difference to the atmosphere and mood of a picture. Shadows help to explain and describe a building and its context and the theory of shadow casting should be studied and mastered (*see* Chapter 2).

Tudor house and proposed garden design: pencil draft of the aerial view showing centre line and two ground lines. The house was constructed using the closer, more convenient ground line while the garden was drawn using the central ground line. Ground lines can be positioned for convenience, ensuring that the scale is correct.

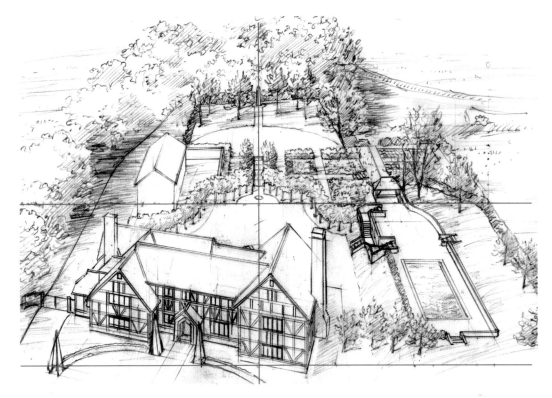

The finished watercolour illustration. This type of drawing fulfils two roles: pictorial and diagrammatic.

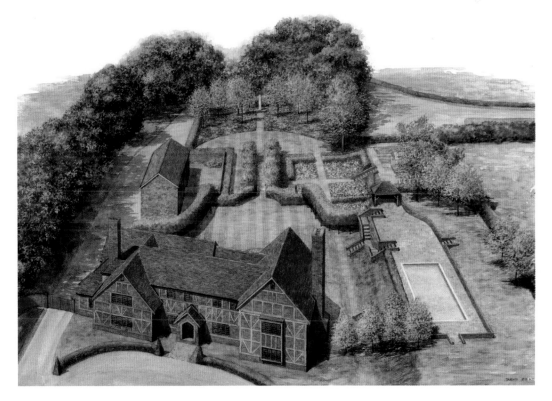

Modern house with observatory

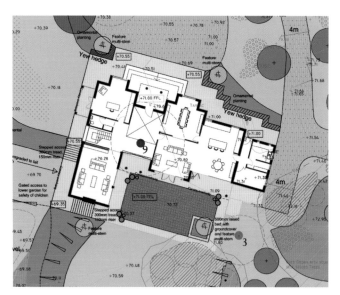

Detail of landscaping plan of proposed dwelling.

An unusual project commissioned by the architects of a client with an interest in astronomy. The house was designed with its own observatory and sliding roof in a fairly remote spot in Cambridgeshire (a necessity for star-gazing is to be away from artificial city lights). With no neighbours, and therefore fewer planning restrictions, this illustration was done for the architects' client in order to develop the house design in its setting. The first brief was to show the building from a standard eye level as if approaching from the entrance drive. This was rejected at pencil draft stage as the architects felt that by elevating the eye level, the view would do more justice to the grounds and landscaping. The second draft went through several amendments before arriving at the final view. The hard and soft landscaping went through several variations before the final design was agreed and the drawing was taken to colour stage. Once again, Google Maps provided useful reference for the existing context and the colouring began with the distant horizon and sky providing a backdrop for the landscaping of the plot. The gardens contained some mature trees which were retained and proposed trees and planting were indicated as shown. The house itself was to be a mix of traditional and modern building materials.

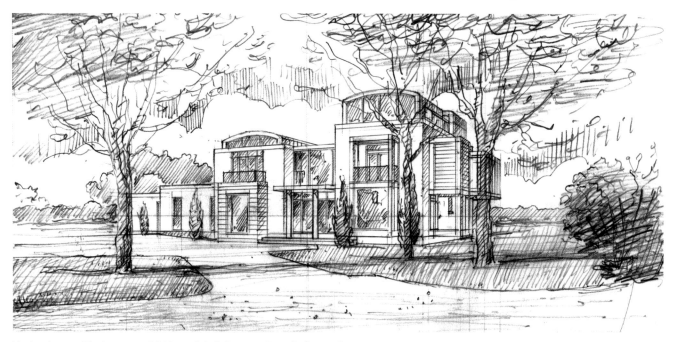

Modern house with observatory: initial pencil draft that was rejected in favour of a more informative aerial view, although the viewing angle of the building was maintained.

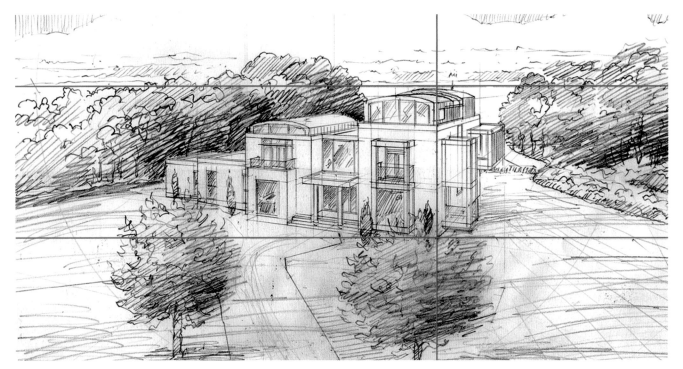

Redrafted pencil drawing constructed from an aerial viewpoint showing true height line and ground line in red. This time the drawing shows information about the retractable roof and grounds.

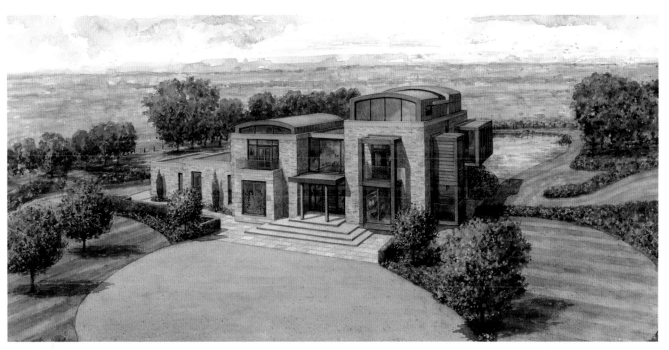

The building view was maintained from the pencil draft stage but the landscaping has been modified with a large pond behind and expanded vehicle turning area in the foreground.

Conversion and restoration of a Grade II listed building

This Grade II listed building was originally built in 1885 as workhouses, becoming a public assistance institution in the 1930s, and was later incorporated into the NHS in 1948 as an infirmary. The planning proposal was to convert its use to residential.

Clearly, as an historic building and landmark and having touched many people's lives in the locality, the change of use needed to be managed with consideration to local residents. The Localism Bill, which came into force in 2011, aims to move land use planning away from central government by introducing new powers, control and influence at a local level. This meant the introduction of neighbourhood development plans and neighbourhood development orders, which give local communities the opportunity to shape development in their area. Any concerns that the external appearance of the buildings might change needed to be communicated, and the illustration was commissioned to help provide visual information on this.

The client's request was for a single illustration to show the context of the three main buildings within the grounds that would be subject to new landscaping. The first step was to meet the client on-site to discuss ideas and take

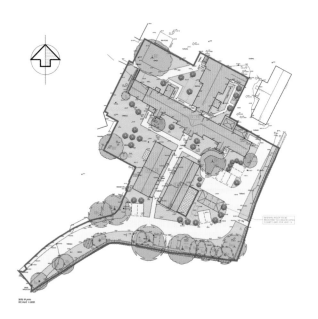

Site plan and landscaping layout proposal for the redevelopment of an old hospital to residential use.

photographs and make sketches. On arrival, the best view wasn't immediately obvious, other than to take an elevated viewpoint in order to include as much of the landscaping as possible. Discussions with the client surrounded the nature and style of the architecture and the possibility that the view should take in the main two-storey entrance façade. It was felt that this would the best feature of the development and would be a major selling point for potential purchasers. The most delightful feature here was the bell tower situated on the ridge at the central point of the main roof behind an attractive Dutch-style gable. The gable also featured a decorative apse and clock beneath a pediment with two inset terracotta date plaques, all of which added to the building's charm.

With the kind of project that involves existing or historic buildings, a site visit really helps to establish a sense of place, and taking photographs of specific aspects and architectural detailing can have a marked effect on the finished illustration. In such circumstances, a site visit should be seen as collecting research material in the form of photographs, sketches and notes, and will make the difference between a mediocre illustration and one that is wholly convincing.

It's good practice to look at this type of project 'in the round' – in other words by documenting even those aspects that may not be used in the final illustration, but provide information on building materials and construction details. Here, all the windows and door openings have arched or round window heads with bull's eye windows to the gable ends of the single storey buildings. Other features include arched pentice boards to the window heads, decorative relief brickwork and copings, and original slate roof tiles with terracotta ridges.

The drawing was set up as a traditional one-point perspective with a raised eye level to intersect the bell tower. Using a central viewpoint allowed the main entrance to be seen above the wrought iron gates and the proposed landscaping and gardens to the front and sides. The angle of view on the site plan was around 50° to encompass the buildings and a ground line was drawn and measured below the eye level to the height just above the tower pediment, as described earlier. This meant that the view would be looking down onto the two single-storey roofs and take in much

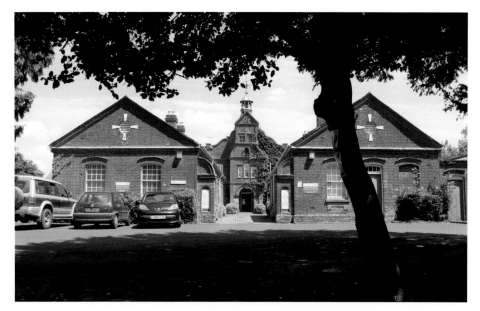
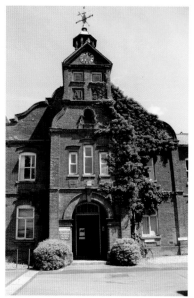

Site photographs showing the decorative entrance with clock tower and view showing access from front of building.

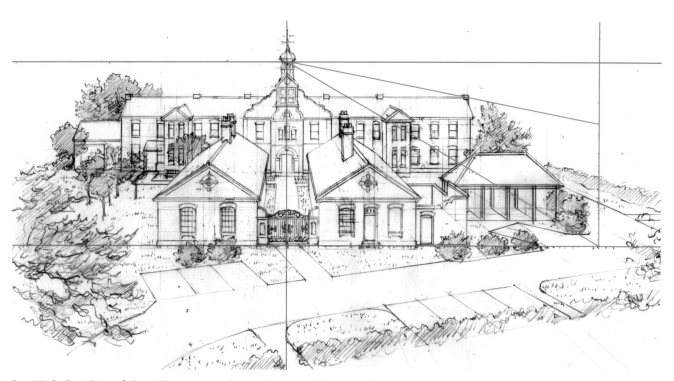

Pencil draft of aerial view of a hospital conversion and restoration proposal. Constructed as a single-point perspective showing the raised eye level, vanishing point (or centre of vision) and position of ground line. The true height line was positioned to one side, in line with the gable end of the main building, for convenience and accurate measuring.

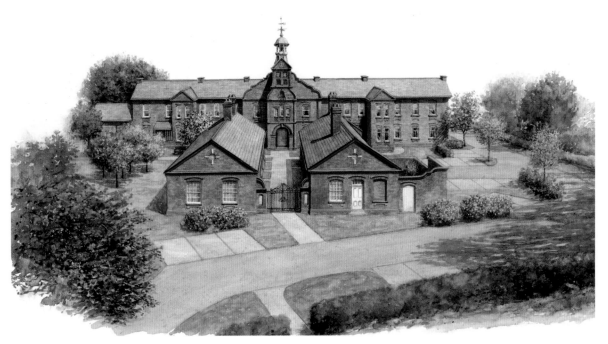

Finished watercolour illustration. With the raised eye level above the roof height, the main entrance can be seen, along with the gardens and parking areas.

of the setting with the entrance drive in the foreground. Normally, for a pleasing composition, it is best to avoid a central viewpoint that is symmetrical to the main subject matter, but on this occasion the requirements dictated the view and the offset foreground landscaping helped to balance this out. Measuring was fairly simple with the ground line positioned on the gable ends of the two buildings and a true height line raised from the ground line at a convenient position, away from the main drawing, to the right-hand side, which projected back to the end of the main building. The carport to the right-hand side was omitted in the final illustration.

Before the application of watercolour, the direction of cast shadows was determined from right to left so that shadows cast from the existing trees out of frame to the right would balance the composition with the large trees that come into view on the left. The extent of the picture was cut to white behind the main building and to give some indication of aerial perspective, the furthest trees were softened and foreground foliage and planting better defined.

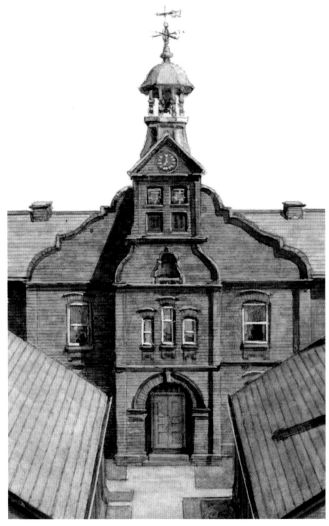

Detail showing the main entrance with ornate Flemish gable with tower and cupola.

Conversion and restoration of farm buildings

This project was to provide an aerial view and subsequent ground level views of a proposal to convert and refurbish existing farm buildings, as well as some new build, to create four residential dwellings. The client wished for the aerial view to take in the whole site to show the landscaping and the extent of each individual plot. Communal areas of existing trees and new planting were to be emphasized, together with a post and rail boundary fencing to the sides and rear of the development. An existing two-storey property was to be faded or ghosted at the edge of the drawing. The viewpoint was to be positioned looking from a westerly direction and high enough to see the enclosed gardens of plots three and four. The view was assessed to be fairly straightforward and so the drawing was carried out by hand using measuring points. The first step was to position the ground line at a convenient point on the site plan. Here you can see that it intersects at the point where the southwest facing wall of plot 2 meets the northwest facing wall of plot 1. This point marks the vertical true-height line in perspective. You will notice that the ground line also passes through a similar position on plot 3, which can also be used for true-height measurements if required. The drawing was set up at 1:200 scale from the site plan; with the ground line approximately positioned to intersect at the mid-point of the buildings, the resulting drawing was larger than if it had been positioned at a point to the front of plot 2. This effect of enlarging the drawing makes it easier and more accurate when marking off measurements. The next step was to draw the two axes through this point and take off the two angles made to the ground line which are 42° left and 48° right. These were then transferred to the perspective set-up. You will notice that on plots 3 and 4, the northwest/southeast wings are obtuse/acute angles and therefore cannot be measured using the same measuring points as plots

1 and 2 and were therefore estimated. The height of the eye level was estimated (*see* Chapter 5) and the footprint of the site plan measured and drawn in place. When setting up a perspective by hand it's always best to mark out the entire site to ensure that the view is correct before adding any detail in case it needs to be amended. The levels varied across the site and were taken into account in the drawing of each building.

Once approved the drawing was enlarged to approximately 250 × 600mm and transferred to watercolour paper using a light box. The colour palette and materials are shown in the box.

FARM BUILDINGS COLOUR PALETTE	
Grass and trees	Lemon Yellow, Cerulean Blue, Payne's Grey with a touch of Yellow Ochre/Burnt Sienna and White/Lemon Yellow gouache highlights. Ultramarine was used for the dark areas and shadows.
Driveway	Burnt Sienna, Cerulean Blue, Yellow Ochre
Pantile roofs	Light Red, Payne's Grey, Yellow Ochre with a touch of Antwerp Blue
Slate roofs	Payne's Grey with touches of Yellow Ochre
Timber cladding	Burnt Sienna, Yellow Ochre with touches of Payne's Grey
Brick plinths	Light Red, Payne's Grey
Stone walling	Yellow Ochre, Burnt Sienna with a little Payne's Grey

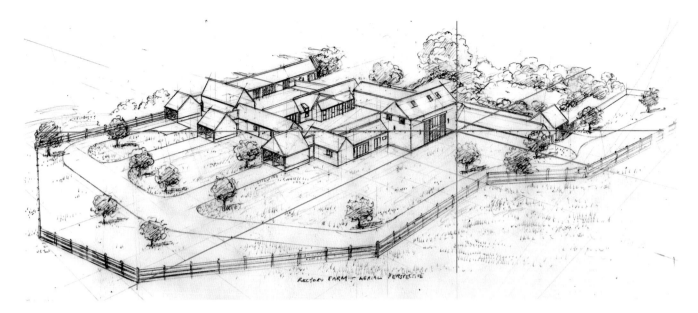

Draft pencil drawing showing aerial viewpoint of proposed barn conversions indicating the position of the ground line (in red) and perspective axes (in blue) with the height line on the corner of the large barn for convenient measuring.

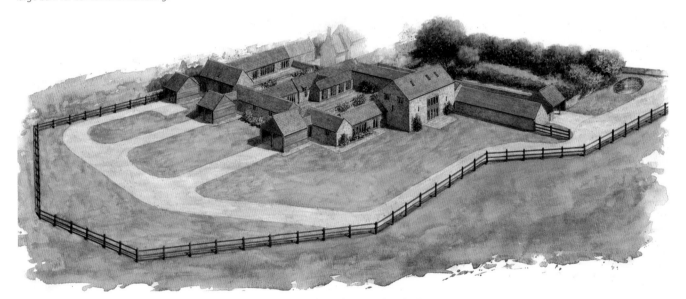

The finished watercolour illustration. In this view the site boundary was of significance with individual perspectives of each unit commissioned separately. The existing building to the rear of the site has been shown ghosted.

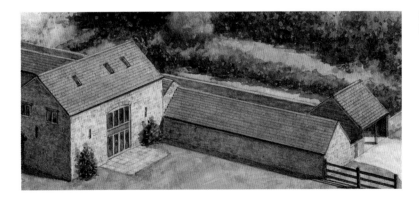

Detail of aerial view showing entrance way.

Richard T. Rees

I am an architect with a background in urban design and was for many years an urban design director in Building Design Partnership (BDP) in London. I am now Chairman of the SAI (Society of Architectural Illustration), a freelance illustrator and masterplanner. My skills also extend to painting and I also exhibit and sell oil pastels of high vantage point city views. My illustration speciality is also in aerial views, using a mixture of hand-drawn and computer colouring techniques. My working methods for this type of work are described below.

The example shown is of a large town centre development in Brentford in West London commissioned by architects AHMM and completed in 2013. Here I was asked to produce a large 'hero image' aerial that encapsulated the whole scheme for use in publicity and marketing. There was a SketchUp model available of the scheme from AHMM, which I manipulated to get the best view of the development. I gave the architects roughs of two different views with different shadow effects as a way of defining the best view into a key central street. They selected Option 1, with no shadows at all. The choice of view for a drawing is a balance between height and visibility of key features, particularly new streets.

Once the view had been chosen I set about drawing a full-scale A1 rough of the whole image on 90g tracing paper to determine details, and I liaised with the architects to firm these up before proceeding to the final image. There were Bing Maps available of the site, which helped to produce a context for the development. The 3D versions of Bing Maps can be manipulated to show views from the four compass points and are very useful for adding detail and specific character when combined with a SketchUp model. However, they are not always available, in which case the context must be made up from ground level photos and flat aerial view information.

After some adjustments and detail discussion, the final black and white drawing base was created by tracing over the rough at A1 and tidying it up. The size of the drawing was critical here to develop enough detail with the size of pen used – in this case a Copic Multiliner. These waterproof pens have a line that scans well; they vary in thickness from 0.03mm to 0.5mm but I generally use 0.05mm to 0.2mm as these give a good line for scanning. The 0.03mm line can be lost and thicker than 0.2mm can look crude. Sometimes I will create a double scale area of the drawing where greater detail is required (e.g. a shopping mall glass roof), draw it at that scale and then shrink it to fit back into the main image. This allows for the appearance of thinner lines without danger of loss of line in scanning.

Once the black and white base was created I got it scanned into the computer at 400dpi. Sometimes I use 300dpi, depending on the drawing size, as too big a drawing is often slow to manipulate. I prefer A1 as a drawing size as I am then able to scan the drawing myself in four parts on my own A3 scanner. This allows more control of the scan. The next task was to colour in the drawing in layers in Photoshop. My methodology includes creating numerous layers to allow for the flexibility of changing the colour balance and tonality of the final image. I often separate out the context layers from the new development layers so that they can be softened off by density or colour reduction to emphasize the new work.

A typical separation of layers for the new development would be: roads; landscape; buildings; roofs; glazing; water and shadows. There would be a similar range of layers for the context.

Figures are critical to the success of these large aerials as they give scale and liveliness to the image. Similarly, the entourage is important and flashes of colour from awnings and landscape features breathes life into the view. In this case there was a last-minute change to the drawing where the architect asked me to include roof gardens on tall blocks. It can be a problem of creating interesting aerials that there is sometimes too much plain roof exposed on the drawing.

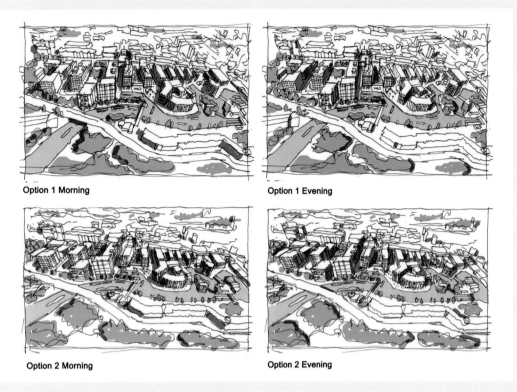

Option 1 Morning

Option 1 Evening

Option 2 Morning

Option 2 Evening

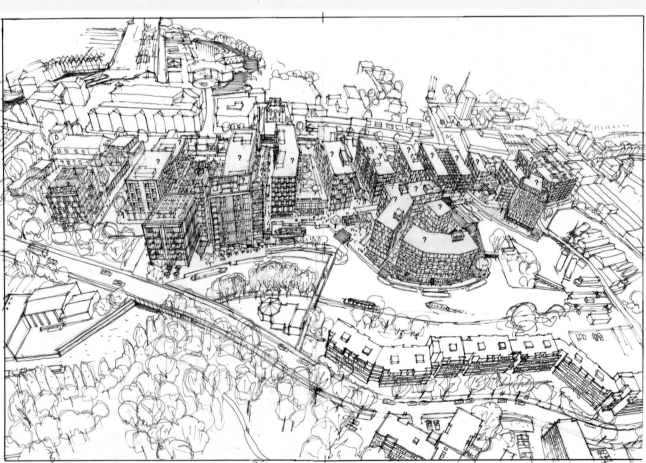

Brentford aerial rough in black and white, showing area of detail on new buildings for approval.

Use of Bing aerial photos for context. A typical section of a Bing map used on the drawing is shown next to the interpretation. (©Microsoft systems.)

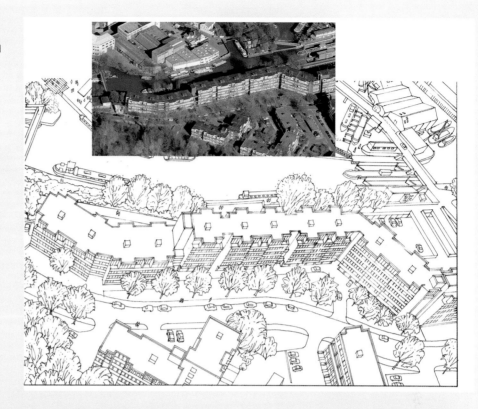

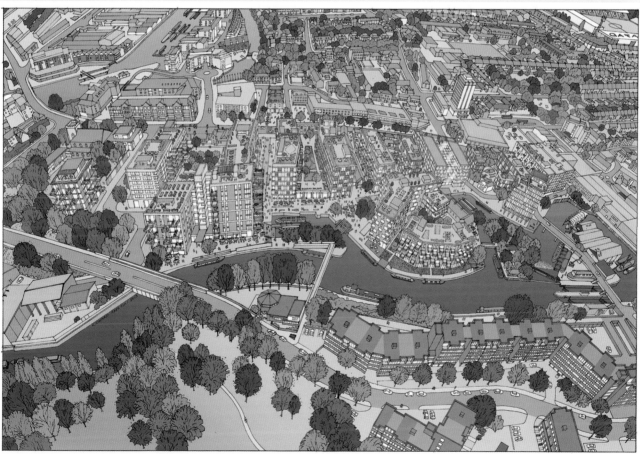

Coloured drawing using Photoshop. My approach at Brentford was a flat colour range with no shadows and no glazing colour, which I have included on other drawings. This suited the architect's aesthetic.

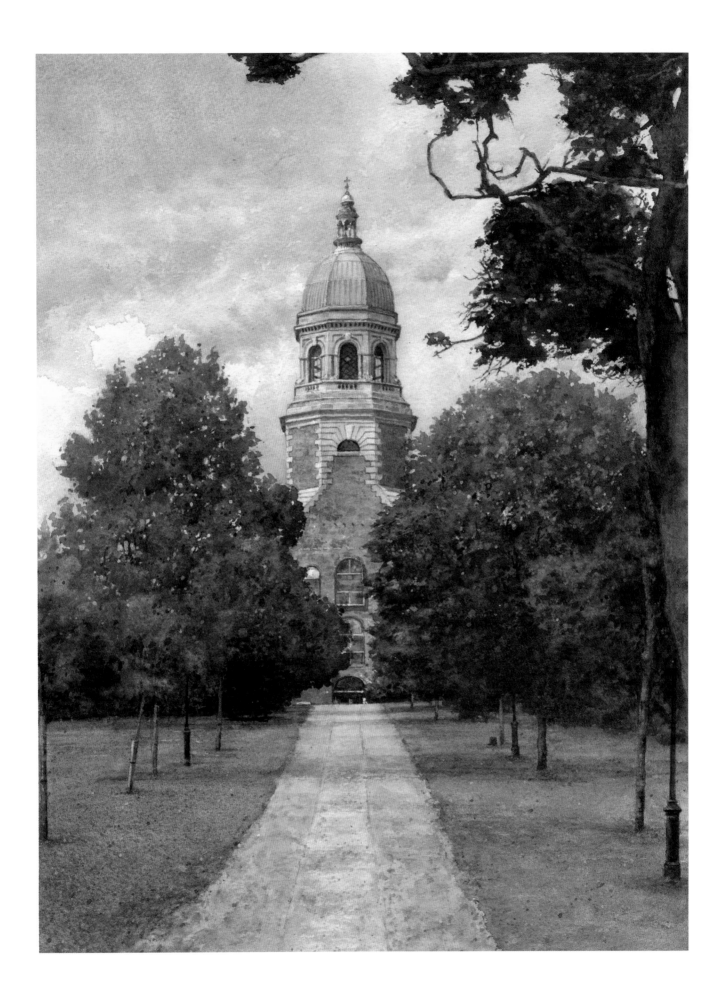

Topographical Illustration

To draw does not simply mean to reproduce contours; the drawing does not simply consist in the idea: the drawing is even the expression, the interior form, the plan, the model. Look what remains after that!

Jean-Auguste-Dominique Ingres

The importance of the topographer – one who describes features of a place or region – has endured since early Victorian times. However, the romantic idea of the academic cleric with a watercolour box and brushes in hand, setting out to document buildings and the landscape within his parish, has clearly moved on. Indeed, in a world of Google Maps and Street View even distant topography can be studied from afar. Nevertheless, the topographical tradition in art continues to attract practitioners from a variety of disciplines, not least in painting and illustration. At the start of the eighteenth century, topographical drawing and painting was purely objective in its approach to the representation of a place, and was considered reliable in its documentation at a time before photography. This began to change with prevailing trends and fashions, not least the insatiable demand from wealthy middle-class travellers on the Grand Tour who would employ topographers to record famous views en route. Artists would manipulate these views to form compositions that would suit copper engravings and could be used later on ceramics. Such drawings soon became more painterly and the artist's style became more important, eventually resulting in the poetic and romantic landscapes of the nineteenth century.

The Royal Victoria Hospital or Netley Hospital was a large military hospital opened in 1863 and demolished in 1966. At the time it was the longest building in the world and this illustration shows the chapel – the only part to be retained. Watercolour over pencil on 140lb Arches NOT stretched watercolour paper at 370 × 290mm.

The legacy of topographical drawing today is inherent within a diverse range of specialisms and sits alongside other forms of painting and illustration. Chapter 2 looked at the process of sketching on location as a means to improving drawing skills as well as preparation for a commissioned illustration. This chapter examines the process in its own right and explores the possibilities of creating later, more considered artworks, for selling or exhibition.

A dialogue with the past

Drawing and painting on geographic location are central to both topographical and predictive architectural illustration. It is crucial to have one foot in the real world to be convincing and the process of documenting a site starts with living in the space as a way of becoming intimately familiar with the surroundings. Sketches and photographs are confirmation of its existence at a particular time and these become reminders of the experience rather than just useful for reference. To be able to walk around a site, taking in its sounds and smells, adds value to photographs and drawings and allows the re-creation of (photographic) realism within an illustration or painting. Realism is central to both aspects of the work and, in the case of an artist's impression, they will feed into one another, going back and forth from visualization to representation.

The writer Julia Moszkowicz (2015) talks about this and ways of reading work made on location in her article published in the *Journal of Visual Art Practice*; she relates topographical illustration with the concept of heterotopia

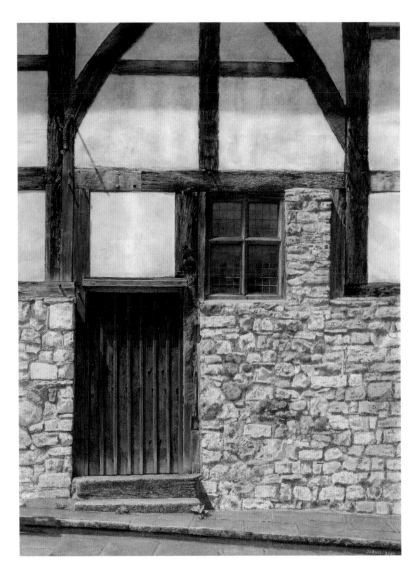

described by the French philosopher Foucault. Moszkowicz talks about 'a dialogue with the past' and discusses the dual role of being in the past and the present simultaneously. She says that the recording of historical buildings and structures offers the opportunity to capture a sense of continuity: a meeting of the past in the present. In the practice of documentary or observation-based illustration, Moszkowicz says that it's most important to create a relatively objective visual record of a location, at a particular historical moment, by paying attention to details and using a naturalistic colour palette in response to the landscape.

The idea of place and location is synonymous with topographical illustration. The Italian term *veduta esatta* meaning 'accurate view' was applied to the genre of painting large cityscapes and vistas; it originated in Flanders in the sixteenth century and later became a speciality amongst seventeenth-century Dutch painters. This term is most apt in the process of illustrating a view through on-site drawings and photography with the intention of producing a detailed studio piece. Site drawings, whether done fleetingly or over time, will make a difference to the final work and it's worth allowing as much time as possible for collecting information through sketches, notes and photography. Once in the studio, and after studying the on-site material, there will always be occasions when something is obscured or vague and a return visit is usually the best policy especially if accuracy is a priority. If a return visit is impossible, and depending on the nature of the subject matter, a Google search on Street View may help solve the problem, particularly if it's architecture-related. Many issues are dictated by the weather and time spent working out the best time of day to set out beforehand is recommended – it is very frustrating to arrive at your location only to find that the view you want means staring directly into the sun. However, a particular viewpoint may dictate an initial visit to assess the conditions and a return visit to carry out the work.

Retaining the moment

Away from the site, and in the relative comfort of a studio, it can be far too easy to over-indulge with the detail of a view; there is always a tendency to overwork a subject and 'lose the moment' when rendering a certain area, especially with the medium of watercolour, which can be unforgiving at times. The size and scale of a drawing will affect how much detail can be applied to your subject but there are certain pre-conditions that will need to be considered. Watercolour drawings need to be planned before making a single mark and the first decision is the type and grade of paper to use. For the illustration of Westgate Hall Southampton, several visits were made to the site to obtain the most favourable lighting conditions. This illustration formed part of a one-man exhibition of architectural drawings and watercolours entitled *A Point of View* and was also to be featured as the exhibition poster. The view was taken from a photograph looking from a position perpendicular to the east elevation and was cropped down from a wider view; this allowed compositional judgement in deciding on the final view and crop dimensions. Several return visits were made in order to capture the right light and shade effects and particularly the cast shadows. You will notice the sun's position was fairly high and with the elevation facing in an easterly direction, the long shadows would have been cast just before it was plunged into complete shade. Shadows are instrumental in the visual description of a structure and in this example they work well across the face of the building. The main shadow cast from the overhanging roof at the top of the façade helps to define what is absent from the picture and the long shadows cast from the protruding dowels in the timber joints, together with the overhanging porch and uneven stonework, work together to create a sense of form and structure.

As has already been emphasized, the time spent on location with sketchbook and camera is time well spent. The idea of 'living' in a space and recording on-site details, as well as making decisions about composition and layout, all helps to make later studio work more successful. What the sketching process offers is almost an out-of-body experience – when the physical state becomes subordinate to the eye, mind and hand coordination as it moves across the paper's surface – and is a kind of meditation. Time races by but without the normal regulators: sounds and movements blend into the activity rather than separate from it. These and other merits of drawing on location revolve around the process of capturing 3D reality on a 2D surface and making sense of it.

Watercolour sketch of Stokesay Castle, Shropshire, done on 140lb Arches NOT watercolour paper in an A5 sketchbook in around an hour and a quarter.

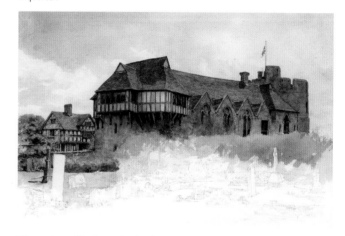

Watercolour of Stokesay Castle, Shropshire, shown here at just over the halfway stage of the painting completed in the studio. Here you can see the detailed drawing in the foreground that remains visible up to the final washes for accurate rendering. Using several washes to build up the final stage render is unique to watercolour in its delicate subtlety.

Stokesay Castle is a fortified manor house in Shropshire built in the late thirteenth century by a wealthy wool merchant. It was intended to be a secure private residence rather than a military fort and its design would never have stood up to a serious siege due to its expansive windows. Its presence is dramatic on arrival with its tower clearly visible above the hedgerows that line the narrow lane – a truly impressive sight on the landscape. The hour or so spent on this colour sketch of Stokesay Castle helped to solve problems relating to the proportions of the building against the background and foreground. The later studio piece, seen here in two stages, was worked up from several photographs taken on site. The composition can be seen as comprising three layers: the timber-framed gatehouse to

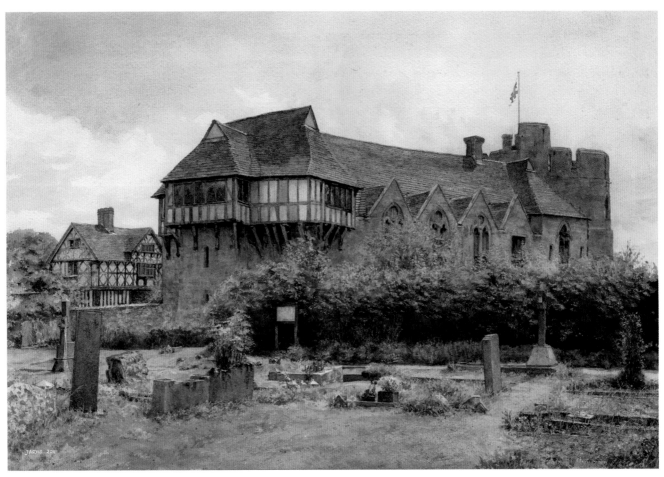

Stokesay Castle. Watercolour over pencil on Saunders Waterford 140lb NOT stretched paper at size 360 × 530mm. The finished work was completed in around twenty hours. (Private collection.)

the left side background, the castle itself and the graveyard in the foreground. This, together with perspective and viewpoint, were organized to 'draw' the observer into the picture.

Capture the castle

On arrival at Wardour Castle in Wiltshire one is instantly captivated by its magnificence. Sitting proudly on a gentle mound that slopes down to a large lake beyond, this imposing structure dates back to the late fourteenth century. At this time it would have been lightly fortified, with a wide ditch, drawbridge and portcullis defending the main entrance. The midday sunshine helped define the partially ruined stonework and I tried to capture this with pencil and watercolours in my sketchbook. My passion is combining suggested detail with atmospheric lighting, and how light falls across a surface. As this view is very square-on, the cast shadows act as pictorial codes and are instrumental in

describing shape and form, giving a sense of depth within the structure. Here you can see the initial watercolour sketch done on location and four stages of the final colour study that was based on photographs.

When taking photographs of tall buildings, depending on the camera lens used, there will always be a certain degree of distortion as the vertical vanishing parallels converge to a point above the structure. To counteract both this and the associated foreshortening, the vertical convergence was corrected and the height increased to retain the structure's true proportions – it's almost like withdrawing one's position so that the distance is increased between object and viewer. This procedure was carried out by scanning the photograph, opening in Photoshop and using the Perspective Crop Tool. The extended height was approximated by eye.

Next, with the verticals corrected, the photograph was traced through onto a sheet of marker paper with

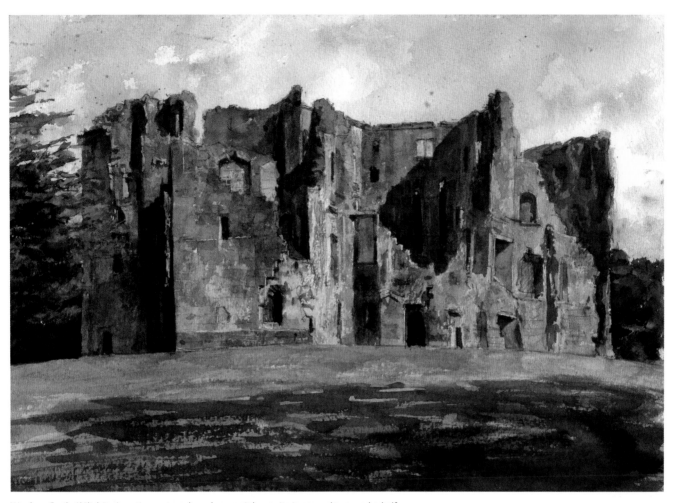

Wardour Castle, Wiltshire. Location watercolour done mainly on-site in around two-and-a-half hours with later touches added in the studio; 280 × 400mm in sketchbook on 140lb NOT watercolour paper.

a fine liner pen using a light box. The smooth surface of the marker paper allows for fine detailing of shapes and textures using shading and cross-hatching. This drawing then acts as the intermediate stage, which is important when working directly from a photograph, by taking the final drawing one step away from the photograph. Using this approach avoids slavishly reproducing the photograph and allows a more creative interpretation, particularly at the colour stage. Once completed this is then placed onto the light box and traced through using a B pencil onto water-colour paper – in this case a sheet of Arches 140lb NOT surface. Using a soft pencil on a textured surface makes the drawing looser and offers more freedom in representing tonal values, particularly relevant to the subject matter here. Once finished, the paper was soaked in a bath of cold water for around ten minutes, allowed to drip dry for a few minutes and then applied to a portable drawing board and stretched with gum strip and allowed to dry on a horizontal

surface for three or four hours (*see* Chapter 4).

A traditional approach was taken in the application of watercolour starting with the sky, background trees, the structure and, last, the foreground grass. A plain water wash was applied to the sky area first and, whilst still wet, a wash mix of Antwerp Blue with a touch of Payne's Grey was introduced to the top of the paper and, with the inclined angle of the board increased, the colour was allowed to blend and merge across the sky area. To control the way the colours mix, the board can be lifted and moved back and forth. Other colours applied to the sky in the same way were Alizarin Crimson and Yellow Ochre to give an atmospheric effect. Also notice how this technique helps to achieve granulation in certain colours where the pigment separates from the binder to produce a grainy finish. The base washes for the building itself were applied in a similar fashion by first dampening down the whole area with water using a large wash brush and introducing local stone

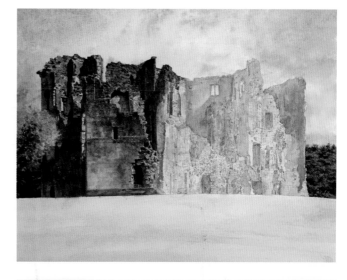

Wardour Castle, Wiltshire. Stages showing the painting process working from background to foreground and left to right (for a right-handed person). The sky was adjusted to suggest the sunlight was a break in the clouds and to create a more atmospheric context for the building. Watercolour over pencil on 140lb Arches NOT at 437 × 596mm.

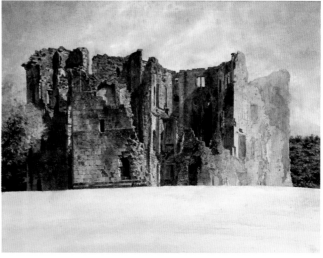

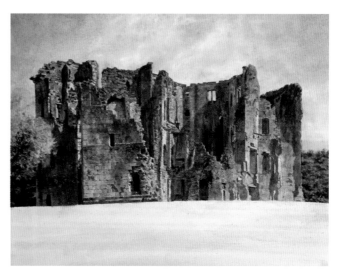

colours to the surface whilst still wet. The colour palette for this was Yellow Ochre, Light Red, Alizarin Crimson, Ultramarine and Cerulean Blue, which were all used as pale washes and introduced while the surface was wet and allowed to dry before laying subsequent washes. This initial washed drawing was done to identify the light and dark areas and surface tonality across the structure and to maintain some consistency. Notice how the colour is applied to the building from left to right, the most natural direction for a right-handed person, and taken to completion in small sections before moving on to the next. This was done to establish the tonal range early on during colour application. The darker areas in shade and shadow were the last details to be added and Permanent White gouache paint was used for highlights to edges and surfaces reflecting light. The overhanging tree to the left was also defined using gouache mixed with touches of watercolour Lemon Yellow and Ultramarine. Finally, the grass and shadow in the foreground were rendered in a similar way to the sky. A large amount of a wash mix of Lemon Yellow, Ultramarine and Cerulean Blue was applied with a large brush and kept wet whilst moving the board, again to separate the pigments. The shadow in the foreground cast from the suggested out-of-frame trees was applied with a mix of Ultramarine with a touch of Burnt Sienna whilst the grass wash was slightly damp so that the edges appear softened. The watercolour was completed over a three-day period and was hung as part of an exhibition entitled *Capture the Castle* in Southampton's City Art Gallery.

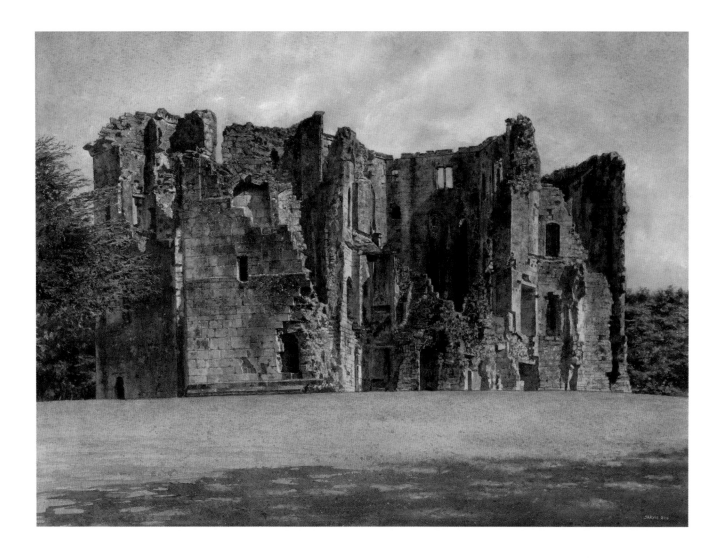

A Tudor house

This was a self-initiated project with the aim of illustrating buildings of particular interest in and around the Old Town area of Southampton with a view to publishing these in a guide to city walks. Tudor House was one of six buildings selected for this purpose and one of the most distinctive. If you share a love for drawing old clay tiled roofs then this one has real character with weathered and discoloured areas covered in patches of moss and lichen. The aim was not to get too involved in detail but to give the impression that every tile had been painted. After making some initial sketches and taking numerous photographs on location, the most suitable view was selected and the photograph was enlarged to a convenient size. On the day of the site visit the weather was overcast, which can create a dull illustration, although this can be remedied by the application of cast shadows worked out in theory and supplemented by other references where available. However, with the building itself offering such contrast between the timber framing, some of

which is black-painted, and light-rendered panelling, as well as the rich red brickwork and clay tiles, the illustration was completed with respect to the prevailing conditions.

As the artwork progressed, the timber framing really stood out against the white render which was accentuated using warm and cool colours in the shaded areas beneath the roof projections on the gable ends. Without cast shadows to provide depth codes, the illustration needed to rely on the subtle tones and textures to explain the building's design in this study.

Tudor House is arguably Southampton's most important historic building, encompassing over 500 years of history on one site. The impressive timber-framed house was built at the end of the fifteenth century by Sir John Dawtrey, and has undergone a £1.9 million restoration scheme, which was funded by the council, the Heritage Lottery Fund and English Heritage.

The side of the house was quite a challenge due to the chosen size of the artwork, which could have been larger

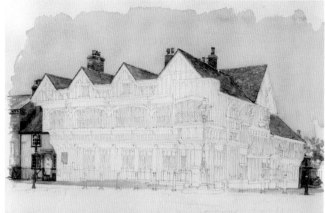

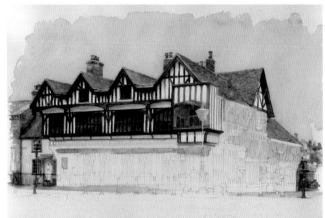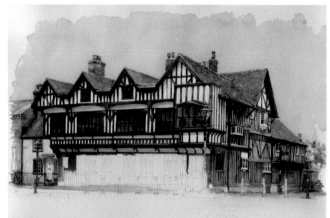

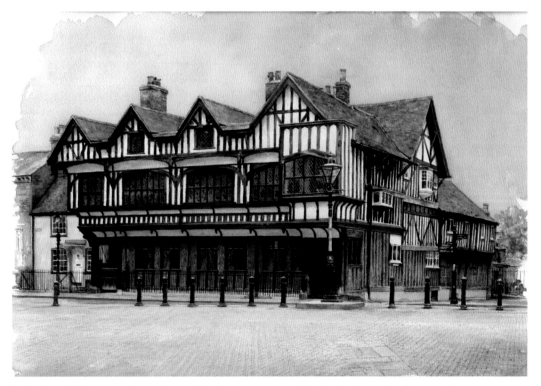

Tudor House, Southampton. Stages showing the painting process working from background to foreground and from light to dark and in each area of the drawing to finished stage. Watercolour over pencil on 140lb Saunders Waterford NOT at 320 × 440mm.

with the amount of detail involved. The palette for this area was basically six colours: Light Red, Yellow Ochre, Alizarin Crimson, Payne's Grey, Cerulean Blue and Permanent Mauve with a little Permanent White for highlights. I use several makes but mainly Winsor and Newton Artists' Water Colour, which I find the best quality. The brushes used were Rosemary and Co Sable series 33 nos. 2, 4 and 6 with no. 12 for the sky. These have a reasonable life and are cheaper than Winsor and Newton's series 7 which are probably the finest sables available. In the finished watercolour the sky was darkened to the right-hand side with an additional wash of Alizarin Crimson/Cerulean Blue mix and touched up in a few small areas of the building – trying not to overwork the details!

Hospital of St Cross

In addition to the beneficial influence on professional and commissioned work, drawing on location is a sure way to recharge batteries and put all those worries aside. Drawing and sketching *en plein air* can be a most therapeutic experience and a few hours spent at the Hospital of St Cross certainly provided this. The Hospital is part of several

Grade I listed buildings in the serene and tranquil village of St Cross near Winchester, including almshouses and a church dating back to 1132. Here you can compare the watercolour sketch, drawn in about two-and-a-half hours, with a more detailed watercolour completed in the studio from photographs taken on the day.

Clearly, the two experiences are quite different and offer their own challenges. Location sketching is more to do with that moment in which time seems to slow down as you interpret what's in front of you. Focus and concentration become all-consuming with brief periods of reassessment and adjustment to your surroundings. After a sustained period, as with this example, prevailing conditions affect how we respond to selected subject matter. As the sun moves across the sky, shadows creep slowly from surface to surface giving explanation and definition to form and structure. On this occasion, after about an hour's drawing, the silence was broken by the arrival of a wedding party, with the bride stepping out from a vintage limousine to enter the church behind me. All went quiet after the last guests had arrived and, knowing there would be a period of uninterrupted drawing, I prepared myself for the duration, ready

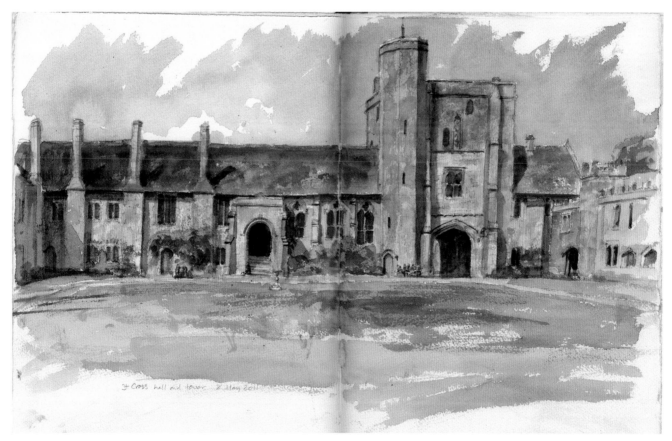

Hospital of St Cross, near Winchester. Location watercolour done in sketchbook on 140lb Saunders Waterford NOT surface paper in around two-and-a-half hours. Working across two pages in a sketchbook is half the size of a single sheet and can help you to be less precious about the finished work.

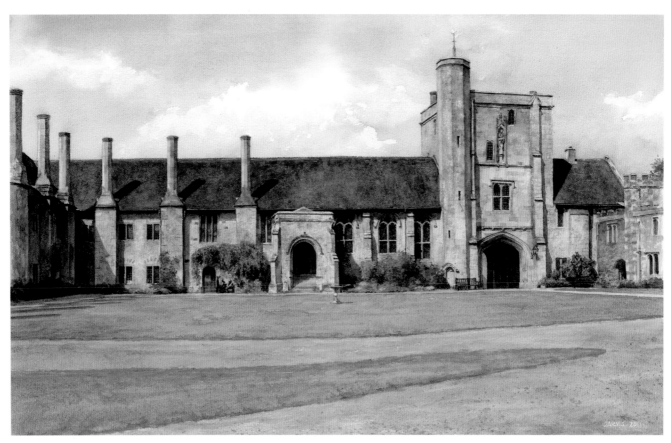

Hospital of St Cross, near Winchester. Watercolour over pencil on Saunders Waterford 140lb NOT stretched paper at size 360 × 530mm. The finished work was completed in around twenty hours.

to avoid unwanted appearances in the formal photography. On returning to my original position I was aware that the sun's angle had changed, creating much longer shadows and this was recorded on camera for later reference.

Location drawing, and especially the use of watercolour, needs planning and preparation before setting out. First, you need to ask yourself what is the purpose of your venture and whether there will be a subsequent painting or illustration. Is the drawing the precursor to a commission or commercial work, or is it for practice or pleasure (or both?). The merits and materials of working *en plein air* have been discussed in Chapter 2 but it's important to have a strategy; otherwise, without discipline, it's easy to waste time or lose focus. At the time of sketching at the Hospital of St Cross, I had been invited to stage a one-man exhibition and therefore there was an end result in mind. Having a purpose in mind will affect how long you intend to sketch for, and the choice of materials. The equipment and materials you use will be crucial to the type of drawing you make and will dictate your choice of paper. Sketchbooks come in all shapes, sizes, and types of paper; alternatively, you may

wish to use a glued pad or block which keeps the paper from buckling when working very wet. It's normally best to keep to a 90lb (190gsm) or 140lb (300gsm) paper and a HP or NOT surface for ease of use, as heavier or rough surfaces tend to inhibit drawing and absorb water very quickly (this varies of course depending on the type and make). You also need to decide what the general shape of your subject matter might be and whether it will be better to use portrait or landscape format paper. Limiting your palette is always a good idea when outside so that colouring is simplified, as is keeping your range of brushes to one wash brush and two or three smaller sizes for broad and fine work. It's usually better to use a paint box with half pans rather than tubes, as they are simpler to apply when outside. A good-sized plastic water container is a must with plenty of bottles to replace dirty water. The sketchbook size used for the Hospital at St Cross was 160 × 250mm and done on Saunders Waterford 140lb NOT paper. The final studio version was completed from photographs taken on site and took around 16 to 18 hours.

St Peter's Church, Forncett St Peter, Norfolk. Pencil sketch on heavyweight cartridge paper in A5 sketchbook done in a few minutes as part of visual research towards a watercolour study.

All Saints' Church, Freethorpe, Norfolk. Pencil sketch on heavyweight cartridge paper in A5 sketchbook. Rapid sketches done in just a few minutes, as seen here, may be all that is necessary for the later production of a finished watercolour. Used as part of visual research material towards a watercolour study.

The round tower church

Churches with round towers are mostly found in Norfolk and Suffolk, with a few in neighbouring counties within the East Anglian region of England. There is evidence of 185 all told, some of which are wholly, or partly, in ruins but show the remains of a round tower. Many of these churches are Saxon in origin and it is thought that the primary reason for building round towers was due to the lack of indigenous stone suitable for building apart from flint. To build square towers a stronger stone is needed for the corners and so the towers were built round and entirely constructed out of flint bound in mortar. This of course doesn't explain why the church nave has stone quoins or corners, as it would have been built first, although not as tall. These unanswerable questions surrounding the design of the 'round towers', in addition to their delightful settings in this part of the country, made their study even more attractive.

The Forncetts are a group of villages that run in to each other to the north-west of Long Stratton in Norfolk. The glory of St Peter's Church is in its tower, which is arguably the best example of an original Saxon round tower in

England, even though the parapet is a later addition. In fact, many round towers are difficult to spot from afar as, with some, there may only be evidence of the original tower not much above ground level. After the Norman invasion many round towers were replaced or added to, using stone quoins and designed with octagonal castellated parapets. After initial research through the Norfolk Churches website, the project began by plotting the churches within an area just southwest of Norwich and, using an Ordnance Survey map together with sat nav, locating and visiting as many churches as possible over several days. On arrival at each, sketches were made and photographs taken as primary reference for making a series of watercolour studies. Each church held its own charm and there was no disappointment, only anticipation, on catching the first glimpse of each of the twenty-nine or so visited over this time. The weather held out for periods of time on each day and even when the sky did cloud over and rain fell, the aftermath of sun reflecting off the wet surfaces created its own unique atmosphere. The majority of churches were open, but those that weren't clearly advertised how to obtain the key; even though I was

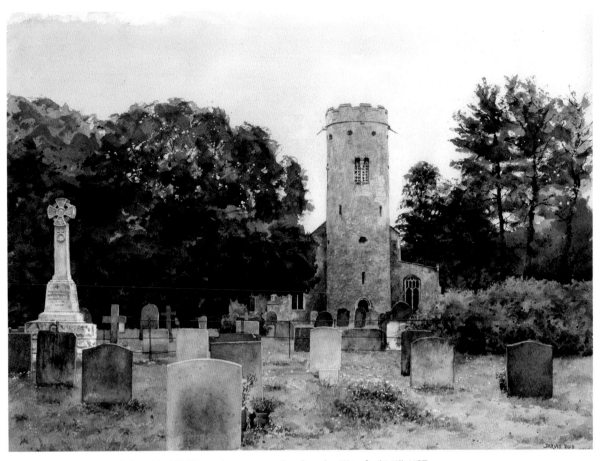

St Peter's Church, Forncett St Peter, Norfolk. Watercolour over pencil on Saunders Waterford 140lb NOT paper at 300 × 440mm. The overcast conditions helped to portray the graveyard in a more tranquil state than if there were strong cast shadows from sunlight. (Private collection.)

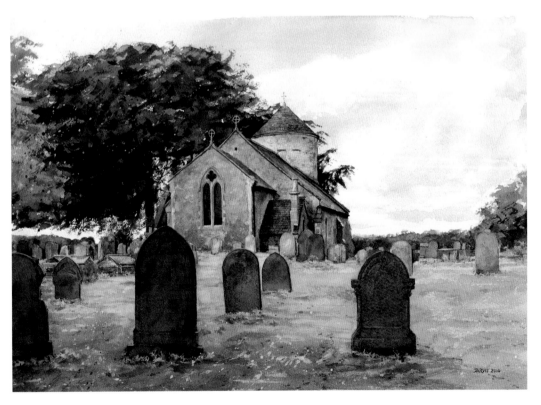

All Saints' Church, Freethorpe, Norfolk. Watercolour over pencil on Saunders Waterford 140lb NOT paper at 300 × 440mm. The main reference for this studio watercolour were photographs taken just after a heavy shower and a weak sun was reflecting off wet grass and foliage. (Private collection.)

mainly concerned with outside views, it was always a pleasure to venture inside or be met by welcoming hosts (in one case offering tea and cakes in the style of a wayfarer's dole!).

Churches are somewhat unique within the story of architecture and can be placed between polite and vernacular buildings: those that have been formally designed and the dwellings that are created by artisans whose skills have been inherited over generations. Because of the large number that have survived wars and conflicts, our churches, above all other buildings, can tell the story of how humanity has developed in a particular place and over centuries through births and deaths and much of what has happened in between. The secret is tapping in to, and making sense of, the cultural language of its time. Although, sadly, church interiors have been subject to much ransacking over time, particularly during the Reformation and, later, the English Civil War, they can still shed light upon the major historical events – sometimes through what is lacking rather than what has been preserved.

Back in the studio, all the information was organized and archived ready for turning into watercolour studies. The intended outcome was to stage an exhibition of the works and, ultimately, for future sales as well as reproduction purposes for possible use by parish and diocese.

A finished sketch

The illustration shown here is of an early twentieth century church built in 1902 in red brick and stone. It is the result of an hour or two spent sketching on location in the churchyard using an A4 sketchbook; it was then coloured back in the studio. It's a good example to end this chapter, as it summarizes all that is relevant in the process of topographical illustration. The initial sketch represents an intimate response to the subject matter and its surroundings, and investigates proportions of shape and form in perspective, whilst the later watercolour application explores light and shade, shadow casting and surface colour and textures. Using photographs taken on location, the finished work reflects the time of day (notice the clock showing just after midday), atmospheric conditions and the view seen from a specific position on a particular day and in this, acts both as documentation and interpretation.

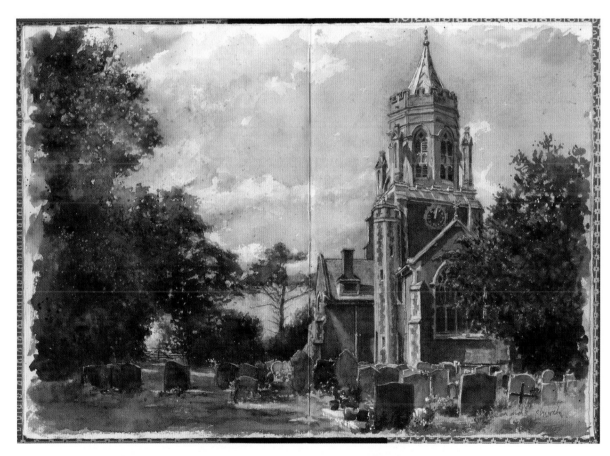

St Leonard's Church, Sherfield English. Watercolour over pencil in A4 sketchbook on 90lb Canson Montval NOT watercolour paper. The pencil sketch was done on location in around an hour and a half, with colour added in the studio.

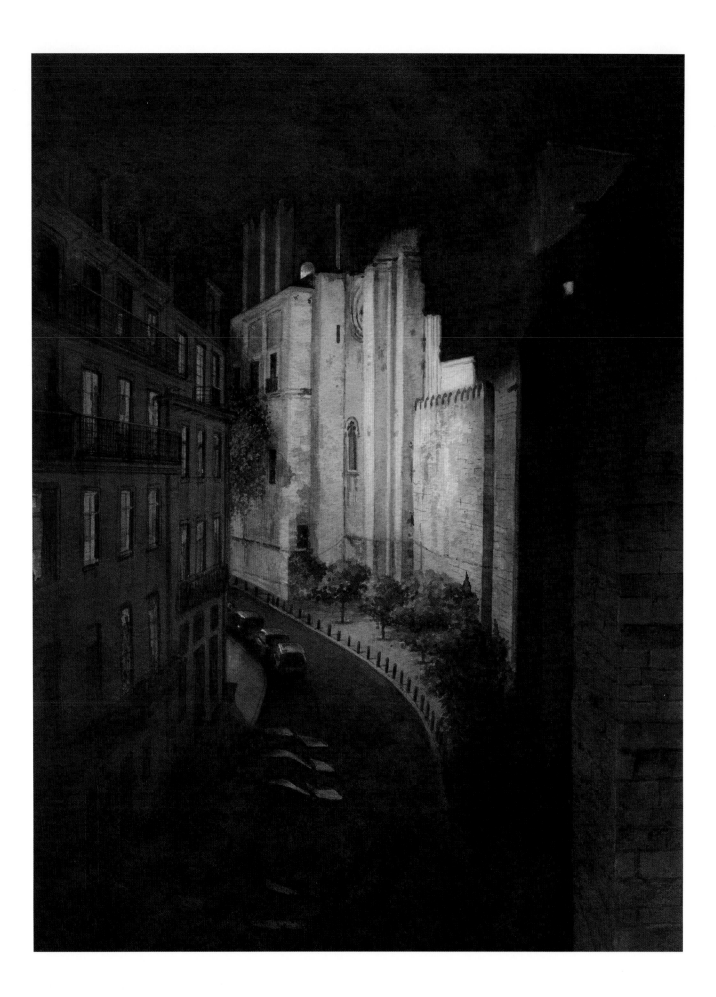

CHAPTER 8

Appraisal and Reflection

Drawing is not what one sees but what one can make others see.

Edgar Degas

This final chapter deals with the kind of issues that the illustrator will encounter on a regular basis during the undertaking of both commissioned and personal or self-promotional work. It's not always easy to define the differences between both aspects and, as has been discussed previously, the benefits from regular observational and location drawing will enhance commercial practice. Sometimes it's the decisions that the illustrator makes whilst site sketching, which have a direct bearing on a subsequent commercial application. Many issues relate to the interpretation of a project and how a building is best represented given personal or commercial limitations. This might simply revolve around questions of viewpoint relating to a particular commission or, on the other hand, might deal with more complex criteria. More often than not, a site will contain restrictions on how a building is viewed and this may clash with the client's needs. Sometimes, an illustration might be the result of an agreed compromise, whereas at other times the view might be entirely representative. When working on a perspective view it's common to make small adjustments to existing and proposed landscape features to suit the composition, although this should be done with caution (*see* Chapter 1). Public opinion surrounding both visual and written descriptions of proposed buildings has caused much suspicion over the decades and today even more so, particularly with computer-generated images. The following criteria may be of value when making judgements relating to architectural perspectives: representation, accuracy, clarity, aesthetic appeal and credibility.

In assessing the effectiveness of an illustration, an important factor is the nature of its representation from a chosen viewpoint in relation to the subject matter: is the view appropriate to the viewpoint and angle of vision? Accuracy refers to the placement of subject matter within an existing environment as well as factors including scale and proportion, distortion of elements and technical details relating to design features. Clarity can be defined as the extent to which the subject matter is represented in a clear and unambiguous manner. This can relate to the medium used in its portrayal and whether any abstraction that might obscure important features has occurred. It can also have an impact on its reproduction on-line and in print. Aesthetic appeal can be described as the extent to which the illustration incorporates pictorial elements to form an interesting and pleasing composition and its appropriateness in terms of drawing and rendering style and medium. The credibility of an illustration can be described as its degree of reliability as a statement of fact when open to scrutiny.

Lisbon Cathedral is the oldest Roman Catholic church in the city, dating back to the year 1147 when construction began. Since then it has been modified many times and represents different architectural styles over the centuries. This view was sketched from a first-floor apartment and worked up in watercolour in the studio. A night scene offers a very different experience to daylight, as demonstrated in this study; the cathedral walls appear to glow in contrast to the darkness of the surrounding buildings with colours intensifying under the strong spotlights.

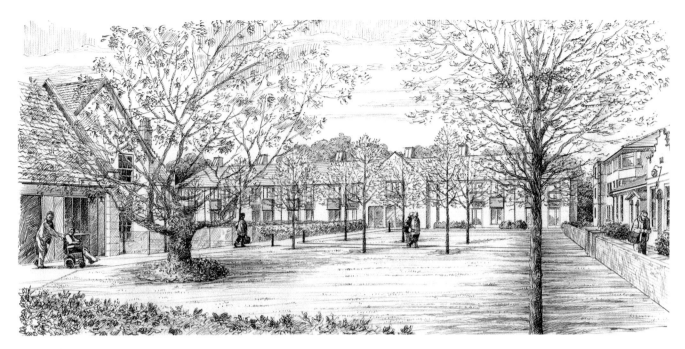

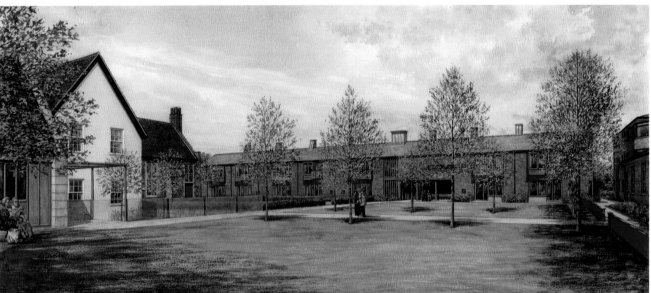

The Great Hospital in Norwich was the subject of renovation and new buildings. The angle of view in this initial pencil drawing was later changed to a viewpoint closer in to the gardens to avoid the existing tree on the left and to focus on the proposed building behind the trees. It was important that the new buildings would blend with the existing listed buildings seen here on the left.

Some of these criteria can be transposed and used for illustration work of a more general nature other than in architectural perspectives. When representing existing buildings or historical reconstructions the emphasis of criteria will vary depending on the nature of the illustration. In the example seen here of a perspective view showing a proposed extension and improvements to listed buildings, the initial pencil draft was rendered to a higher-than-usual finish to show the client how the view would look prior

to applying colour. The Great Hospital in Norwich was founded in 1249 and provided shelter for aged priests, scholars and the sick and remains today sheltered housing for the elderly. As a building of national concern it was important that the illustrations communicated the right messages of conservation as well as improvement to the area. The pencil drawing was well received but over time the architects had amended the design of the two-storey building seen at the far end of the garden courtyard. The

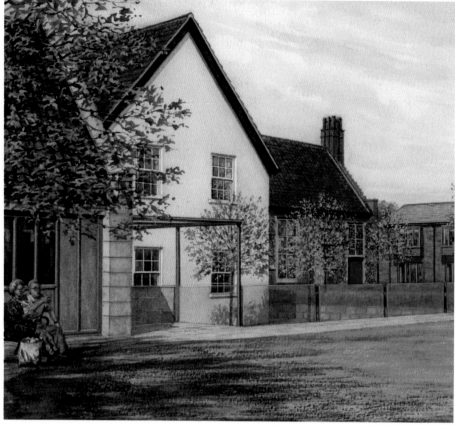

Detail of the Great Hospital, showing the glass balustrade and existing buildings.

second image shows how the perspective has changed to move closer in to the courtyard giving more emphasis to the additional building. The existing tree to the left-hand side has been moved out of view with only a few branches showing so as not to obscure the existing buildings. The cast shadow projected by the tree helps with the composition, as do the proposed trees to the right-hand side where one has been removed but its shadow remains.

In the entrance view to the proposed development seen on the next page, the client has annotated the illustration, indicating changes to be made. As you can see, the original artwork sent to the client shows a parked car placed near the centre of the illustration. This was felt to be out of scale at the position it occupied and needed to be adjusted or removed and the latter decision was taken. This, together with other changes, meant that it was too complex to do digitally and so the original artwork was changed. To do this, plain water was first applied to the car and left for a few minutes to soak into the paper. Then, a paper tissue was applied to the surface using considerable pressure, which absorbed much of the colour. After that a small brush was used to take off most of the remaining colour and then left to dry (to speed things along, a hairdryer could be used).

Once dry, a putty rubber was used to rub away the pencil marks and then a plastic rubber to resurface the paper. If any marks still remained, then the use of a hard rubber, the type available in pencil form, would complete the job. For standard architectural perspective illustrations a good paper to use is Canson Montval Aquarelle NOT surface at either 90lb or 140lb. This provides the benefit of a rugged surface, which will stand up to a hard eraser to make changes and show little stress, and the surface can be drawn and painted over with ease. With difficult amendments it is sometimes necessary to use Designers Gouache to cover unwanted marks or discoloration. Making changes to the original artworks is preferable to using Photoshop as it's easier to maintain consistency and the client will often wish to frame the original. However, it's often a matter of using both means to achieve the best end result and a digital version would be sent to the client.

The brief for the aerial view later in this chapter was not only to show the barn conversion but also its context in relation to the parish church opposite and adjacent houses. This is when Google Maps becomes a useful resource in helping to establish the relationship between various landscape features and landmarks. It's surprisingly accurate

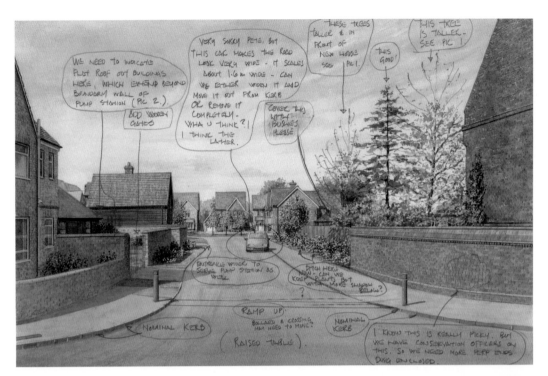

Proposed entrance view to a new development of houses. Although the pencil draft was approved by the client, the finished colour illustration needed several amendments as shown here with architect's comments and amended artwork. All the changes were made on the original artwork rather than using digital means.

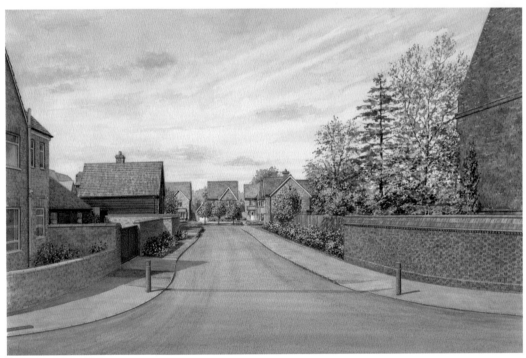

when using satellite views to proportion overall plans of buildings and sites. These, together with architects' plans and other visual material, all come together to create the finished illustration. In aerial views the cast shadows are most important in achieving a convincing whole and will add to its credibility as an accurate representation. Also, due to the extent of the overall view, the buildings give few visual clues regarding depth and it's the perspective applied to the furrows in the large field in the foreground that draws you into the picture.

Practising sketching people on location really helps when you are faced with incorporating figures into a commercial perspective illustration. In the colour sketch of the Christmas market at Winchester Cathedral on the next page, the

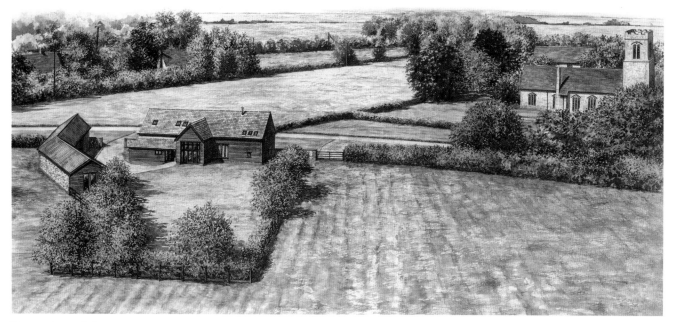

This aerial view of a barn conversion was composed to show the immediate locality and was used for marketing purposes. The client felt that the position itself, close to the local parish church and adjacent houses, would help describe the location before prospective purchasers viewed the property.

Christmas market at Winchester Cathedral. Regular drawing practice on location will improve studio work and sometimes results in a portfolio piece, as with this view of bustling market stalls on a cold winter's afternoon. The sketch was completed in around forty minutes in an A5 sketchbook whilst sitting on a bench; the colour was added later on in the studio.

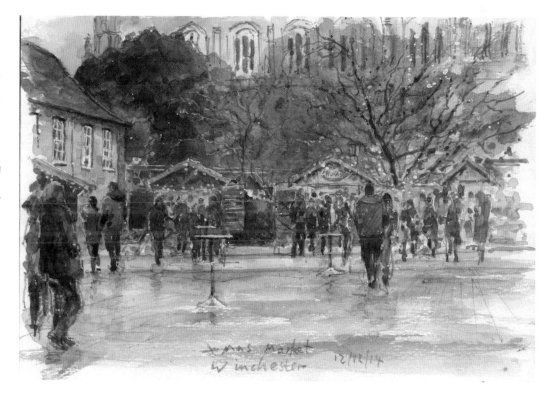

drawing was made in pencil whilst seated on a convenient bench and then coloured in the studio with the aid of photographs taken on the spot. This kind of approach to sketching offers the best of both worlds and allows more discipline when applying colour, something which can be difficult when in a busy location on a cold winter's evening. The figures in the foreground are well defined and become less so as they recede into the background; this helps to depict recession and depth in a picture alongside perspective and softening of colours and tones.

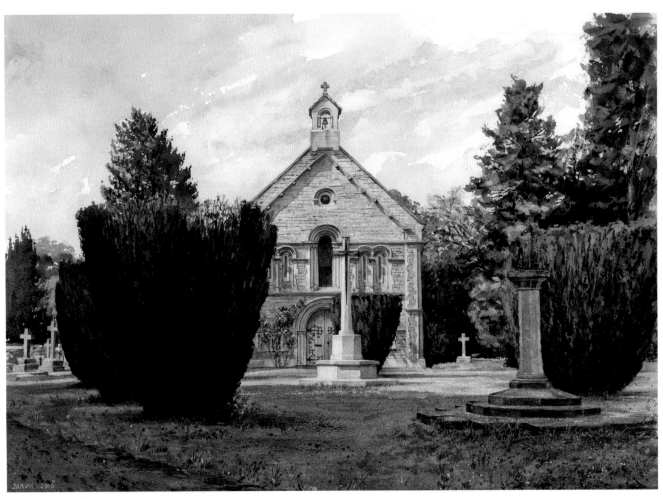

This chapel in Southampton's Old Cemetery has been the author's studio for well over a decade. This watercolour shows the chapel's entrance and memorials and is used on the cover of the newsletter of the Friends of Southampton Old Cemetery. The sunlight works well in the composition, which draws the eye into the picture across the shaded foreground and onto the illuminated gable end of the chapel. (Private collection.)

This Church of England chapel nestles into an array of trees and shrubs in Southampton's Old Cemetery. Done from photographs and sketches, this view represents a familiar sight for the city's cyclists, joggers and dog walkers throughout the year. With the recently pollarded yew trees exposing the chapel's east elevation and decorative entrance bathed in midday sunlight, the opportunity presented itself as the perfect composition. The dense shrubbery to the right of the building acted as an ideal contrast to the yellow ochre stone quoins and a single stone cross. The dark stained-glass window above the entrance leads the eye into the picture via the two stone memorials. And the shaded foreground invites the onlooker into the sunlit grass beyond. The contrast created by the dark yew tree to the left of centre with the chapel's façade sets the tonal range for the whole scene. As the eye moves in and out of the

picture, colours move from warm to cool in creating this frozen moment in time. The sky has been left almost without colour, relying on the composition of elements, while acting as a backdrop.

Creating a balanced composition when working on a perspective view from architects' plans can be challenging, particularly if the building's design is less than inspiring. It helps if there are existing features to work with, such as mature trees and shrubs, hard landscaping elements, or well-established roads or paths. With many new residential developments it's often a matter of starting from scratch and you can only go so far when representing proposed planting in order to give that 'established' look without taking too many liberties. This small apartment block on the next page combined typical design features with lead-faced dormers, slate roof, a glazed canopy and ashlar stone stucco

Perspective view of a proposed apartment block. Site photographs were used to superimpose this building into the location on an overgrown corner plot at below ground level. The selected trees and hedging were based on the existing and 'pruned back' to suit. The neighbouring building's roof was softened to be less significant.

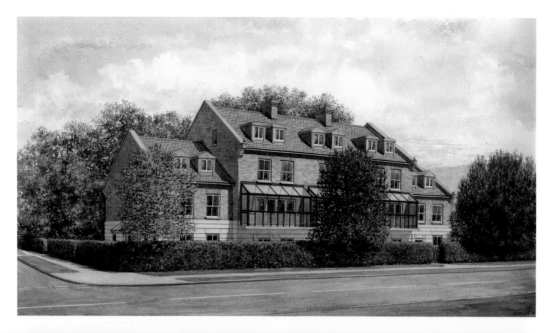

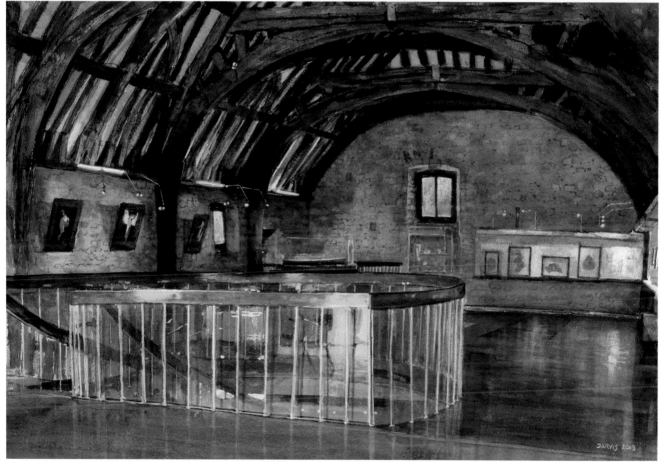

The Wool House, Southampton. This watercolour study was mainly done on location and completed in the studio. It records the upper floor and roof structure prior to remodelling to accommodate a micro-pub. The effects of lighting from natural and artificial sources creates an array of light reflections and shadows, which all add to the atmosphere of this medieval interior.

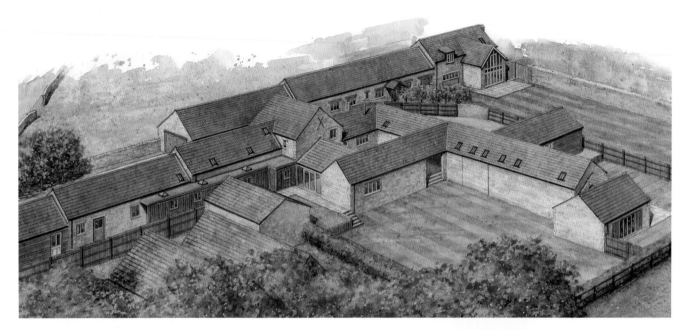

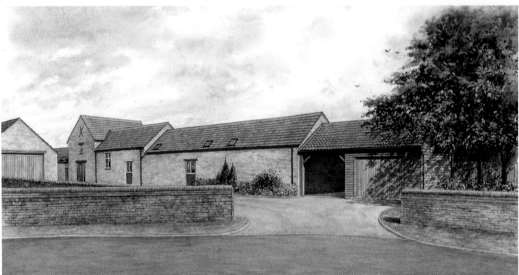

Detail from an aerial perspective and street level view of barn conversions to three residential properties. Multiple views can sometimes describe a proposed development 'in the round' better than digital walk-throughs, especially of vernacular buildings that benefit from traditional rendering media such as watercolour to explain materials, texture and detail.

to the ground floor. The site was very overgrown with mature trees and hedging on a corner plot with grass verges to the paths. The developers were keen that the hedge should be shown neatly trimmed around the entire plot, together with selected trees to complement the building. A neighbouring building was ghosted into the background so that the roof would not be so prominent. The levels within the site dropped away significantly from the road and this portrayed the whole building sitting snugly behind the hedging and blending with the overall environment.

Interior views rely very much on lighting to achieve successful results and this needs to be considered when creating a perspective from plans. Once again, working on location can help in understanding how natural and

artificial light affect colour, materials and texture within an interior space. The Wool House in Southampton on the previous page is a Grade I listed medieval warehouse situated near to the Town Quay. Built in the late fourteenth century it was originally designed to store wool before being exported to Italy. Since then it has had a number of reincarnations and is currently a micro-brewery and public house. Prior to this, for a short period of time, it was used as an arts venue open to the public and it was during this time that this watercolour study was done as an opportunity to record the building's structure before its change of use and refurbishment. Mostly done on location and completed in the studio, the subject matter is ideal for investigating the way light defines shape and form as it

St Peter's Church, Boxted, Essex. Pen drawings, once prolific during the first half of the twentieth century, can still fulfil an illustration requirement for a drawing with impact both in print and on screen. This illustration was used for wedding stationery.

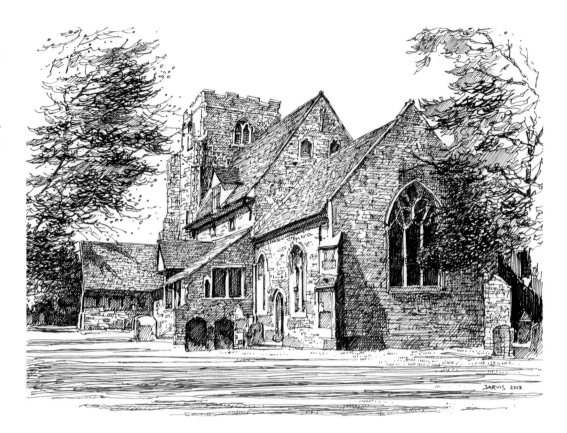

Building elevation for a brochure design.

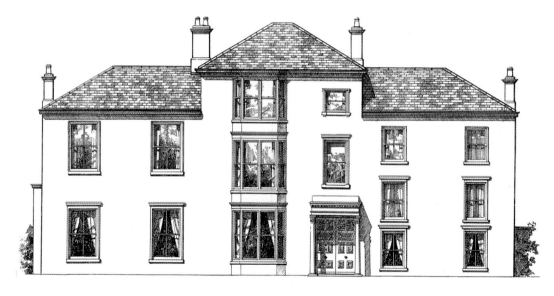

illuminates and subdues colour, surface and structure. The space was mainly lit by natural light flooding in through large windows to the front of the building but with only limited light to the back, as seen here. At this time the space was being used to house an exhibition of paintings and these were lit individually with picture lights, all adding to an array of lights and reflections bouncing from surface to surface. The large spiral stairway with glazing behind the spindles reflected light from the front windows, and the polished floorboards reflected light from the picture lights and wall case. The stone walls varied in colour from bluish grey to yellow ochre and burnt sienna, all coming together in a faithful representation of this interior.

Multiple views are often required when a proposed scheme has a variety of individually designed buildings or houses and the starting point is usually an aerial view.

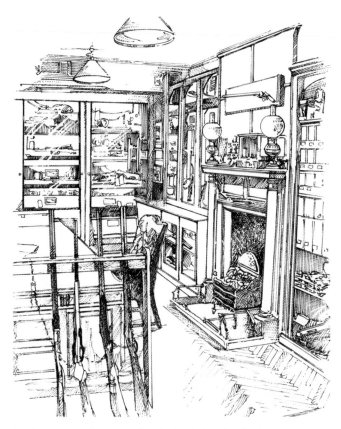

London gun shop interior, used as the frontispiece for a book.

As discussed previously, aerial views can fulfil two roles, being both diagrammatic and at the same time realistically pictorial. This aerial view (shown earlier in the chapter) was set up in SketchUp and shows a proposed development of three barn conversions, the layout of which can be easily understood from above. However, a more realistic viewpoint from a standing eye level requires less understanding of pictorial codes and represents a view that an observer would be more familiar with and can relate to.

Sometimes a pen drawing may be all that is needed for an illustration. These ink drawings were commissioned for a variety of reasons, from wedding stationery to designs for brochures. Black and white artwork can have a strong effect on a target audience and harks back to the days of *Punch* magazine during the first half of the twentieth century, when colour printing was very expensive. The illustrations shown here were all done from photographic reference using a 0.2 and 0.5 Edding 1880 Drawliner Pen on bleed-proof marker paper.

This detail, from an aerial view of a business park (on the next page), was commissioned to show the proposed layout and buildings for promotion and marketing purposes. The main focus was to be on the vernacular style of the buildings, an important aspect in this rural location, and the client requested that the parking areas should be emphasized as this was a selling point for this development. The cars added to the pictorial realism of the illustration and the one-point perspective aerial view provided a diagrammatic overview of the design and layout. The perspective view, as in this case, would normally be the first choice for most raised eye level or 'birds-eye' views of a development, but on some occasions a more simple method might be appropriate.

This view showing a small development of town houses (later in the chapter) is drawn in oblique projection; in this case the site plan was turned to a convenient angle and the building heights projected vertically to a scale of about half true size (*see* Chapter 2). Although essentially a diagram, it does fulfil most of the criteria listed previously in its realistic rendering of colour and form but lacks convincing representation, especially difficult to interpret for those unfamiliar with the drawing method used. This illustration was annotated with labels to indicate each property and was used for advertising and selling purposes.

Large residential developments incorporating apartment blocks can often be difficult to portray attractively in a single view, but in the case of the proposed riverside housing scheme (shown later in the chapter) the setting helped. Not quite Venice (although Little Venice was only a short distance away), this location offered the opportunity to indulge with reflections on the water surface and a canal boat coming into view. The existing Victorian warehouse building behind was softened to make it distinct from the scheme itself, and the whole view was subjected to strong sunlight from the right-hand side of the picture. All the entourage elements contribute to the illustration's representative nature and aesthetic appeal without losing its credibility as an accurate portrayal, at least, of the architect's vision.

Sometimes natural features need adjustment; there is an example later in the chapter where the existing trees fronting a charming Victorian town house have been faded so as not to detract from the building. The subject of a refurbishment and modernization within, the house was one of several scheduled for improvements close to the city of Cambridge. The trees were originally shown to the client as fully rendered and were changed afterwards. This was easily amended by applying clean water to the trunk and branches and the colour was then easily removed by blotting with tissue paper.

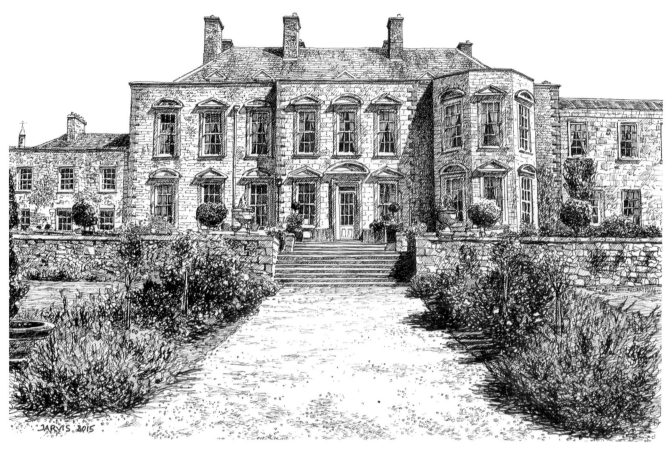

Castle Durrow, Ireland. Wedding reception stationery.

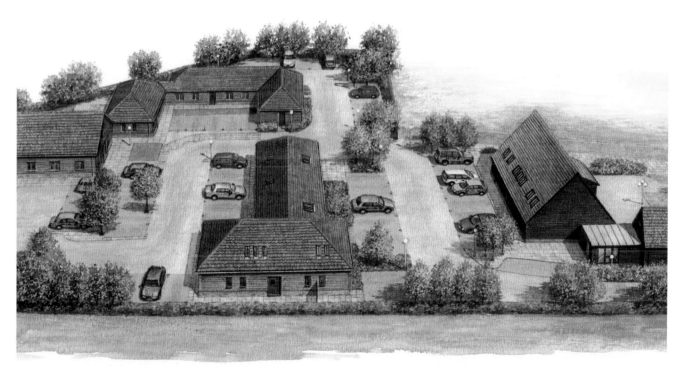

Detail from a perspective of a proposed business park.

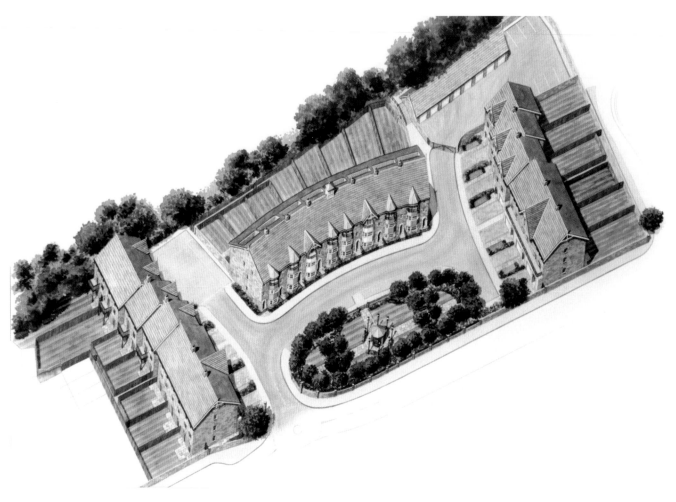

Oblique projection showing layout of a proposed residential development. Rendering in a realistic style helps to communicate such views, which can sometimes be difficult to read.

A final reflection...

The introduction to this book discussed the role of drawing and its importance in the process of architectural illustration. In its many forms, drawing encompasses a range of disciplines from the formality of geometry to the freehand sketch, but it's the line itself that is common to all. Whether a computer-generated wire-frame model or a concept sketch, the line predominates as the initial tool for expressing ideas or communicating shape and form. Of course, a pen outline used to convey an object on a sheet of paper doesn't exist in reality, just as a contour line made on a computer screen is there to give explanation and is accepted as such. We all have the innate ability to make

sense of what an outline represents because our brains are able to interpret abstract concepts. In its simplest form, a surgeon may outline in pen on paper the workings of a defective organ and this may be enough to convey the relevant information to his or her patient, just as a plumber will draw the pipe that runs around a kitchen providing a hot and cold water supply. In terms of illustration, the line may remain in the final work, as in a pen drawing, or be partly or completely obscured in a watercolour rendering. Whatever the final medium used and however masterful it is applied, the level of competency in drawing will always impact on the credibility of the finished work.

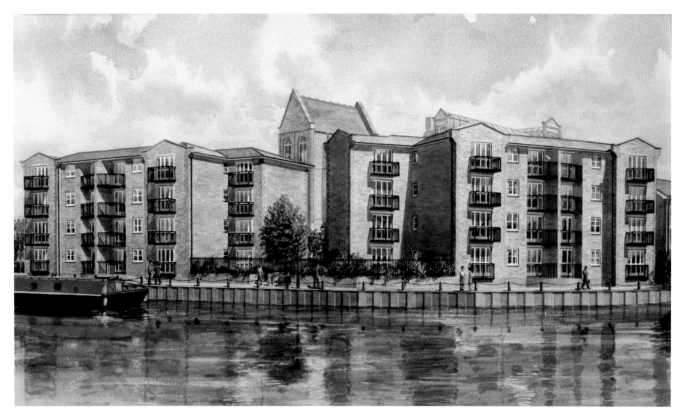

This proposed riverside view uses the water surface and entourage elements to 'soften' this impression of a large urban development.

Street view of a Victorian house subject to restoration and renovation. The existing trees were 'ghosted' to lessen the imposing effect on the elevation of the building.

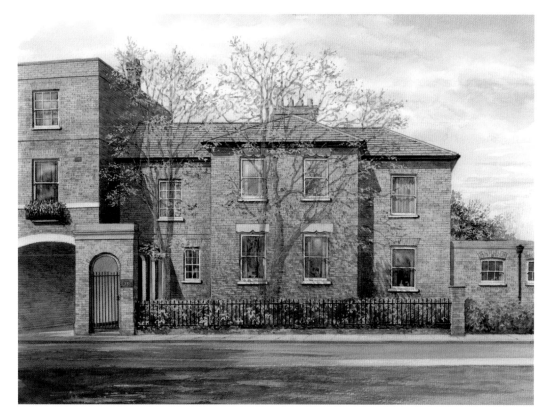

Glossary of Terms

ILLUSTRATION TERMS

3D model
A Computer Generated Image (CGI) as a line drawing which is created using 3D software.

Additive colour
The way light is emitted directly from a source creating colours from the visible spectrum and commonly uses primary colours red, green and blue or RGB. Examples of use are televisions and computer monitors and theatre stage lighting.

Aerial perspective
The effect of atmosphere on the representation of distance within an artwork or photograph.

Architects' plans
Often referred to as a set of plans, this broad term covers general arrangement orthographic drawings and site and location plans.

Axonometric drawing (*see also* Isometric drawing)
A 3D method of drawing that uses the scale from orthographic projection and foreshortens measurements in a single view.

Centre of vision (CV)
The point on the horizon line (eye level) perpendicular to the spectator (SP).

CGI
A Computer Generated Image.

Cockling
The buckling of lightweight watercolour paper when used unstretched.

Complementary colours
Colours opposite each other in the colour wheel. They can be used to enhance or contrast one another.

En plein air
The term that French impressionist painters used to describe the act of painting outdoors.

Entourage elements
Environment and landscape features within a composition including figures, cars, street furniture, etc.

Eye level (*see also* Horizon line)
An imaginary line representing the height of the viewer's eyes in a perspective drawing or photograph.

Field of vision
The extent of an observable view from a specific location.

Golden ratio
The mathematical ratio of 1 to 1.618 commonly found in nature and believed by artists and designers to be an aesthetically pleasing proportion.

Ground line (GL)
In perspective theory this is the meeting of the Picture Plane and the Ground Plane onto which true measurements are made.

Horizon line (HL)
The line in nature where sky meets earth or water on the horizon, which also coincides with a person's eye level.

Hue
A pure colour of the spectrum.

Isometric drawing
An axonometric drawing that is set up using two 30° angles and drawn true to scale.

Measuring point (MP)
Each Vanishing Point has a Measuring Point which is used to project true measurements onto the Ground Line and back to a vanishing parallel.

One-point perspective
Where the picture plane is at 90 degrees to the viewer's line of sight, sometimes called parallel perspective.

Orthographic projection
A single plane method of scale drawing using plan, elevation and section

Perspective, The
A term used to describe an architectural illustration that utilizes linear perspective in its construction.

Pictorial coding
Related signs and symbols representing a framework of accepted and agreed conventions which act as cues to interpretation.

Picture plane (PP)
An imaginary surface between an object and a viewpoint on which points are projected to create a drawing.

Proportion
The relationship of different parts within a whole (body).

Rule of thirds
The division of a given space into nine equal parts using two equally spaced horizontal and vertical lines as an aid to composition.

Scale
The relationship between the size of one object to another.

Shade
The degree of darkness within a colour.

Subtractive colour
The way that pigmented colours mix to create further colours by absorbing wavelengths of light from the visible spectrum and reflecting others. This system is used in traditional painting (primary colours yellow, red and blue or YRB) and printing (cyan, magenta and yellow or CMY).

Tint
The degree of whiteness within a colour.

Tone
The lightness or darkness within a picture.

Topographical illustration
A drawing or painting of an existing place often completed on-location.

Two-point perspective
Where the picture plane is at an angle more or greater than 90 degrees to the line of sight.

Vanishing point (VP)
The point where vanishing parallels converge to in the picture plane.

Viewpoint or station point (SP)
The position of the viewer or spectator in the geometry of a perspective drawing.

Visual
Artwork used to represent a view or views showing how a proposed scheme will look.

Visualization
This refers to any pictorial representation that expresses ideas concerning future built form.

ARCHITECTURAL AND BUILDING TERMS

Roofs

Barge board
Sloping trim of wood or plastic along the edge of a gable to cover and protect roof timbers.

Dormer
A vertical window through a sloping roof.

Eaves
The lowest part of a sloping roof, often meaning the underside of the roof overhang.

Fascia
A board or trim set on edge along the eaves to cover the rafter ends and carry the gutter.

Gable
A standard pitch roof with two slopes, the angles of which vary depending on the weight and style of roof covering.

Hipped
A pitched roof with four slopes, normally with two shorter sides roofed with sloping triangles or hips.

Joist
A horizontal member for supporting floors and ceilings.

Mansard
A pitched roof with a change of angle on each slope, the lower part being steeper than the top and often with dormers.

Rafter
A structural member that slopes up from wall to ridge.

Soffit
A horizontal sheet fixed under the eaves concealing the rafters.

Walls

Ashlar
Hewn stone with straight-cut edges laid in courses.

Brick bonds
The arrangement of bricks (or blocks) providing strength and visual appeal, the most common being header, stretcher, English and Flemish.

Cavity
The gap between two skins of bricks (or blocks) that are held together with metal ties, the void providing ventilation and insulation.

Cladding
Any non-loadbearing material on external walls including weather boarding, brick, stone facing for decorative or weather-proofing purposes.

Pointing
Joints between brick or stonework which have been filled with a mortar mix to run off water.

Soldier course
A course of bricks laid on end, e.g. over a window or just for decoration.

String course
A thin horizontal course of bricks or stone along the wall of a building for decoration; can be projecting to throw off water.

Windows and doors

Bay
A window formed in the projection of a wall on its own foundations.

Casement
A window with one or more hinged sashes which normally open outwards.

Double hung
A standard sash window with frames that slide vertically.

Fanlight
A semi-circular window over a door with radiating bars resembling a fan shape.

Head
A beam or equivalent used to bond two sides of a wall opening, window or door.

Lintel
A horizontal beam over a window or door that carries the weight of the wall above.

Mullion
A vertical dividing member of a window frame.

Sill
The horizontal member that forms the lowest part of a door or window frame (usually called a threshold on a door).

Threshold
A door sill.

Transom
A horizontal bar in stone or timber separating the sashes of a window, or a door from a fanlight above.

General architectural details and terms

Arch
Usually refers to a curved structure spanning the top of an opening in a wall, but can also mean a horizontal lintel made of bricks on edge.

Balustrade
A structure comprising a series of balusters or spindles supporting a handrail.

Buttress
A vertical structure member as in a pier supporting an external wall.

Capital
The decorative feature at the top of a column or pilaster.

Column
A vertical structural member consisting of a base, shaft and capital.

Corbel
A projecting block of brickwork or masonry often supporting a beam or roof truss.

Cupola
A small dome on a roof or similar.

Gable
The triangular upper part of a wall formed by the slopes of a pitched roof, the whole often referred to as a gable end.

Keystone
The highest central part of an arch.

Parapet
A low wall standing above a roof.

Pediment
In classical architecture, the triangular end of a low-pitched gable or a triangular element over a window or door.

Pier
The loadbearing brickwork or masonry in a wall between openings or under columns or arches.

Pitch
The angle of a roof from the eaves to ridge, the most common of which is a double-pitched roof.

Porch
The covered entrance to a building.

Portico
An open-sided porch with columns and pediment.

Quoins
Stone or brickwork forming the outer corner of a wall, often very decorative.

Ridge
The horizontal line on top of a double-pitched roof between the two slopes, usually capped with tiles.

Profile Artists

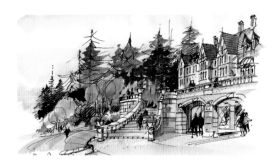

Don Coe
www.sai.org.uk/member/doncoe

Don is President of the Society of Architectural Illustration following over twenty years as its Chairman. Over the years he has established a reputation for his spontaneous and lively pen and wash illustrations, which he normally carries out at the offices of his clients, of which he boasts a current list of over 130.

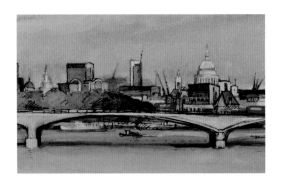

Kate Dicker
www.machelp.org.uk/katedicker/welcome.html

Kate studied at Camberwell College of the Arts where her love of drawing was nurtured through regular location drawing of the urban environment. She completed an MA in Fine Art Printmaking at Winchester School of Art and now divides her time between creating artwork and teaching. She is a member of the Royal Society of Painter-Printmakers and the Society of Wood Engravers.

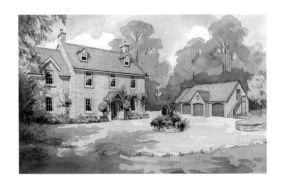

Chris Fothergill
www.chrisfothergill.co.uk

Chris is a Cotswold-based artist and illustrator specializing in house portraits in watercolour and architectural illustrations to clients throughout the UK. He originally started out in 1987 and has been a practising artist, selling paintings and drawings in the Cotswolds for more than 20 years. Chris is a Fellow of the Society of Architectural Illustration.

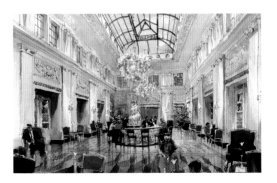

Keith Hornblower
www.hornblower.uk.com

Keith lives and works in his town of birth, Hitchin, Hertfordshire. He followed a rather tortuous path to becoming an architectural illustrator, via mapping, civil and structural engineering and then architecture, qualified in none of the above. He has been an illustrator for 27 years with a wide-ranging portfolio of work and is now in demand as a tutor/demonstrator in the art of watercolour.

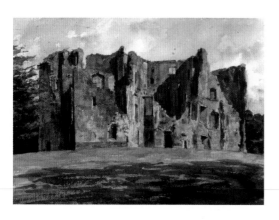

Peter Jarvis (author)

www.pjarvis.co.uk

Peter Jarvis has been creating fine art watercolours and commissioned illustrations for over 25 years. He gained an MPhil from the Royal College of Art in Information Illustration in 1997 and has been practising as a freelance architectural illustrator alongside teaching posts since 1984. He was awarded the prestigious Matt Bruce Memorial Award in 2014 at the annual exhibition of the Royal Institute of Painters in Water Colours (RI). His watercolours have been exhibited at venues throughout the UK including the Mall Galleries and Bankside Gallery in London as well as in Liverpool, Birmingham, Cambridge and Southampton. He also has work in private collections in the UK and abroad.

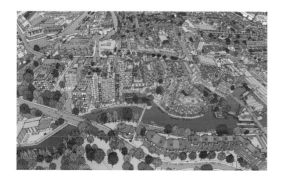

Richard Rees

www.artyrees.com

Richard is an architect with a background in urban design and was for many years an urban design director with Building Design Partnership (BDP) in London. He is now Chairman of the Society of Architectural Illustration (SAI), a freelance illustrator and masterplanner. His skills also extend to painting and he exhibits and sells oil pastels of high vantage-point city views.

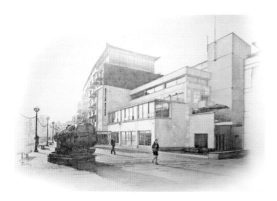

Joseph Robson

www.anisegallery.co.uk/joseph-robson
www.avrlondon.co.uk

Joseph studied Architecture at undergraduate and postgraduate levels before starting teaching at the University of Bath on what has become the acclaimed Digital Illustration Course. He drew his first commission at the age of 14 and has been happily making a living from illustrating architecture ever since. Joseph helped establish the research group CASA and founded AVR London in 2006.

Useful Contacts

American Society of Architectural Illustrators
www.asai.org

Association of Illustrators
www.theaoi.com

The Campaign for Drawing
www.thebigdraw.org

Presenting Architecture
www.presentingarchitecture.com

The Royal Drawing School
www.royaldrawingschool.org

The Royal Institute of British Architects
www.architecture.com

The Society of Architectural Illustration
www.sai.org.uk

Urban Sketchers
www.urbansketchers.org

The V&A Collections/Architecture
www.vam.ac.uk/collections/architecture

Further Reading

Berger, J. *Ways of Seeing*. Penguin Classics, 2008.

Campanario, G. *The Art of Urban Sketching: Drawing on location around the world*. Quarry Books, 2011.

Male, A. *Illustration: A theoretical and contextual perspective*. Bloomsbury, 2017.

Moszkowicz, J. 'The compensations of contemporary topographical illustration: A discussion of the value of the watercolourist in light of Foucault's heterotopia'. In *Journal of Visual Art Practice*. Routledge, 2015 (on-line publication).

Pipes, A. *Foundations of Art and Design*. Laurence King, 2013.

Ridyard, S. *Archisketcher: A guide to spotting and sketching urban landscapes*. Apple Press, 2015.

Robson, J. and Reece, R. *Drawing on Architecture*. Society of Architectural Illustration, 2014.

Schaller, T.W. *The Art of Architectural Drawing*. Van Nostrand Reinhold, 1997.

Stamp, G. *The Great Perspectivists* (RIBA Drawing Series). Trefoil, 1982.

Wilton, A. and Lyles, A. *The Great Age of British Watercolours, 1750–1880*. Prestel, 1997.

Wright, L. *Perspective in Perspective*. Routledge, 1983.

Index